Presented
to the Library of the
Harvard Natural History
Society,
By their unprofitable associate
but sincere well-wisher & friend,
Edward Everett.

Cambridge 13th March 1849.

THE

BIRDS OF AMERICA,

FROM

DRAWINGS MADE IN THE UNITED STATES

AND THEIR TERRITORIES.

BY JOHN JAMES AUDUBON, F. R. SS. L. & E.

Fellow of the Linnean and Zoological Societies of London; Member of the Lyceum of Natural History
of New York, of the Natural History Society of Paris, the Wernerian Natural History Society of
Edinburgh; Honorary Member of the Society of Natural History of Manchester, and of the
Royal Scottish Academy of Painting, Sculpture, and Architecture; Member of
the American Philosophical Society, of the Academy of Natural Sciences
at Philadelphia, of the Natural History Societies of Boston, of
Charleston in South Carolina, the Quebec Literary and
Historical Society, the Ornithological Society
in London, the Société Française de
Statistique Universelle de
Paris, &c. &c.

VOL. I.

NEW YORK:

PUBLISHED BY J. J. AUDUBON.

PHILADELPHIA:

J. B. CHEVALIER.

1840.

E. G. DORSEY, PRINTER.
LIBRARY STREET.

INTRODUCTION.

HAVING been frequently asked, for several years past, by numerous friends of science, both in America and Europe, to present to them and to the public a work on the Ornithology of our country, similar to my large work, but of such dimensions, and at such price, as would enable *every* student or lover of nature to place it in his Library, and look upon it during his leisure hours as a pleasing companion—I have undertaken the task with the hope that those good friends and the public will receive the "BIRDS OF AMERICA," in their present miniature form, with that favour and kindness they have already evinced toward one who never can cease to admire and to study with zeal and the most heartfelt reverence, the wonderful productions of an Almighty Creator.

<div align="right">

J. J. AUDUBON.

</div>

New York, Nov. 1839.

CONTENTS.

L.

BIRDS OF AMERICA.

FAMILY I. VULTURINÆ. VULTURINE BIRDS, or VULTURES.

Bill of moderate length, stout, cerate; upper mandible with the tip elongated and decurved; lower mandible rounded and thin-edged at the end. Head rather small, or of moderate size, ovato-oblong, and with part of the neck destitute of feathers. Eyes of moderate size, without projecting ridges. External aperture of ears rather small and simple. Skin over the fore part of the neck bare, or merely downy. Tarsus rather stout, bare, and shorter than the middle toe; hind toe much smaller than the second; anterior toes connected at the base by a web; claws large, moderately curved, rather acute. Plumage full and rather compact. Wings very long, subacuminate. Œsophagus excessively wide, and dilated into a crop; stomach rather large, somewhat muscular, with a soft rugous epithelium; intestine of moderate length and width; cœca extremely small. The young when fledged have the head and upper part of the neck generally covered with down. Eggs commonly two.

Genus I.—CATHARTES, *Illiger*. TURKEY-VULTURE.

Bill of moderate length, rather slender, somewhat compressed; upper mandible with its dorsal outline nearly straight and declinate to the end of the large cere, then decurved, the edges a little festooned, rather thick, the tip descending and rather obtuse; lower mandible with the angle long and rather narrow, the dorsal line ascending and slightly convex, the back broad,

the edges sharp, towards the end decurved. Nostrils oblong, large, pervious. Head oblong. Tongue deeply concave or induplicate, its edges serrate with reversed papillæ. Œsophagus dilated into an enormous crop; stomach moderately muscular; duodenum convoluted. Head and upper part of neck denuded, being only sparingly covered with very short down. Wings very long and extremely broad; third, fourth, and fifth primaries longest, first much shorter. Tail of moderate length, nearly even. Tarsus short, rather stout, roundish, reticulate. Hind toe very small, second a little shorter than fourth, third very long, all scutellate for more than half their length. Claws strong, arched, compressed, obtuse.

CALIFORNIAN VULTURE.

CATHARTES CALIFORNIANUS, *Lath.*

PLATE I.—ADULT MALE.

Of the three species of Vulture which inhabit the southern parts of North America, this is so much superior in size to the rest that it bears to them the same proportion as a Golden Eagle to a Goshawk. It inhabits the valleys and plains of the western slope of the continent, and has not been observed to the eastward of the Rocky Mountains. Mr. TOWNSEND, who has had opportunities of observing it, has favoured me with the following account of its habits.

"The Californian Vulture inhabits the region of the Columbia river, to the distance of five hundred miles from its mouth, and is most abundant in spring, at which season it feeds on the dead salmon that are thrown upon the shores in great numbers. It is also often met with near the Indian villages, being attracted by the offal of the fish thrown around the habitations. It associates with *Cathartes Aura,* but is easily distinguished from that species in flight, both by its greater size and the more abrupt curvature of its wing. The Indians, whose observations may generally be depended upon, say that it ascertains the presence of food solely by its power of vision, thus corroborating your own remarks on the vulture tribe generally. On the upper waters of the Columbia the fish intended for winter store are usually deposited in huts made of the branches of trees interlaced. I have frequently seen the Ravens attempt to effect a lodgement in these deposits, but have never known the Vulture to be engaged in this way, although these birds were numerous in the immediate vicinity."

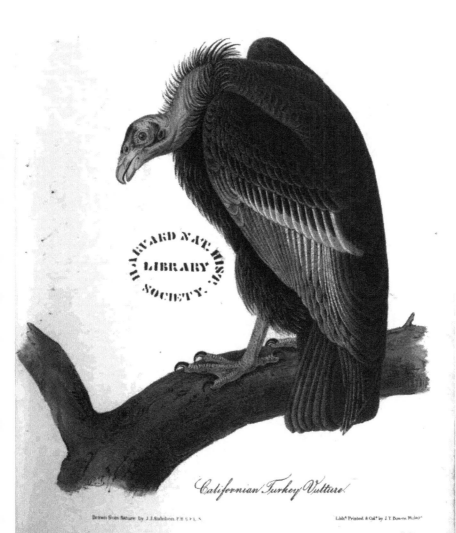

Californian Turkey Vulture.

Drawn from Nature by J.J.Audubon, F.R.S. F.L.S.

Lith⁴ Printed & Col⁴ by J.T. Bowen Philad⁴

Harvard Natural History Society

In a subsequent notice, he continues:—"I have never seen the eggs of the Californian Vulture. The Indians of the Columbia say that it breeds on the ground, fixing its nest in swamps under the pine forests, chiefly in the Alpine country. The Wallammet Mountains, seventy or eighty miles south of the Columbia, are said to be its favourite places of resort. I have never visited the mountains at that season, and therefore cannot speak from my own knowledge. It is seen on the Columbia only in summer, appearing about the first of June, and retiring, probably to the mountains, about the end of August. It is particularly attached to the vicinity of cascades and falls, being attracted by the dead salmon which strew the shores in such places. The salmon, in their attempts to leap over the obstruction, become exhausted, and are cast up on the beaches in great numbers. Thither, therefore, resort all the unclean birds of the country, such as the present species, the Turkey-Buzzard, and the Raven. The Californian Vulture cannot, however, be called a plentiful species, as even in the situations mentioned it is rare to see more than two or three at a time, and these so shy as not to allow an approach to within a hundred yards, unless by stratagem. Although I have frequently seen this bird I have never heard it utter any sound. The eggs I have never seen, nor have I had any account of them that I could depend upon.

"I have never heard of their attacking living animals. Their food while on the Columbia is fish almost exclusively, as in the neighbourhood of the rapids and falls it is always in abundance; they also, like other Vultures, feed on dead animals. I once saw two near Fort Vancouver feeding on the carcass of a pig that had died. I have not seen them at roost. In walking they resemble a Turkey, strutting over the ground with great dignity; but this dignity is occasionally lost sight of, especially when two are striving to reach a dead fish, which has just been cast on the shore; the stately walk then degenerates into a clumsy sort of hopping canter, which is any thing but graceful. When about to rise, they always hop or run for several yards, in order to give an impetus to their heavy body, in this resembling the Condor of South America, whose well known habit furnishes the natives with an easy mode of capturing him by means of a narrow pen, in which a dead carcass has been deposited. If I should return to the Columbia, I will try this method of taking the Vulture, and I am satisfied that it would be successful."

CATHARTES CALIFORNIANUS, Aud. Birds of Am., pl. 426; Orn. Biog., vol. v. p. 240.
CATHARTES CALIFORNIANUS, Bonap. Syn., p. 22.
CALIFORNIAN VULTURE, Nuttall, Man., vol. i. p. 39.

The head and upper part of the neck are bare, but the middle of the fore-

head to beyond the nostrils, and a semicircular space before the eye, are closely covered with very small firm feathers; the fore part of the neck is longitudinally, the occiput and hind neck transversely wrinkled. Plumage full, compact; feathers of the ruff and fore part of the breast lanceolate and acuminate, of the upper parts ovato-elliptical, broadly rounded, and glossy. Wings very long, ample, concave; primaries finely acuminate, secondaries rounded; the first quill two inches and a half shorter than the second, which is half an inch shorter than the third, the latter exceeded by the fourth by half an inch, and equal to the fifth. Tail of moderate length, nearly even, of twelve broad, rounded feathers.

The horny part of the bill yellow; the cere and naked part of the head and neck yellowish-red. Iris dark hazel. Feet yellowish-grey, claws brownish-black. The general colour of the plumage is greyish-black, the feathers of the upper parts narrowly margined with light brown and grey; the secondaries light grey externally, as are the edges of the primaries; the margins of the inner secondaries toward the base, and those of the secondary coverts, with a large portion of the extremity of the latter, are white. The feathers on the sides under the wing, the axillaries, and many of the lower wing-coverts, are white.

Length to end of tail 55 inches; bill along the ridge $4\frac{3}{4}$, along the edge of lower mandible $3\frac{5}{12}$; wing from flexure 34; tail 16; tarsus $4\frac{1}{4}$; hind toe $1\frac{4}{12}$, its claw $1\frac{1}{2}$; second toe $2\frac{1}{2}$, its claw $1\frac{10}{12}$; third toe $4\frac{1}{4}$, its claw 2; fourth toe $2\frac{9}{12}$, its claw $1\frac{4}{12}$.

The young have the horny part of the bill dusky yellowish-grey; the head and neck covered with dull brown very soft down; the feet greyish-yellow, the scutella darker, the claws brownish-black. The general colour of the plumage is blackish-brown, the feathers on the upper part strongly tinged with grey, especially the secondary quills; the feathers of the back edged with light brown, the secondary coverts tipped with brownish-white. The feathers on the sides under the wing, the axillaries, and some of the lower wing-coverts white, with the centre dusky.

Length to end of tail 48 inches; bill along the ridge 4; wing from flexure 32; tail 16; tarsus 4; middle toe 4, its claw $1\frac{9}{12}$.

Harvard Natural History Society.

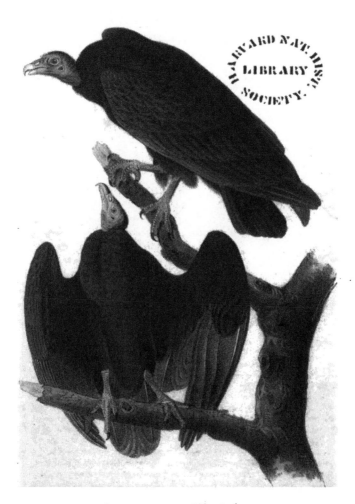

Red-headed Turkey Vulture.

Drawn from Nature by J.J.Audubon F.R.S.F.L.S Lith⁴ Printed & Col⁴ by J. T Bowen Philad⁴

THE TURKEY-BUZZARD.

CATHARTES AURA, *Linn.*

PLATE II.—MALE AND YOUNG.

This species* is far from being known throughout the United States, for it has never been seen farther eastward than the confines of New Jersey. None, I believe, have been observed in New York; and on asking about it in Massachusetts and Maine, I found that, excepting those persons acquainted with our birds generally, none knew it. On my late northern journeys I nowhere saw it. A very few remain and spend the winter in New Jersey and Pennsylvania, where I have seen them only during summer, and where they breed. As we proceed farther south, they become more and more abundant. They are equally attached to maritime districts, and the vicinity of the sea-shore, where they find abundance of food.

The Turkey-Buzzard was found in abundance on the Rocky Mountains and along the Columbia river by LEWIS and CLARK, as well as subsequently by Mr. TOWNSEND, although it is said by Mr. DAVID DOUGLAS to be extremely rare on the north-west coast of America. On the Island of Galveston in Texas, where it is plentiful, we several times found its nest, as usual, on the ground, but on level parts of salt marshes, either under the wide-spread branches of cactuses, or among tall grass growing beneath low bushes,

* The olfactory nerve has been ascertained in the mammalia to be the instrument of smell; but in the class of birds, experiments and observations are wanting to determine its precise function, although analogy would lead us to suppose it to be the same in them. So inaccurate have observers been in this matter, that some of them have mistaken the large branch of the fifth pair, which traverses the nasal cavity, for the olfactory nerve. The experiments instituted upon Vultures shew that not only are they not led to their prey by the sense of smell, but also that they are not made sensible by it of the presence of food when in their immediate proximity. Yet, if the olfactory nerve be really the nerve of smell, and if a large expansion of the nasal membrane be indicative of an extension of the faculty, one would necessarily infer that Vultures must possess it in a high degree. On the other hand, however, the organ and the nerves being found to be equally developed in birds, such as Geese and Gallinaceous species, which have never been suspected of being guided by smell when searching for food, it would seem to follow that the precise function of this nerve, and the nasal cavities, has not yet been determined in birds. That the nasal passages must be sub-servient to some other purpose than that of respiration merely, is evident from their complexity, but what that purpose is, remains to be determined by accurate observations and experiments.

on which Herons of different species also bred, their young supplying a plentiful store of food for those of the Vultures. The eggs, which never exceed two in number, measure two inches and seven-eighths in length, and one inch and seven and a half eighths in their greatest breadth.

The flight of the Turkey-Buzzard is graceful compared with that of the Black Vulture. It sails admirably either high or low, with its wings spread beyond the horizontal position, and their tips bent upward by the weight of the body. After rising from the ground, which it does at a single spring, it beats its wings only a very few times, to enable it to proceed in its usual way of sailing. Like the Black Vultures, they rise high in the air, and perform large circles, in company with those birds, the Fork-tailed Hawk, Mississippi Kite, and the two species of Crow. The Hawks, however, generally teaze them, and force them off toward the ground.

They are gregarious, feed on all sorts of food, and suck the eggs and devour the young of many species of Heron and other birds. In the Floridas, I have, when shooting, been followed by some of them, to watch the spot where I might deposit my game, which, if not carefully covered, they would devour. They also eat birds of their own species, when they find them dead. They are more elegant in form than the Black Vultures, and walk well on the ground or the roofs of houses. They are daily seen in the streets of the southern cities, along with their relatives, and often roost with them on the same trees. They breed on the ground, or at the bottom of hollow trees and prostrate trunks, and lay *only two eggs*. These are large, of a light cream-colour, splashed toward the great end with large irregular markings of black and brown. The young somewhat resemble those of the Black Vulture, and take a long time before they can fly. Both species drink water freely, and in doing this immerse their bill to the base, and take a long draught at a time. They both breed at the same period, or nearly so, and raise only one brood in the season.

I have found birds of this species apparently very old, with the upper parts of their mandibles, and the wrinkled skin around their eyes, so diseased as to render them scarcely able to feed amongst others, all of which seldom failed to take advantage of their infirmities. I have represented the adult male in full plumage, along with a young bird, procured in the autumn of its first year. The average weight of a full grown bird is 6½ lbs., about 1 lb. less than that of the Carrion Crow.

Turkey-Vulture or Turkey-Buzzard, *Vultur Aura*, Wils., vol. ix. p. 96.
Cathartes Aura, Bonap. Syn., p. 22.
Cathartes Aura, Turkey-Vulture, Rich. & Swains., F. Bor. Amer., vol. ii. p. 4.
Turkey-Vulture or Turkey-Buzzard, Nuttall, Man., vol. ii. p. 43.
Turkey-Buzzard, *Cathartes Aura*, Aud., vol. ii. p. 296; vol. v. p. 339.

Harvard Natural History Society.

Pl. 3.

Black Vulture or Carrion Crow.

In the adult, the head and upper part of the neck are destitute of feathers, having a red wrinkled skin, sparsely covered with short black hair, and downy behind. Feathers of the neck full and rounded, concealing the naked crop. Wings ample, long; the first quill rather short, the third and fourth longest. Tail longish, rounded, of twelve broad straight feathers.

Bill at the tip yellowish-white; the cere and the naked part of the head of a tint approaching to blood-red. Iris dark brown. Feet flesh-coloured, tinged with yellow; claws black. The general colour of the plumage is blackish-brown, deepest on the neck and under parts, the wing-coverts broadly margined with brown; the back glossed with brown and greenish tints; the tail purplish-black; the under parts of a sooty brown, on the breast glossed with green.

Length 32 inches; extent of wings 6 feet 4 inches; bill $2\frac{1}{4}$ along the ridge, $2\frac{3}{16}$ along the gap; tarsus $2\frac{1}{2}$, middle toe $3\frac{1}{2}$.

Young fully fledged.

The bill is, of course, shorter and more slender, its horny tip pale blue, black on the back; the skin of the head is flesh-coloured, the iris yellowish, the feet flesh-coloured. The plumage is nearly of the same colour as in the adult.

BLACK VULTURE, OR CARRION CROW.

CATHARTES ATRATUS, *Wilson.*

PLATE III.—MALE AND FEMALE.

This bird is a constant resident in all our southern States, extends far up the Mississippi, and continues the whole year in Kentucky, Indiana, Illinois, and even in the State of Ohio as far as Cincinnati. Along the Atlantic coast it is, I believe, rarely seen farther east than Maryland. It seems to give a preference to maritime districts, or the neighbourhood of water. Although shy in the woods, it is half domesticated in and about our cities and villages, where it finds food without the necessity of using much exertion. Charleston, Savannah, New Orleans, Natchez, and other cities, are amply provided with these birds, which may be seen flying or walking about the streets the whole day in groups. They also regularly attend the markets and shambles, to pick up the pieces of flesh thrown away by the butchers, and, when an opportunity occurs, leap from one bench to another, for the purpose of help-

their parents through the woods. At this period, their head is covered with feathers to the very mandibles. The plumage of this part gradually disappears, and the skin becomes wrinkled; but they are not in full plumage till the second year. During the breeding season, they frequent the cities less, those remaining at that time being barren birds, of which there appear to be a good number. I believe that the individuals which are no longer capable of breeding, spend all their time in and about the cities, and roost on the roofs and chimneys. They go out, in company with the Turkey-Buzzards, to the yards of the hospitals and asylums, to feed on the remains of the provisions cooked there, which are as regularly thrown out to them.

I have represented a pair of Carrion Crows or Black Vultures in full plumage, engaged with the head of our Common Deer, the *Cervus virginianus*.

BLACK VULTURE or CARRION CROW, *Vultur atratus*, Wils. Amer. Orn., vol. ix. p. 104.
CATHARTES IOTA, Bonap. Syn., p. 23.
BLACK VULTURE or CARRION CROW, *Cathartes Iota*, Nuttall, Man., vol. i. p. 46.
BLACK VULTURE or CARRION CROW, Aud., vol. ii. p. 33; vol. v. p. 345.
CATHARTES ATRATUS, BLACK VULTURE, Swains. & Rich., F. Bor. Amer., vol. ii. p. 6.

Adult Male.

Bill elongated, rather stout, straight at the base, slightly compressed; the upper mandible covered to the middle by the cere, broad, curved, and acute at the end, the edge doubly undulated. Nostrils medial, approximate, linear, pervious. Head elongated, neck longish, body robust. Feet strong; tarsus roundish, covered with small rhomboidal scales; toes scutellate above, the middle one much longer, the lateral nearly equal, second and third united at the base by a web. Claws arched, strong, rather obtuse.

Plumage rather compact, with ordinary lustre. The head and upper part of the neck are destitute of feathers, having a black, rugose, carunculated skin, sparsely covered with short hairs, and downy behind. Wings ample, long, the first quill rather short, third and fourth longest. Tail longish, even, or very slightly emarginated at the end, of twelve broad, straight feathers.

Bill greyish-yellow at the end, dusky at the base, as is the corrugated skin of the head and neck. Iris reddish-brown. Feet yellowish-grey; claws black. The general colour of the plumage is dull-black, slightly glossed with blue; the primary quills light brownish on the inside.

Length 26 inches; extent of wings 54; bill 2½; tarsus 3½; middle toe 4.

Adult Female.

The female resembles the male in external appearance, and is rather less.

Harvard Natural History Society.

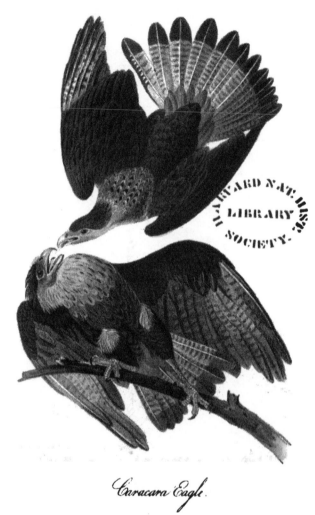

Caracara Eagle.

Drawn from Nature by J.J.Audubon F.R.S.F.L.S. Lithd Printed & Cold by J.T.Bowen Philad.

FAMILY II. FALCONINÆ. FALCONINE BIRDS.

Bill short, stout, cerate; upper mandible with the tip elongated and decurved; lower mandible rounded and thin-edged at the end. Head rather large, broadly ovate, feathered. Eyes large, with prominent superciliary ridges. External aperture of ears of moderate size, and simple. Tarsus longer than the middle toe; claws very large, much curved, extremely acute. Plumage full and generally compact. Wings very long and broad. Œsophagus excessively wide and dilated into a crop; stomach large, somewhat membranous, its muscular fasciculi being placed in a single series; intestine short and rather wide, or very long and slender; cœca extremely small. The young, when fledged, generally having the lower parts longitudinally streaked. Eggs from two to six, ovate, or roundish. Nest on trees, rocks, or the ground.

Genus I.—POLYBORUS, *Vieill.* CARACARA.

Bill large, high, rather long, much compressed; cere large, covered with hair-like feathers; upper outline convex and declinate to the edge of the cere, then decurved; edge of upper mandible slightly arched and nearly even, tip of lower compressed and rounded. Nostrils elliptical, oblique, in the anterior part of the cere near the ridge. Eyelids and space anterior to the eye denuded, as is the skin over the crop. Feet rather long; tarsi anteriorly scutellate, sharp-edged and scaly behind; toes rather long, broadly scutellate, the first much shorter than the second; claws long, little curved, that of the middle toe being only slightly arched. Wings long, rounded, the third and fourth quills longest, the first five having the inner web cut out. Tail rather long, rounded.

THE CARACARA EAGLE.

POLYBORUS BRAZILIENSIS, *Gm.*

PLATE IV.

I was not aware of the existence of the Caracara or Brazilian Eagle in the United States, until my visit to the Floridas in the winter of 1831. On the

24th November of that year, in the course of an excursion near the town of St. Augustine, I observed a bird flying at a great elevation, and almost over my head. Convinced that it was unknown to me, and bent on obtaining it, 'I followed it nearly a mile, when I saw it sail towards the earth, making for a place where a group of Vultures were engaged in devouring a dead horse. Walking up to the horse, I observed the new bird alighted on it, and helping itself freely to the savoury meat beneath its feet; but it evinced a degree of shyness far greater than that of its associates, the Turkey-Buzzards and Carrion Crows. I moved circuitously, until I came to a deep ditch, along which I crawled, and went as near to the bird as I possibly could; but finding the distance much too great for a sure shot, I got up suddenly, when the whole of the birds took to flight. The eagle, as if desirous of forming acquaintance with me, took a round and passed over me. I shot, but to my great mortification missed it. However it alighted a few hundred yards off, in an open savanna, on which I laid myself flat on the ground, and crawled towards it, pushing my gun before me, amid burs and mud-holes, until I reached the distance of about seventy-five yards from it, when I stopped to observe its attitudes. The bird did not notice me; he stood on a lump of flesh, tearing it to pieces, in the manner of a Vulture, until he had nearly swallowed the whole. Being now less occupied, he spied me, erected the feathers of his neck, and, starting up, flew away, carrying the remainder of his prey *in his talons.* I shot a second time, and probably touched him; for he dropped his burden, and made off in a direct course across the St. Sebastian river, with alternate sailings and flappings, somewhat in the manner of a Vulture, but more gracefully. He never uttered a cry, and I followed him wistfully with my eyes until he was quite out of sight.

The following day the bird returned, and was again among the Vultures, but at some distance from the carcass, the birds having been kept off by the dogs. I approached by the ditch, saw it very well, and watched its movements, until it arose, when once more I shot, but without effect. It sailed off in large circles, gliding in a very elegant manner, and now and then diving downwards and rising again.

Two days elapsed before it returned. Being apprised by a friend of this desired event, instead of going after it myself, I despatched my assistant, who returned with it in little more than half an hour. I immediately began my drawing of it. The weather was sultry, the thermometer being at 89°; and, to my surprise, the vivid tints of the plumage were fading much faster than I had ever seen them in like circumstances, insomuch that Dr. BELL of Dublin, who saw it when fresh, and also when I was finishing the drawing twenty-four hours after, said he could scarcely believe it to be the same bird. How often have I thought of the changes which I have seen effected

in the colours of the bill, legs, eyes, and even the plumage of birds, when looking on imitations which I was aware were taken from stuffed specimens, and which I well knew could not be accurate! The *skin*, when the bird was quite recent, was of a bright yellow. The bird was extremely lousy. Its stomach contained the remains of a bullfrog, numerous hard-shelled worms, and a quantity of horse and deer-hair. The skin was saved with great difficulty, and its plumage had entirely lost its original lightness of colouring. The deep red of the fleshy parts of the head had assumed a purplish livid hue, and the spoil scarcely resembled the coat of the living Eagle.

I made a double drawing of this individual, for the purpose of shewing all its feathers, which I hope will be found to be accurately represented.

Since the period when I obtained the specimen above mentioned, I have seen several others, in which no remarkable differences were observed between the sexes, or in the general colouring. My friend Dr. BENJAMIN STROBEL, of Charleston, South Carolina, who has resided on the west coast of Florida, procured several individuals for the Reverend JOHN BACHMAN, and informed me that the species undoubtedly breeds in that part of the country, but I have never seen its nest. It has never been seen on any of the Keys along the eastern coast of that peninsula; and I am not aware that it has been observed any where to the eastward of the Capes of Florida.

The most remarkable difference with respect to habits, between these birds and the American Vultures, is the power which they possess of carrying their prey in their talons. They often walk about, and in the water, in search of food, and now and then will seize on a frog or a very young alligator with their claws, and drag it to the shore. Like the Vultures, they frequently spread their wings towards the sun, or in the breeze, and their mode of walking also resembles that of the Turkey-Buzzard.

CARACARA EAGLE, *Polyborus vulgaris*, Aud. Orn. Biog., vol. ii. p. 350; vol. v. p. 351.

Adult Male.

Bill rather long, very deep, much compressed, cerate for one-half of its length; upper mandible with the dorsal outline nearly straight, but declinate for half its length, curved in the remaining part, the ridge narrow, the sides flat and sloping, the sharp edges slightly undulated, the tip declinate, trigonal; lower mandible with the sides nearly erect, the back rounded, the tip narrow, and obliquely rounded. Nostrils oblong, oblique, in the fore and upper parts of the cere. Head of moderate size, flattened; neck rather short, body rather slender. Feet rather long and slender; tarsus rounded, covered all round with hexagonal scales, the anterior much larger, and the five lower broad

and transverse; toes of moderate size, scutellate above, the inner scaly at the base; the outer is connected with the middle toe at the base by a web, as is the inner, although its web is smaller; lateral toes equal, middle one considerably longer, hind toe shortest, and not proportionally stronger; claws long, arched, roundish, tapering to a point.

Plumage compact, slightly glossed. Upper eyelid with short strong bristles; space before the eye, cheeks, throat and cere of both mandibles bare, having merely a few scattered bristly feathers. Feathers of the head, neck and breast narrow; of the back broad and rounded; outer tibial feathers elongated, but shorter than in most Hawks. Wings long, reaching to within two inches of the tip of the tail; primaries tapering, secondaries broad and rounded, with an acumen; the fourth quill longest, third scarcely shorter, first and seventh about equal; almost all the primaries are more or less sinuate on their inner webs, and the second, third, fourth, fifth and sixth on their outer. Tail long, rounded, of twelve broadish, rounded feathers. There is a large bare space on the breast, as in the Turkey-Buzzard.

Bill pale blue, yellow on the edges, cere carmine. Iris dark-brown. Feet yellow; claws black. Upper part of the head umber-brown, streaked with brownish-black. Feathers of hind-neck and fore part of the back light brownish-yellow, mottled with dark brown towards the end. Back and wings dark brown, edged with umber. Primaries and some of the secondaries barred with broad bands of white, excepting towards the end. Tail coverts dull white, slightly barred with dusky. Tail greyish-white, with sixteen narrow bars, and a broad terminal band of blackish-brown, the tips lighter. Fore part and sides of the neck light brownish-yellow; the fore part of the breast marked like that of the back, the yellow colour extending over the lateral part of the neck; the hind part, abdomen, sides, and tibia dark brown; the lower tail-coverts yellowish-white. Interior of mouth and skin of the whole body bright yellow.

Length 23½ inches; extent of wings 4 feet; bill along the ridge 2¼, the cere being 1, along the edge 2¼; tarsus 3¼, middle toe and claw 3¾.

Genus II.—BUTEO, *Bechst.* BUZZARD.

Bill short, with the upper outline nearly straight and declinate to the edge of the cere, then decurved, the sides rapidly sloping, the edges with a slight festoon, the tip trigonal, acute; lower mandible with the dorsal line convex and ascending, the edges arched, at the end deflected, the tip rounded. Head large, roundish, flattened above. Nostrils obovate, nearer the ridge than the

Harvard Natural History Society.

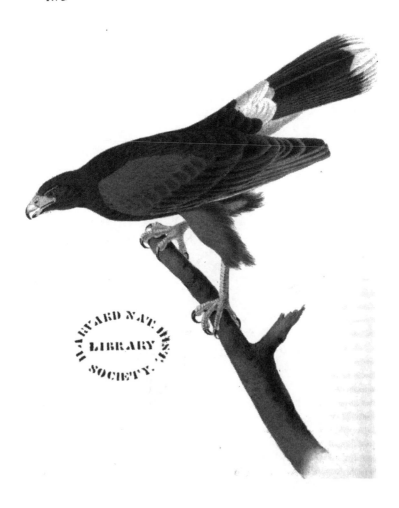

Harris's Buzzard

Drawn from nature by J.J.Audubon F.R.S.F.L.S

Lith? Printed & Cold by J.T. Bowen Philad?

margin. Neck rather short. Body full. Feet short, robust; tarsi roundish, anteriorly feathered half way down, and scutellate, posteriorly also scutellate; toes of moderate length, scaly for half their length; claws long, arched, compressed, acuminate. Plumage full and rather blended. Space between the bill and eye covered with bristly feathers. Wings long, broad, the fourth quill longest, the first and seventh or eighth about equal; the first four abruptly cut out on the inner web. Tail rather long, broad, slightly rounded. Cere and feet yellow; bill light blue at the base, black at the tip, in all the American species.

HARRIS'S BUZZARD.

BUTEO HARRISII, *Aud.*

PLATE V.

The varying modes of flight exhibited by our diurnal birds of prey have always been to me a subject of great interest, especially as by means of them I have found myself enabled to distinguish one species from another, to the farthest extent of my power of vision. On considering this matter, I have become fully convinced that a greater length of the wings in any one species is not, as most naturalists have imagined, an indication of its greater power of flight. Writers of the present day who, judging of the flight of birds from such circumstances, think that those species which have longer and, as they suppose, more complete wings, fly with more rapidity than those whose wings are comparatively short, are, in my opinion, quite mistaken. They judge in this matter, not from experience, but from appearance, having previously determined theoretically that a long wing is a more efficient instrument than a short one; and being acquainted with birds only through the medium of skins and feathers, presume to inform us as to their comparative agility. The power of flight in birds of any kind depends not upon the length, amplitude, or shape of the wings, but upon the rapidity with which these members are moved, and the muscular energy applied to them. It is not a little surprising to me that not one of the authors who have written on this subject, has spoken of the mode of flight of our Turkey-Buzzard, which, notwithstanding its very ample wings, is one of the very slowest birds; for, although it manages to rise to a great height, all its movements are laborious and heavy, unless when it is at some considerable elevation. The amplitude of its wings serves it in sailing only, never in enabling it to pass swiftly

through the air, as birds of much shorter wings, but greater muscular energy, are wont to do.

The Golden Eagle, which has universally been considered as a bird of most extraordinary powers of flight, is in my estimation little more than a sluggard, though its wings are long and ample. It is true that it can sustain itself for a very considerable time on wing, but the observer cannot fail to see that, instead of being swift, it moves slowly and somewhat heavily. For this reason it is rarely seen to give chase on wing, but depends more on the weight of its body while falling or swooping on its prey from a certain height than upon any dexterity or velocity of flight. Eagles while swooping do not use their wings as a medium of propelling themselves farther than by nearly closing them, that they may descend with more rapidity, in doing which they produce a loud rustling noise, which I have often thought has a tendency to frighten the quarry so much as to render it unable to seek for safety by flight or speed of foot. The Golden Eagle can, indeed, soar to a very great height, but this it accomplishes by a circling or gyratory flight of a very slovenly character, and not much superior to that of Vultures or birds still more nearly allied to itself. Thus, reader, I would look on this celebrated bird as one of the slowest and heaviest of its tribe; and would place next in order our Red-tailed Hawk, *Falco borealis*, which being also possessed of ample wings, of considerable length, moves through the air and pounces upon its prey in a similar manner. Then in succession will come the Black Warrior, *Falco Harlani;* the Broad-winged Hawk, *F. Pennsylvanicus;* the Red-shouldered Hawk, *F. lineatus;* the Common Buzzard, *Buteo vulgaris;* and the Rough-legged Falcon, *F. lagopus* or *F. Sancti-Johannis*, which is in a manner the very counterpart of the Golden Eagle, as well as every other species endowed with no greater powers, and furnished with wings and tails of similar size and form; although, of course, some slight differences are to be observed in these different species, on all of which I would willingly bestow the distinctive name of *Swoopers*. All these birds are more or less indolent; one might say they are destitute of the power of distinguishing themselves in any remarkable manner, and none of them shew a propensity to remove to any great distance from the place of their birth, unless, indeed, when very hard pressed either by want of food or by very intense cold.

The next group, which attracts the attention of the American ornithologist, is that composed of such birds as are provided with longer and almost equally broad wings, but assisted by more or less elongated and forked tails. Of this kind are our Swallow-tailed Hawk, *Falco furcatus;* the Black-shouldered Hawk, *F. dispar;* and the Mississippi Kite, *F. Mississippiensis*. These species assume what I would call a flowing manner of flight, it being

extremely graceful, light, buoyant, and protracted beyond that of most other hawks. They are, however, devoid of the power of swooping on their quarry, which they procure by semicircular glidings of greater or less extent, according to the situation or nature of the place, over the land or the water, on the branches or trunks of trees, or even through the air, while in the latter they are wont to secure large coleopterous insects. These species are provided with short, strong tarsi, are scarcely able to walk with ease, wander to great distances, and possess very little courage.

After these long-winged fork-tailed hawks, comes the Marsh Hawk, *Falco cyaneus*, which, by its easy manner of flying, it being supported by ample wings and tail, is in some degree allied to them, though it is by no means a bird of rapid flight, but one which procures its food by patient industry, and sometimes by surprising its prey. Its style of chase is very inferior to that of those species which I consider as not only the swiftest, but the most expert, active, and persevering marauders. The Marsh Hawk is connected with these by its long and slender tail, and also by its propensity to wander over vast tracts of country. It may be said to swoop or to glide in procuring its prey, which consists both of birds and small quadrupeds, as well as insects, some of the latter of which it even seizes on wing.

Taking somewhat into consideration the usual low flight of the latter species, I feel induced to place next it the very swiftest of our Hawks, as I am convinced you would consider them, had you witnessed, like me, their manners for many successive years. These are the Goshawk, *F. palum-barius*, Cooper's Hawk, *F. Cooperi*, the Pigeon Hawk, *F. columbarius*, and the Sharp-shinned Hawk, *F. fuscus*. Though their wings are compara-tively short, somewhat rounded, and rather concave, they have longer bodies and larger tails than any other of our hawks. The tail is used as a rudder, and appears most effectually to aid them in their progress on wing. None of these birds ever pounce on their prey, but secure it by actual pursuit on wing. Industrious in the highest degree, they all hunt for game, instead of remaining perched on a rocky eminence, or on the top branch of a tall tree, waiting the passing or appearance of some object. They traverse the coun-try in every direction, and dash headlong in the wildest manner, until their game being up they follow it with the swiftness of an arrow, overtake it, strike it to the ground with wonderful force, and at once fall to, and devour it. Although the flight of our Passenger Pigeon is rapid and protracted almost beyond belief, aided as this bird is by rather long and sharp wings, as well as an elongated tail, and sustained by well regulated beats, that of the Goshawk or of the other species of this group so very far surpasses it, that they can overtake it with as much ease as that with which the pike seizes a carp. I have often thought that the comparatively long tarsi of these

Pl. 6.

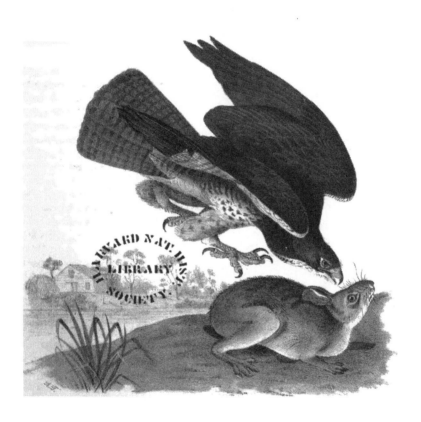

Common Buzzard.

Drawn from Nature by J.J.Audubon, F.R.S.FL.S.

Lithᵈ Printed & Colᵈ by J.T. Bowen Phil.

Harvard Natural History Society.

time motionless on the bough of a tree, watching patiently for some small quadruped, bird, or reptile to pass within its reach. As soon as it espies its prey, it glides silently into the air, and, sweeping easily and rapidly down, seizes it in its claws. When disturbed, it makes a short circuit, and soon settles on another perch. It builds its nest on a tree, of short sticks, lining it sparingly with deer's hair. The eggs, from three to five in number, are equal in size to those of the domestic fowl, and have a greenish-white colour, with a few large dark brown blotches at the thick end. It was seen by the Expedition as far north as the fifty-seventh parallel of latitude, and it most probably has a still higher range."

BUTEO VULGARIS, COMMON BUZZARD, Rich. & Sw. F. Bor. Amer., vol. ii. p. 47.
COMMON BUZZARD, *Falco buteo,* Aud. Orn. Biog., vol. iv. p. 108.

Female.

Bill short, strong, as broad as deep at the base, compressed toward the end. Upper mandible cerate, its dorsal outline declinate and little convex as far as the cere, then decurved, the sides rapidly sloping, towards the end nearly perpendicular but convex, the edge with a slight festoon, the tip trigonal, acute; lower mandible with the angle short and rounded, the dorsal line convex and ascending, the edges sharp, arched, at the end deflected, the tip rounded. Nostrils irregularly obovate, in the fore part of the cere, nearer the ridge than the margin.

Head large, roundish, flattened above; neck rather short; body full. Feet short, robust; tarsi roundish, anteriorly feathered half-way down, anteriorly scutellate, laterally reticulate, posteriorly also scutellate; the lower part all round covered with series of small scales, as are the toes for half their length, the terminal portion being scutellate; they are strong, of moderate length, the hind toe stouter, with four large scutella, the inner with four, the middle with about eight, and connected at the base by a web with the outer, which has four large scutella. Claws long, arched, compressed, tapering to a point, flat beneath.

Plumage ordinary, full, rather blended beneath. Space between the bill and eye covered with bristly feathers; eyelids with soft downy feathers, and ciliate; the superciliary ridge prominent. Feathers of the head and neck ovato-oblong, of the back and breast ovate and rounded, of the sides and outer part of the leg elongated, of the rest of the leg short. Wings long, broad, the fourth quill longest, the third next, the fifth very little shorter, the second longer than the fifth, the first and seventh about equal; first four abruptly cut out on the inner web; secondaries broad and rounded. Tail rather long, broad, slightly rounded.

Bill light blue at the base, with the margins yellowish, the tip black; the cere yellow. Iris hazel. Feet yellow; claws black, at the base bluish. The general colour of the upper parts is chocolate-brown. The quills are of the general colour externally, but the primaries are black toward the tip; a great part of the inner web, with the shaft, white, and barred with brownish-black, the bars more extended on the secondaries. The tail is marked with about ten dusky bars on a reddish-brown ground, tinged with grey, the last dark bar broader, the tips paler. The eyelids are whitish, as is the throat, which is longitudinally streaked with dusky. The rest of the lower parts are yellowish or brownish-white, barred with brown. The lower wing-coverts are white, barred or spotted with dusky; the white of the inner webs of the primaries forms a conspicuous patch, contrasted with the greyish-black of their terminal portion.

Length to end of tail 23 inches; wing from flexure 17; tail $10\frac{1}{2}$; bill along the ridge $1\frac{8}{12}$, along the edge of lower mandible $1\frac{7}{12}$; tarsus $3\frac{4}{12}$; hind toe 1, its claw $1\frac{1}{12}$; middle toe $1\frac{10}{12}$, its claws $1\frac{1}{12}$.

Another specimen in my possession, procured by Mr. TOWNSEND on the plains of Snake river, has the upper parts brown, streaked and spotted with reddish-white; the upper tail-coverts white, barred with dusky, the lower parts as above described. The colours however vary, and in some the upper parts are deep brown, the lower reddish or brownish-white, barred with reddish-brown.

When compared with European specimens, mine have the bill somewhat stronger; but in all other respects, including the scutella and scales of the feet and toes, and the structure of the wings and tail, the parts are similar.

THE RED-TAILED BUZZARD.

BUTEO BOREALIS, *Gmel.*

PLATE VII.—MALE AND FEMALE.

The Red-tailed Hawk (Buzzard) is a constant resident in the United States, in every part of which it is found. It performs partial migrations, during severe winters, from the Northern Districts towards the Southern. In the latter, however, it is at all times more abundant, and I shall endeavour to present you with a full account of its habits, as observed there.

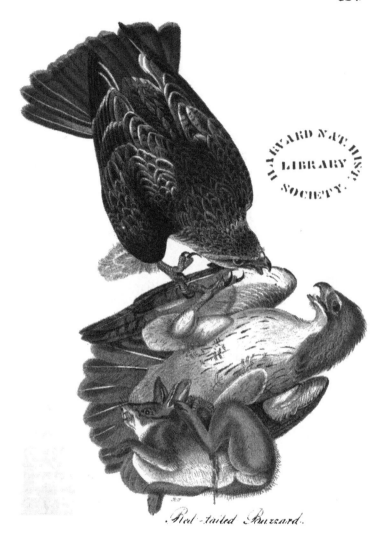

Red-tailed Buzzard.

Drawn from Nature by J. J. Audubon, F.R.S. F.L.S. Lith⁴ Printed & col⁴ by J. T. Bowen Philad⁴

Harvard Natural History Society

Its flight is firm, protracted, and at times performed at a great height. It sails across the whole of a large plantation, on a level with the tops of the forest trees which surround it, without a single flap of its wings, and is then seen moving its head sidewise to inspect the objects below. This flight is generally accompanied by a prolonged mournful cry, which may be heard at a considerable distance, and consists of a single sound resembling the mono-syllable *Kae*, several times repeated, for three or four minutes, without any apparent inflection or difference of intensity. It would seem as if uttered for the purpose of giving notice to the living objects below that he is passing, and of thus inducing them to bestir themselves and retreat to a hiding-place, before they attain which he may have an opportunity of pouncing upon one of them. When he spies an animal, while he is thus sailing over a field, I have observed him give a slight check to his flight, as if to mark a certain spot with accuracy, and immediately afterwards alight on the nearest tree. He would then instantly face about, look intently on the object that had attracted his attention, soon after descend towards it with wings almost close to his body, and dart upon it with such accuracy and rapidity as seldom to fail in securing it.

When passing over a meadow, a cotton-field, or one planted with sugar-canes, he performs his flight close over the grass or plants, uttering no cry, but marking the prey in the manner above described, and on perceiving it, ascending in a beautiful curved line to the top of the nearest tree, after which he watches and dives as in the former case. Should he not observe any object worthy of his attention, while passing over a meadow or a field, he alights, shakes his feathers, particularly those of the tail, and, after spending a few minutes in pluming himself, leaves the perch, uttering his usual cry, and ascending in the air, performs large and repeated circular flights, care-fully inspecting the field, to assure himself that there is in reality nothing in it that may be of use to him. He then proceeds to another plantation. At other times, as if not assured that his observations have been duly made, he rises in circles over the same field to an immense height, where he looks like a white dot in the heavens. Yet from this height he must be able to distinguish the objects on the ground, even when these do not exceed our little partridge or a young hare in size, and although their colour may be almost the same as that of surrounding bodies; for of a sudden his circlings are checked, his wings drawn close to his body, his tail contracted to its smallest breadth, and he is seen to plunge headlong towards the earth, with a rapidity which produces a loud rustling sound nearly equal to that of an Eagle on a similar occasion.

Should he not succeed in discovering the desired object in the fields, he enters the forest and perches on some detached tree, tall enough to enable

brown; larger lighter brown, tipped with white. Primary quills blackish-brown; secondaries lighter, tipped with brownish-white; all barred with blackish. Upper tail-coverts whitish, barred with brown, and yellowish-red in the middle. Tail bright yellowish-red, tipped with whitish, and having a narrow bar of black near the end. Lower parts brownish-white; the fore part of the breast and neck light yellowish-red, the former marked with guttiform, somewhat sagittate brown spots; abdomen and chin white; feathers of the leg and tarsus pale reddish-yellow, those on the outside indistinctly spotted.

Length 20½ inches; extent of wings 46; bill along the back 1¼, along the gap 2; tarsus 3½, middle toe 2¾. Wings when closed reaching to within two inches of the tip of the tail.

Adult Female.

The female, which is considerably larger, agrees with the male in the general distribution of its colouring. The upper parts are darker, and the under parts nearly white, there being only a few narrow streaks on the sides of the breast; the tibial and tarsal feathers as in the male. The tail is of a duller red, and wants the black bar.

Length 24 inches.

HARLAN'S BUZZARD.

BUTEO HARLANI, *Aud.*

PLATE VIII.—MALE AND FEMALE.

Long before I discovered this fine Hawk, I was anxious to have an opportunity of honouring some new species of the feathered tribe with the name of my excellent friend Dr. RICHARD HARLAN of Philadelphia. This I might have done sooner, had I not waited until a species should occur, which in its size and importance should bear some proportion to my gratitude toward that learned and accomplished friend.

The Hawks now before you were discovered near St. Francisville, in Louisiana, during my late sojourn in that State, and had bred in the neighbourhood of the place where I procured them, for two seasons, although they had always eluded my search, until, at last, as I was crossing a large cotton field, one afternoon, I saw the female represented in the Plate standing

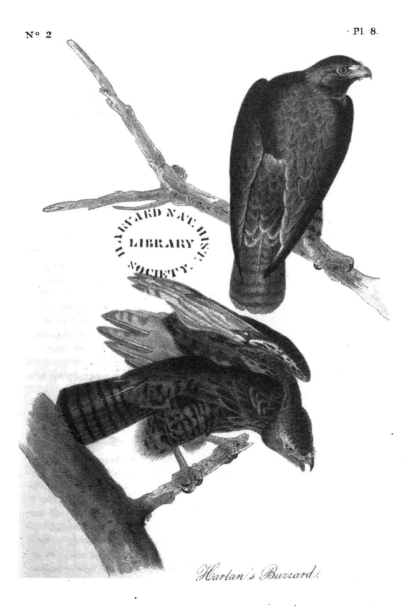

Harlan's Buzzard.

Drawn from Nature by J.J. Audubon. F.R.S.F.L.S

Lith.ᵈ Printed & Col.ᵈ by J.T. Bowen Philad.ᵃ

Harvard Natural History
Society

perched on the top of a high belted tree in an erect and commanding attitude. It looked so like the Black Hawk (*Falco niger*) of WILSON, that I apprehended what I had heard respecting it might prove incorrect. I approached it, however, when, as if it suspected my evil intentions, it flew off, but after at first sailing as if with the view of escaping from me, passed over my head, when I shot at it, and brought it winged to the ground. No sooner had I inspected its eye, its bill, and particularly its naked legs, than I felt assured that it was, as has been represented by those persons who had spoken to me of its exploits, a new species. I drew it whilst alive; but my intentions of preserving it and carrying it to England as a present to the Zoological Society were frustrated by its refusing food. It died in a few days, when I preserved its skin, which, along with those of other rare birds, I have since given to the British Museum, through my friend J. G. CHILDREN, Esq. of that institution.

A few days afterwards I saw the male bird perched on the same tree, but was unable to approach him so long as I had a gun, although he frequently allowed me and my wife to pass close to the foot of the tree when we were on horseback and unarmed. I followed it in vain for nearly a fortnight, from one field to another, and from tree to tree, until our physician, Dr. JOHN B. HEREFORD, knowing my great desire to obtain it, shot it in the wing with a rifle ball, and sent it alive to me. It was still wilder than the female, erected the whole of the feathers of its head, opened its bill, and was ever ready to strike with its talons at any object brought near it. I made my drawing of the male also while still alive.

This species, although considerably smaller than the Red-tailed Hawk, to which it is allied, is superior to it in flight and daring. Its flight is rapid, greatly protracted, and so powerful as to enable it to seize its prey with apparent ease, or effect its escape from its stronger antagonist, the Red-tail, which pursues it on all occasions.

The Black Warrior has been seen to pounce on a fowl, kill it almost instantly, and afterwards drag it along the ground for several hundred yards, when it would conceal it, and return to feed upon it in security. It was not observed to fall on Hares or Squirrels, but at all times evinced a marked preference for common Poultry, Partridges, and the smaller species of Wild Duck.

I was told that the young birds appeared to be of a leaden-gray colour at a distance, but at the approach of winter became as dark as the parents. None of them were to be seen at the time when I procured the latter. Of its nest or eggs nothing is yet known. My friends Messrs. JOHNSON and CARPENTER frequently spoke of this Hawk to me immediately after my return to Louisiana from Europe, which took place in November 1829.

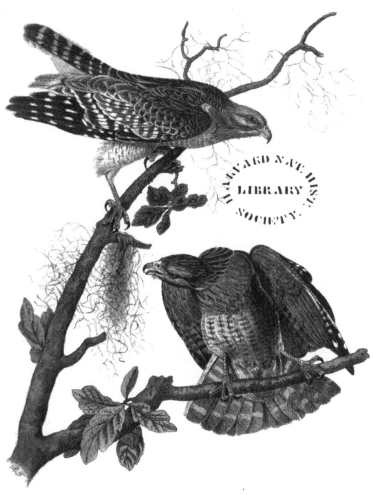

Red-shouldered Buzzard

the open grounds, and about the vicinity of small lakes, for the purpose of securing Red-winged Starlings and wounded Ducks.

The interior of woods seems, as I have said, the fittest haunts for the Red-shouldered Hawk. He sails through them a few yards above the ground, and suddenly alights on the low branch of a tree, or the top of a dead stump, from which he silently watches, in an erect posture, for the appearance of squirrels, upon which he pounces directly and kills them in an instant, afterwards devouring them on the ground. If accidentally discovered, he essays to remove the squirrel, but finding this difficult, he drags it partly through the air and partly along the ground, to some short distance, until he conceives himself out of sight of the intruder, when he again commences feeding. The eating of a whole squirrel, which this bird often devours at one meal, so gorges it, that I have seen it in this state almost unable to fly, and with such an extraordinary protuberance on its breast as seemed very unnatural, and very injurious to the beauty of form which the bird usually displays. On all occasions, such as I have described, when the bird is so gorged, it is approached with the greatest ease. On the contrary, when it is in want of food, it requires the greatest caution to get within shooting distance of it.

At the approach of spring, this species begins to pair, and its flight is accompanied with many circlings and zigzag motions, during which it emits its shrill cries. The male is particularly noisy at this time. He gives chase to all other Hawks, returns to the branch on which its mate has chanced to perch, and caresses her. This happens about the beginning of March. The spot adapted for a nest is already fixed upon, and the fabric is half finished. The top of a tall tree appears to be preferred by this Hawk, as I have found its nest more commonly placed there, not far from the edges of woods bordering plantations. The nest is seated in the forks of a large branch, towards its extremity, and is as bulky as that of the Common Crow. It is formed externally of dry sticks and Spanish moss, and is lined with withered grass and fibrous roots of different sorts, arranged in a circular manner. The female usually lays four eggs, sometimes five. They are of a broad oval form, granulated all over, pale blue, faintly blotched with brownish-red at the smaller end.

When one ascends to the nest, which, by the way, is not always an easy matter, as some of our trees are not only very smooth, but frequently without any boughs to a considerable distance from the ground, as well as of rather large size, the female bird, if she happens to be sitting, flies off silently and alights on a neighbouring tree, to wait the result. But, should the male, who supplies her with food, and assists in incubation, be there, or make his appearance, he immediately sets up a hue and cry, and plunges towards the assailant with such violence as to astonish him. When, on several occasions,

I have had the tree on which the nest was placed cut down, I have observed the same pair, a few days after, build another nest on a tree not far distant from the spot in which the first one had been.

The mutual attachment of the male and the female continues during life. They usually hunt in pairs during the whole year; and although they build a new nest every spring, they are fond of resorting to the same parts of the woods for that purpose. I knew the pair represented in the Plate for three years, and saw their nest each spring placed within a few hundred yards of the spot in which that of the preceding year was.

The young remain in the nest until fully fledged, and are fed by the parents for several weeks after they have taken to wing, but leave them and begin to shift for themselves in about a month, when they disperse and hunt separately until the approach of the succeeding spring, at which time they pair. The young birds acquire the rusty reddish colour of the feathers on the breast and shoulders before they leave the nest. It deepens gradually at the approach of autumn, and by the first spring they completely resemble the old birds. Only one brood is raised each season. Scarcely any difference of size exists between the sexes, the female being merely a little stouter.

This Hawk seldom attacks any kind of poultry, and yet frequently pounces on Partridges, Doves, or Wild Pigeons, as well as Red-winged Starlings, and now and then very young rabbits. On one or two occasions I have seen them make their appearance at the report of my gun, and try to rob me of some Blue-winged Teals shot in small ponds. I have never seen them chase any other small birds than those mentioned, or quadrupeds of smaller size than the *cotton rat;* nor am I aware of their eating frogs, which are the common food of the Winter Falcon.

Red-shouldered Hawk, *Falco lineatus,* Wils. Amer. Orn., vol. vi. p. 86. Young.
Winter Falcon, *Falco hyemalis,* Wils. Amer. Orn., vol. iv. p. 73. Adult.
Falco hyemalis, Bonap. Syn., p. 33.
Winter Falcon or Red-shouldered Hawk, *Falco hyemalis,* Nutt. Man., vol. i. p. 106.
Red-shouldered Hawk, *Falco lineatus,* Aud. Orn. Biog., vol. i. p. 296; vol. v. p. 380.
Winter Hawk, *Falco hyemalis,* Aud. Orn. Biog., vol. i. p. 364. Young.

Adult Male.

Plumage compact, imbricated; feathers of the head and neck narrow towards the tip, of the back broad and rounded; tibial feathers elongated behind. Wings long, third and fourth primaries longest, first short.

Bill light blue at the base, bluish-black at the tip; cere, basal margin of the bill, edges of the eyelids, and the feet bright yellow. Iris hazel. Claws black. Head, neck, and back light yellowish-red, longitudinally spotted with dark brown. Tail brownish-black, banded with greyish-white, the tip

Harvard Natural History Society.

Pl. 10.

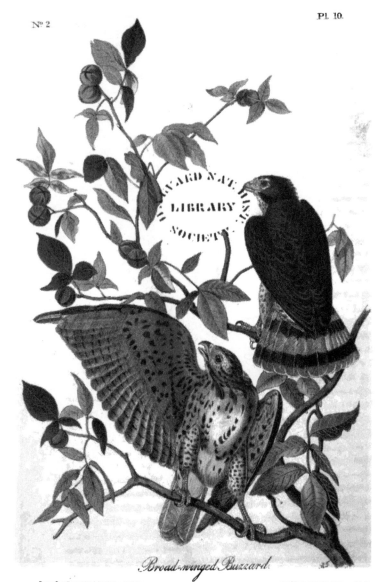

Broad-winged Buzzard.

Lithd Printed & Cold by J.T. Bowen Philadª

Pl. 10.

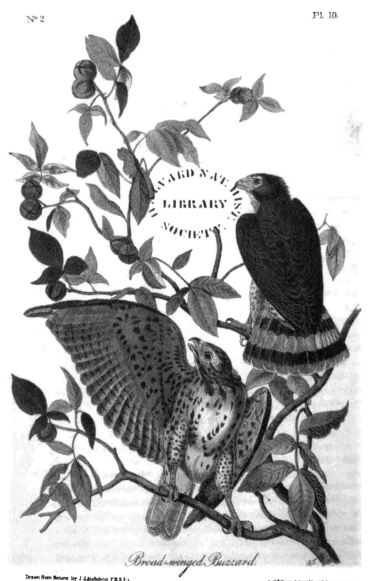

Broad-winged Buzzard.

Drawn from Nature by J. J. Audubon F.R.S.F.L.

Lith⁴ Printed & Col⁴ by J. T. Bowen Philad⁹

of the latter colour. Lesser wing-coverts bright yellowish-red, spotted with brown; larger coverts and secondary quills dusky, broadly barred with white; primary quills brownish-black, banded with white, the greater part of their inner webs being of the latter colour. Lower parts of the neck and under wing-coverts light yellowish-red, the former longitudinally lined with blackish; breast reddish-white, marked with transverse yellowish-red spots; abdomen and under tail-coverts reddish-white. Tibial feathers yellowish, transversely barred with dull orange.

Length 18 inches; bill along the back 1¼, along the gap from the tip of upper mandible 1½; tarsus 2¾.

Adult Female.

The female differs from the male in being a little larger, and in having the tints lighter.

THE BROAD-WINGED BUZZARD.

BUTEO PENNSYLVANICUS, *Wils.*

PLATE X.—MALE AND FEMALE.

One fine May morning, when nature seemed to be enchanted at the sight of her own great works, when the pearly dew-drops were yet hanging at the point of each leaf, or lay nursed in the blossoms, gently rocked, as it were, by the soft breeze of early summer, I took my gun, and, accompanied by my excellent brother-in-law, WILLIAM G. BAKEWELL, Esq., at that time a youth, walked towards some lovely groves, where many songsters attracted our attention by their joyous melodies. The woods were all alive with the richest variety, and, divided in choice, we kept going on without shooting at any thing, so great was our admiration of every bird that presented itself to our view. As we crossed a narrow skirt of wood, my young companion spied a nest on a tree of moderate height, and, as my eye reached it, we both perceived that the parent bird was sitting in it. Some little consultation took place, as neither of us could determine whether it was a Crow's or a Hawk's nest, and it was resolved that my young friend should climb the tree, and bring down one of the eggs. On reaching the nest, he said the bird, which still remained quiet, was a Hawk and unable to fly. I desired him to cover it with his handkerchief, try to secure it, and bring it down,

quills curved inwards, broadly obtuse. Tail longish, nearly even, the feathers rather broad, truncated and rounded.

Bill bluish-black at the tip, blue towards the base; cere and margin yellow. Iris hazel. Feet gamboge-yellow; claws brownish-black. The general colour of the upper parts is dark umber; the forehead with a slight margin of whitish, the quills blackish-brown, the tail with three bands of dark brown, alternating with two whitish bands, and a narrower terminal band of greyish, the tips white. Throat whitish; cheeks reddish-brown, with a dark brown mustachial band; the under parts generally light reddish, marked with guttiform umber spots along the neck, and sagittiform larger spots of the same colour on the breast and sides. Tibial feathers of the same colour, with numerous smaller spots.

Length 14 inches; extent of wings 32; bill $\frac{11}{12}$ along the ridge, $1\frac{1}{4}$ along the gap.

Adult Female.

Colouring generally similar to that of the male, lighter above, more tinged with red beneath, where the spots are larger and more irregular.

Length 16 inches; extent of wings 35; bill 1 along the ridge, $1\frac{1}{4}$ along the gap.

ROUGH-LEGGED BUZZARD.

BUTEO LAGOPUS, *Gmel.*

PLATE XI.

The Rough-legged Hawk seldom goes farther south along our Atlantic coast than the eastern portions of North Carolina, nor have I ever seen it to the west of the Alleghanies. It is a sluggish bird, and confines itself to the meadows and low grounds bordering the rivers and salt-marshes, along our bays and inlets. In such places you may see it perched on a stake, where it remains for hours at a time, unless some wounded bird comes in sight, when it sails after it, and secures it without manifesting much swiftness of flight. It feeds principally on moles, mice, and other small quadrupeds, and never attacks a duck on the wing, although now and then it pursues a wounded one. When not alarmed, it usually flies low and sedately, and does not exhibit any of the courage and vigour so conspicuous in most other Hawks, suffering

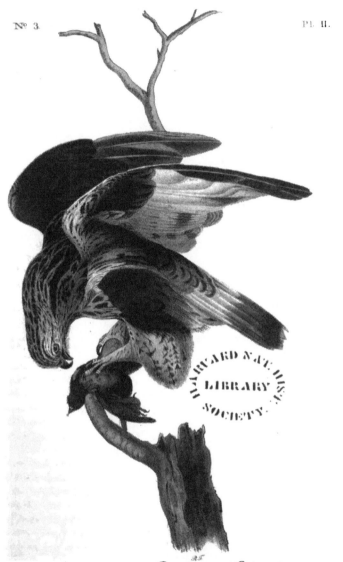

Rough-legged Buzzard.

Drawn from Nature by J. J. Audubon, F.R.S.F.L.S

Lith⁴ Printed & Col⁴ by J. T. Bowen, Phila.

thousands of birds to pass without pursuing them. The greatest feat I have seen them perform was scrambling at the edge of the water, to secure a lethargic frog.

They alight on trees to roost, but appear so hungry or indolent at all times, that they seldom retire to rest until after dusk. Their large eyes indeed seem to indicate their possession of the faculty of seeing at that late hour. I have frequently put up one, that seemed watching for food at the edge of a ditch, long after sunset. Whenever an opportunity offers, they eat to excess, and, like the Turkey Buzzards and Carrion Crows, disgorge their food, to enable them to fly off. The species is more nocturnal in its habits than any other Hawk found in the United States.

M. TEMMINCK says that this species frequents the north of Europe in autumn and winter, and it is at times seen in Holland. My friend Mr. YARRELL states, that, "although it has now been killed once or oftener in almost every county in England, it has rarely been known to breed there, and is usually obtained in the spring or autumn, when changing its latitude from south to north, or *vice versa.*"

The number of meadow mice which this species destroys ought, one might think, to ensure it the protection of every husbandman; but so far is this from being the case, that in America it is shot on all occasions, simply because its presence frightens Mallards and other Ducks, which would alight on the ponds, along the shores of which the wily gunner is concealed; and in England it is caught in traps as well as shot, perhaps for no better reason than because it is a Hawk. But so scarce is it in the latter country, that I never could procure one in the flesh there.

My friend Mr. SWAINSON considered our bird in its immature plumage, in which he has figured it in the Fauna Boreali-Americana, as the true *Falco lagopus;* and Dr. RICHARDSON, in the same work, speaks of it as follows:— "A specimen of this bird, in most perfect plumage, was killed in the month of September, by Mr. DRUMMOND, on the Smoking river, one of the upper branches of the Peace river. It arrives in the Fur Countries in April or May, and, having reared its young, retires southward early in October. It winters on the banks of the Delaware and Schuylkill, returning to the north in the spring. It is by no means an uncommon bird in the districts through which the expedition travelled, but, being very shy, only one specimen was procured. A pair were seen at their nest, built of sticks, on a lofty tree, standing on a low, moist, alluvial point of land, almost encircled by a bend of the Saskatchewan. They sailed round the spot in a wide circle, occasionally settling on the top of a tree, but were too wary to allow us to come within gun-shot; so that, after spending much time in vain, we were fain to relinquish the chase. In the softness and fulness of its plumage, its feathered

legs, and habits, this bird bears some resemblance to the Owls. It flies slowly, sits for a long time on the bough of a tree watching for mice, frogs, &c., and is often seen skimming over swampy pieces of ground, and hunting for its prey by the subdued daylight, which illuminates even the midnight hours in the high parallels of latitude."

Nothing is known respecting their propagation in the United States, and I must pass over this subject. They leave us in the beginning of March, and betake themselves to more northern countries; yet not one did either myself, or my youthful and enterprising party, observe on my late rambles in Labrador.

BLACK HAWK, *Falco niger*, Wils. Amer. Orn., vol. vi. p. 82. Adult.
FALCO LAGOPUS, Bonap. Syn., p. 32. Young.
FALCO SANCI-JOHANNIS, Bonap. Syn., p. 32. Adult.
BUTEO LAGOPUS, ROUGH-LEGGED BUZZARD, Swains. & Rich., F. Bor. Amer., vol. ii. p. 52.
ROUGH-LEGGED FALCON, *Falco lagopus*, Wils. Amer. Orn., vol. iv. p. 59, Young; vol. v. p. 216, Adult and Young.

Middle-aged Male.

Wings long, third quill longest, fourth almost equal, second shorter than fifth, first very short; first four abruptly cut out towards the end on the inner web; secondaries broad and rounded. Tail rather long, broad, rounded.

Bill dull bluish-grey, black at the end. Iris hazel, projecting part of the eyebrow greenish-blue, cere yellow. Toes yellow, claws black. Bases of the black bristles of the lore whitish. The head and neck are streaked with umber-brown and yellowish-white, the centre and tip of each feather being of the former colour. Back umber-brown, variegated with light reddish-brown and yellowish-white. Quills dark brown towards the end, the outer webs of the first six tinged with grey, the base of all white, that colour extending farther on the secondaries, of most of which, and of some of the primaries, the inner web is irregularly barred with brown. Upper tail-coverts white, irregularly barred with dark brown. Tail white at the base, brown and mottled towards the end, with a broad subterminal band of brownish-black, the tips brownish-white. Middle and hind part of the thorax, with the sides, blackish-brown. Breast yellowish-white, largely spotted and blotched with umber. Feathers of the legs paler yellowish-red, barred with dusky; abdomen yellowish-white, as are the under tail-coverts, which are marked with a small brown spot.

Length 22 inches; extent of wings 4 feet 1 inch; bill along the back $1\frac{5}{8}$, along the edge $1\frac{7}{12}$; tarsus $2\frac{11}{12}$.

The Female agrees in colouring, but is considerably larger.

The old bird, which has a very different look as to colour, has been noticed or described under different names.

BLACK HAWK, *Falco niger*, Wils. Amer. Orn., vol. vi. p. 82. pl. liii. fig. 1.
FALCO SANCTI-JOHANNIS, Bonap. Synops. of Birds of the United States, p. 32.

The bill, feet, and iris are coloured as in middle age; but the plumage is of a nearly uniform chocolate-brown, the bases of the quills, however, remaining white, the broad band on the under surface of the wing being the same as in the younger bird; and the tail being brown, without a subterminal bar of black, but slightly tipped with brownish-white, and barred with yellowish-white on the inner webs, the bars becoming more distinct on the outer feathers. The wings in both reach to near the tip of the tail. The feathers on the nape of the neck are white, excepting at the extremities, which is also the case in the young and middle aged birds, and is not a circumstance peculiar to this species, being observed in *F. Albicilla, F. palumbarius, F. Nisus,* and many others.

GENUS III.—AQUILA, *Briss.* EAGLE.

Bill rather short, deep, compressed; upper mandible with the dorsal outline nearly straight and sloping at the base, beyond the cere decurved, the sides sloping and slightly convex, the edges nearly straight, with a slight convexity and a shallow sinus close to the strong subtrigonal tip; lower mandible with the dorsal outline convex, the tip obliquely truncate. Head large, roundish, flattened above. Nostrils oval, oblique, nearer the ridge than the margin. Neck rather short. Body very large. Feet rather short, very robust; tarsi roundish, feathered to the toes, which are rather short, united at the base by short webs, covered above with a series of angular scales, and towards the end with a few large scutella; claws long, curved, rounded, flat beneath, acuminate. Plumage compact, imbricated, glossy; feathers of the head and neck narrow and pointed; space between the bill and eye covered with small bristle-pointed feathers, disposed in a radiating manner. Wings long, the fourth quill longest; the first short; the outer six abruptly cut out on the inner web. Tail rather long, ample, rounded.

THE GOLDEN EAGLE.

AQUILA CHRYSAËTOS, *Linn.*

PLATE XII.

The Golden Eagle, although a permanent resident in the United States, is of rare occurrence, it being seldom that one sees more than a pair or two in the course of a year, unless he be an inhabitant of the mountains, or of the large plains spread out at their base. I have seen a few of them on the wing along the shores of the Hudson, others on the upper parts of the Mississippi, some among the Alleghanies, and a pair in the State of Maine. At Labrador we saw an individual sailing, at the height of a few yards, over the moss-covered surface of the dreary rocks.

Although possessed of a powerful flight it has not the speed of many Hawks, nor even of the White-headed Eagle. It cannot, like the latter, pursue and seize on the wing the prey it longs for, but is obliged to glide down through the air for a certain height to insure the success of its enterprise. The keenness of its eye, however, makes up for this defect, and enables it to spy, at a great distance, the objects on which it preys; and it seldom misses its aim, as it falls with the swiftness of a meteor towards the spot on which they are concealed. When at a great height in the air, its gyrations are uncommonly beautiful, being slow and of wide circuit, and becoming the majesty of the king of birds. It often continues them for hours at a time, with apparently the greatest ease.

The nest of this noble species is always placed on an inaccessible shelf of some rugged precipice;—never, that I am aware of, on a tree. It is of great size, flat, and consists merely of a few dead sticks and brambles, so bare at times that the eggs might be said to be deposited on the naked rock. They are generally two, sometimes three, having a length of $3\frac{1}{4}$ inches, and a diameter at the broadest part of $2\frac{1}{2}$. The shell is thick and smooth, dull white, brushed over, as it were, with undefined patches of brown, which are most numerous at the larger end. The period at which they are deposited, is the end of February or the beginning of March. I have never seen the young when newly hatched, but know that they do not leave the nest until nearly able to provide for themselves, when their parents drive them off from their home, and finally from their hunting grounds. A pair of these birds bred on the rocky shores of the Hudson for eight successive years, and in the same chasm of the rock.

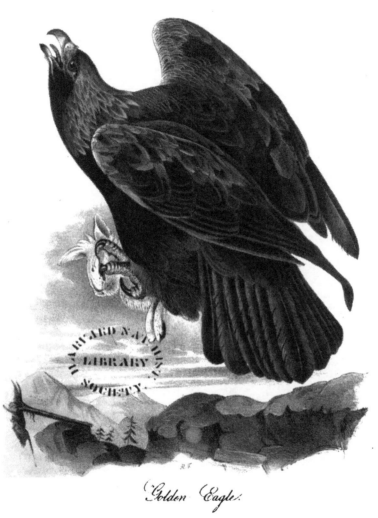

Golden Eagle.

Their notes are harsh and sharp, resembling at times the barking of a dog, especially about the breeding season, when they become extremely noisy and turbulent, flying more swiftly than at other times, alighting more frequently, and evincing a fretfulness which is not so observable after their eggs are laid.

They are capable of remaining without food for several days at a time, and eat voraciously whenever they find an opportunity. Young fawns, racoons, hares, wild turkeys, and other large birds, are their usual food; and they devour putrid flesh only when hard pressed by hunger, none alighting on carrion at any other time. They are nice in cleaning the skin or plucking the feathers of their prey, although they swallow their food in large pieces, often mixed with hair and bones, which they afterwards disgorge. They are muscular, strong, and hardy, capable of bearing extreme cold without injury, and of pursuing their avocations in the most tempestuous weather. A full grown female weighs about twelve pounds, the male about two pounds and a half less. This species seldom removes far from its place of residence, and the attachment of two individuals of different sexes appears to continue for years.

They do not obtain the full beauty of their plumage until the fourth year, the Ring-tailed Eagle of authors being the young in the dress of the second and third years. Our north-western Indians are fond of ornamenting their persons and implements of war with the tail-feathers of this Eagle, which they kill expressly for that purpose.

I conclude my account of this species with an anecdote relating to it given in one of Dr. RUSH's lectures upon the effects of fear on man. During the revolutionary war, a company of soldiers were stationed near the highlands of the Hudson river. A Golden Eagle had placed her nest in a cleft of the rocks half way between the summit and the river. A soldier was let down by his companions suspended by a rope fastened around his body. When he reached the nest, he suddenly found himself attacked by the Eagle; in self-defence he drew the only weapon about him, his knife, and made repeated passes at the bird, when accidentally he cut the rope almost off. It began unravelling; those above hastily drew him up, and relieved him from his perilous situation at the moment when he expected to be precipitated to the bottom. The Doctor stated that so powerful was the effect of the fear the soldier had experienced whilst in danger, that ere three days had elapsed his hair became quite grey.

FALCO FULVUS, Bonap. Syn., p. 25.
AQUILA CHRYSAETOS, GOLDEN EAGLE, Swains. & Rich. F. Bor. Amer., vol. ii. p. 12.
RING-TAILED EAGLE, *Falco fulvus*, Wils. Amer. Orn., vol. vii. p. 13.
ROYAL or GOLDEN EAGLE, Nutt. Man., vol. i. p. 62.
GOLDEN EAGLE, *Falco Chrysaetos*, Aud. Orn. Biog., vol. ii. p. 464.

Adult Female.

Wings long; the fourth quill longest, the third almost equal, the second considerably shorter, the first short; the first, second, third, fourth, fifth, and sixth abruptly cut out on the inner webs; the secondaries long, broad, and rounded. Tail rather long, ample, rounded, of twelve broad, rounded, and acuminate feathers.

Bill light bluish-grey at the base, black at the tip; cere and basal margins yellow. Eyebrows and margins of the eyelids light blue; iris chestnut. Toes rich yellow; claws bluish-black. Fore part of the head, cheeks, throat, and under parts deep brown. Hind head, and posterior and lateral parts of the neck light brownish-yellow, the shafts and concealed parts of the feathers deep brown. The back is deep brown, glossy, with purplish reflections; the wing-coverts lighter. The primary quills brownish-black, the secondaries with their coverts brown, and those next the body more or less mottled with brownish-white, excepting at the ends; the edge of the wing at the flexure pale yellowish-brown. Tail dark brown, lighter towards the base, and with a few irregular whitish markings, like fragments of transverse bands; its coverts pale brown, mottled with white at the base, and paler at the ends. The short feathers of the legs and tarsi are light yellowish-brown, each with a dark shaft; the outer elongated feathers dark brown; the lower tail-coverts light yellowish-brown. The base of the feathers on the upper parts of the body is white, on the lower pale dusky grey.

Length 3 feet 2 inches; extent of wings 7 feet; bill along the back 2¾, edge of lower mandible 2½; tarsus 4½, middle toe and claw 4½, hind claw 2¾. The extremities of the wings are 1 inch short of that of the tail.

Genus IV.—HALIAETUS, *Savigny.* SEA-EAGLE.

Bill rather short, very deep, compressed; upper mandible with the dorsal outline nearly straight at the base, beyond the cere decurved, the sides sloping, the edges nearly straight, with a slight obtuse process, and a shallow sinus close to the strong trigonal tip; lower mandible with the dorsal outline slightly convex, the tip obliquely truncate. Head large, oblong, flattened above. Nostrils oblong, oblique near the ridge. Neck of moderate length. Body very large. Feet rather short, very robust; tarsi roundish, covered anteriorly with transverse scutella, posteriorly with large, laterally with small scales; toes robust, free, scutellate above; claws large, curved, rounded, flat beneath, acuminate. Plumage compact, imbricated; feathers of the head and neck narrow and pointed; space between the bill and eye barish, being

Harvard Natural History Society

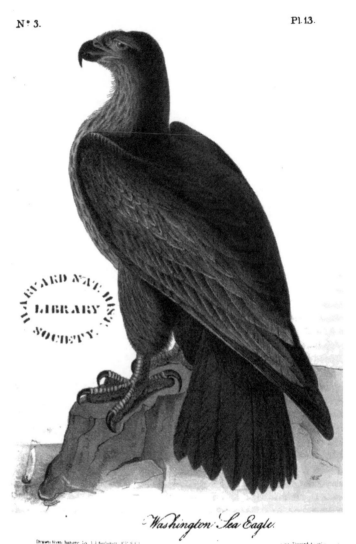

Washington Sea Eagle.

Drawn from Nature by J.J.Audubon, F.R.S.L.

Printed

sparsely covered with bristle-like feathers, disposed in a radiating manner. Wings long, the second and third quills longest, the outer five cut out abruptly on the inner web. Tail rather long, rounded. Duodenum convoluted.

WASHINGTON SEA-EAGLE.

HALIAETUS WASHINGTONI, *Aud.*

PLATE XIII.—MALE.

It was in the month of February, 1814, that I obtained the first sight of this noble bird, and never shall I forget the delight which it gave me. Not even HERSCHEL, when he discovered the planet which bears his name, could have experienced more rapturous feelings. We were on a trading voyage, ascending the Upper Mississippi. The keen wintry blasts whistled around us, and the cold from which I suffered had, in a great degree, extinguished the deep interest which, at other seasons, this magnificent river has been wont to awake in me. I lay stretched beside our patroon. The safety of the cargo was forgotten, and the only thing that called my attention was the multitude of ducks, of different species, accompanied by vast flocks of swans, which from time to time passed us. My patroon, a Canadian, had been engaged many years in the fur trade. He was a man of much intelligence, and, perceiving that these birds had engaged my curiosity, seemed anxious to find some new object to divert me. An Eagle flew over us. "How fortunate!" he exclaimed; "this is what I could have wished. Look, sir! the Great Eagle, and the only one I have seen since I left the lakes." I was instantly on my feet, and having observed it attentively, concluded, as I lost it in the distance, that it was a species quite new to me. My patroon assured me that such birds were indeed rare; that they sometimes followed the hunters, to feed on the entrails of animals which they had killed, when the lakes were frozen over, but that when the lakes were open, they would dive in the daytime after fish, and snatch them up in the manner of the Fishing Hawk; and that they roosted generally on the shelves of the rocks, where they built their nests, of which he had discovered several by the quantity of white dung scattered below.

Convinced that the bird was unknown to naturalists, I felt particularly anxious to learn its habits, and to discover in what particulars it differed from the rest of its genus. My next meeting with this bird was a few years afterwards, whilst engaged in collecting crayfish on one of those flats which

In the month of January following, I saw a pair of these Eagles flying over the Falls of the Ohio, one in pursuit of the other. The next day I saw them again. The female had relaxed her severity, had laid aside her coyness, and to a favourite tree they continually resorted. I pursued them unsuccessfully for several days, when they forsook the place.

The flight of this bird is very different from that of the White-headed Eagle. The former encircles a greater space, whilst sailing keeps nearer to the land and the surface of the water, and when about to dive for fish falls in a spiral manner, as if with the intention of checking any retreating movement which its prey might attempt, darting upon it only when a few yards distant. The Fish Hawk often does the same. When rising with a fish, the Bird of Washington flies to a considerable distance, forming, in its line of course, a very acute angle with the surface line of the water. My last opportunity of seeing this bird was on the 15th of November, 1821, a few miles above the mouth of the Ohio, when two passed over our boat, moving down the river with a gentle motion. In a letter from a kind relative, Mr. W. BAKEWELL, dated, "Falls of the Ohio, July 1819," and containing particulars relative to the Swallow-tailed Hawk (*Falco furcatus*), that gentleman says:—"Yesterday, for the first time, I had an opportunity of viewing one of those magnificent birds which you call the Sea-Eagle, as it passed low over me, whilst fishing. I shall be really glad when I can again have the pleasure of seeing your drawing of it."

FALCO WASHINGTONI, Aud. Birds of America, pl. ii.; Orn. Biog., vol. i. p. 58.

Adult Male.

Tarsus and toes uniformly scutellate in their whole length. Bill bluish-black, cere yellowish-brown, feet orange-yellow, claws bluish-black. Upper part of the head, hind neck, back, scapulars, rump, tail-coverts, and posterior tibial feathers blackish-brown, glossed with a coppery tint; throat, fore neck, breast, and belly light brownish-yellow, each feather with a central blackish-brown streak; wing-coverts light greyish-brown, those next the body becoming darker; primary quills dark brown, deeper on their inner webs; secondaries lighter, and on their outer webs of nearly the same light tint as their coverts; tail uniform dark brown.

Length 3 feet 7 inches; extent of wings 10 feet 2 inches; bill 3¼ inches along the back; along the gap, which commences directly under the eye, to the tip of the lower mandible 3½, and 1¾ deep. Length of wing when folded 32 inches; length of tail 15 inches; tarsus 4½, middle 4¾, hind claw 2½.

Harvard Natural History
Society.

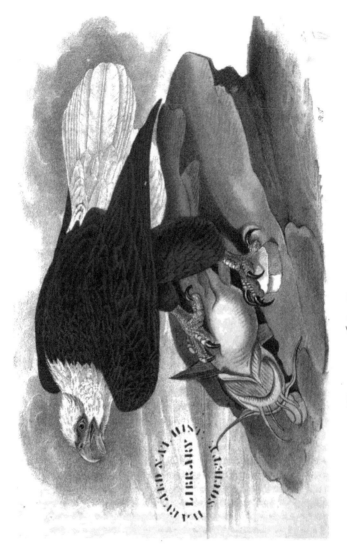

White-headed Sea Eagle, or Bald Eagle?

Drawn from Nature by J.J.Audubon F.R.S.F.L.S.

Eng.d Printed & Col.d [] Neat's Plate.

Again, when the... considerable... its enter, and the res height, and as if observ glides through the... not unlike that proc...

WHITE-HEADED OR BALD EAGLE.

HALIAETUS LEUCOCEPHALUS, *Linn.*

PLATE XIV.—MALE.

The figure of this noble bird is well known throughout the civilized world, emblazoned as it is on our national standard, which waves in the breeze of every clime, bearing to distant lands the remembrance of a great people living in a state of peaceful freedom. May that peaceful freedom last for ever!

The great strength, daring, and cool courage of the White-headed Eagle, joined to his unequalled power of flight, render him highly conspicuous among his brethren. To these qualities did he add a generous disposition towards others, he might be looked up to as a model of nobility. The ferocious, overbearing, and tyrannical temper which is ever and anon displaying itself in his actions, is, nevertheless, best adapted to his state, and was wisely given him by the Creator to enable him to perform the office assigned to him.

The flight of the White-headed Eagle is strong, generally uniform, and protracted to any distance, at pleasure. Whilst travelling, it is entirely supported by equal easy flappings, without any intermission, in as far as I have observed it, by following it with the eye or the assistance of a glass. When looking for prey, it sails with extended wings, at right angles to its body, now and then allowing its legs to hang at their full length. Whilst sailing, it has the power of ascending in circular sweeps, without a single flap of the wings, or any apparent motion either of them or of the tail; and in this manner it often rises until it disappears from the view, the white tail remaining longer visible than the rest of the body. At other times, it rises only a few hundred feet in the air, and sails off in a direct line, and with rapidity. Again, when thus elevated, it partially closes its wings, and glides downwards for a considerable space, when, as if disappointed, it suddenly checks its career, and resumes its former steady flight. When at an immense height, and as if observing an object on the ground, it closes its wings, and glides through the air with such rapidity as to cause a loud rustling sound, not unlike that produced by a violent gust of wind passing amongst the branches of trees. Its fall towards the earth can scarcely be followed by the eye on such occasions, the more particularly that these falls or glidings through the air usually take place when they are least expected.

At times, when these Eagles, sailing in search of prey, discover a Goose, a Duck, or a Swan, that has alighted on the water, they accomplish its destruction in a manner that is worthy of your attention. The Eagles, well aware that water-fowl have it in their power to dive at their approach, and thereby elude their attempts upon them, ascend in the air in opposite directions over the lake or river, on which they have observed the object which they are desirous of possessing. Both Eagles reach a certain height, immediately after which one of them glides with great swiftness towards the prey; the latter, meantime, aware of the Eagle's intention, dives the moment before he reaches the spot. The pursuer then rises in the air, and is met by its mate, which glides toward the water-bird, that has just emerged to breathe, and forces it to plunge again beneath the surface, to escape the talons of this second assailant. The first Eagle is now poising itself in the place where its mate formerly was, and rushes anew to force the quarry to make another plunge. By thus alternately gliding, in rapid and often repeated rushes, over the ill-fated bird, they soon fatigue it, when it stretches out its neck, swims deeply, and makes for the shore, in the hope of concealing itself among the rank weeds. But this is of no avail, for the Eagles follow it in all its motions, and the moment it approaches the margin, one of them darts upon it, and kills it in an instant, after which they divide the spoil.

During spring and summer, the White-headed Eagle, to procure sustenance, follows a different course, and one much less suited to a bird apparently so well able to supply itself without interfering with other plunderers. No sooner does the Fish-Hawk make its appearance along our Atlantic shores, or ascend our numerous and large rivers, than the Eagle follows it, and, like a selfish oppressor, robs it of the hard-earned fruits of its labour. Perched on some tall summit, in view of the ocean, or of some water-course, he watches every motion of the Osprey while on wing. When the latter rises from the water, with a fish in its grasp, forth rushes the Eagle in pursuit. He mounts above the Fish-Hawk, and threatens it by actions well understood, when the latter, fearing perhaps that its life is in danger, drops its prey. In an instant, the Eagle, accurately estimating the rapid descent of the fish, closes his wings, follows it with the swiftness of thought, and the next moment grasps it. The prize is carried off in silence to the woods, and assists in feeding the ever-hungry brood of the marauder.

This bird now and then procures fish himself, by pursuing them in the shallows of small creeks. I have witnessed several instances of this in the Perkiomen Creek in Pennsylvania, where, in this manner, I saw one of them secure a number of *Red-fins*, by wading briskly through the water, and striking at them with his bill. I have also observed a pair scrambling over the ice of a frozen pond, to get at some fish below, but without success.

It does not confine itself to these kinds of food, but greedily devours young pigs, lambs, fawns, poultry, and the putrid flesh of carcasses of every description, driving off the Vultures and Carrion Crows, or the dogs, and keeping a whole party at defiance until it is satiated. It frequently gives chase to the Vultures, and forces them to disgorge the contents of their stomachs, when it alights and devours the filthy mass. A ludicrous instance of this took place near the city of Natchez, on the Mississippi. Many Vultures were engaged in devouring the body and entrails of a dead horse, when a White-headed Eagle accidentally passing by, the Vultures all took to wing, one among the rest with a portion of the entrails partly swallowed, and the remaining part, about a yard in length, dangling in the air. The Eagle instantly marked him, and gave chase. The poor Vulture tried in vain to disgorge, when the Eagle, coming up, seized the loose end of the gut, and dragged the bird along for twenty or thirty yards, much against its will, until both fell to the ground, when the Eagle struck the Vulture, and in a few moments killed it, after which he swallowed the delicious morsel.

The Bald Eagle has the power of raising from the surface of the water any floating object not heavier than itself. In this manner it often robs the sportsman of ducks which have been killed by him. Its audacity is quite remarkable. While descending the Upper Mississippi, I observed one of these Eagles in pursuit of a Green-winged Teal. It came so near our boat, although several persons were looking on, that I could perceive the glancings of its eye. The Teal, on the point of being caught, when not more than fifteen or twenty yards from us, was saved from the grasp of its enemy, one of our party having brought the latter down by a shot, which broke one of its wings. When taken on board, it was fastened to the deck of our boat by means of a string, and was fed by pieces of catfish, some of which it began to eat on the third day of its confinement. But, as it became a very disagreeable and dangerous associate, trying on all occasions to strike at some one with its talons, it was killed and thrown overboard.

When these birds are suddenly and unexpectedly approached or surprised, they exhibit a great degree of cowardice. They rise at once and fly off very low, in zig-zag lines, to some distance, uttering a hissing noise, not at all like their usual disagreeable imitation of a laugh. When not carrying a gun, one may easily approach them; but the use of that instrument being to appearance well known to them, they are very cautious in allowing a person having one to get near them. Notwithstanding all their caution, however, many are shot by approaching them under cover of a tree, on horseback, or in a boat. They do not possess the power of smelling gunpowder, as the Crow and the Raven are absurdly supposed to do; nor are they aware of the effects of spring-traps, as I have seen some of them caught by these instru-

ments. Their sight, although probably as perfect as that of any bird, is much affected during a fall of snow, at which time they may be approached without difficulty.

The White-headed Eagle seldom appears in very mountainous districts, but prefers the low lands of the sea-shores, those of our large lakes, and the borders of rivers. It is a constant resident in the United States, in every part of which it is to be seen. The roosts and breeding places of pigeons are resorted to by it, for the purpose of picking up the young birds that happen to fall, or the old ones when wounded. It seldom, however, follows the flocks of these birds when on their migrations.

When shot at and wounded, it tries to escape by long and quickly repeated leaps, and, if not closely pursued, soon conceals itself. Should it happen to fall on the water, it strikes powerfully with expanded wings, and in this manner often reaches the shore, when it is not more than twenty or thirty yards distant. It is capable of supporting life without food for a long period. I have heard of some, which, in a state of confinement, had lived without much apparent distress for twenty days, although I cannot vouch for the truth of such statements, which, however, may be quite correct. They defend themselves in the manner usually followed by other Eagles and Hawks, throwing themselves backwards, and furiously striking with their talons at any object within reach, keeping their bill open, and turning their head with quickness to watch the movements of the enemy, their eyes being apparently more protruded than when unmolested.

It is supposed that Eagles live to a very great age,—some persons have ventured to say even a hundred years. On this subject, I can only observe, that I once found one of these birds, which, on being killed, proved to be a female, and which, judging by its appearance, must have been very old. Its tail and wing-feathers were so worn out, and of such a rusty colour, that I imagined the bird had lost the power of moulting. The legs and feet were covered with large warts, the claws and bill were much blunted; it could scarcely fly more than a hundred yards at a time, and this it did with a heaviness and unsteadiness of motion such as I never witnessed in any other bird of the species. The body was poor and very tough. The eye was the only part which appeared to have sustained no injury. It remained sparkling and full of animation, and even after death seemed to have lost little of its lustre. No wounds were perceivable on its body.

The White-headed Eagle is seldom seen alone, the mutual attachment which two individuals form when they first pair seeming to continue until one of them dies or is destroyed. They hunt for the support of each other, and seldom feed apart, but usually drive off other birds of the same species. They commence their amatory intercourse at an earlier period than any other

land bird with which I am acquainted, generally in the month of December. At this time, along the Mississippi, or by the margin of some lake not far in the interior of the forest, the male and female birds are observed making a great bustle, flying about and circling in various ways, uttering a loud cackling noise, alighting on the dead branches of the tree on which their nest is already preparing, or in the act of being repaired, and caressing each other. In the beginning of January incubation commences. I shot a female, on the 17th of that month, as she sat on her eggs, in which the chicks had made considerable progress.

The nest, which in some instances is of great size, is usually placed on a very tall tree, destitute of branches to a considerable height, but by no means always a dead one. It is never seen on rocks. It is composed of sticks, from three to five feet in length, large pieces of turf, rank weeds, and Spanish moss in abundance, whenever that substance happens to be near. When finished, it measures from five to six feet in diameter, and so great is the accumulation of materials, that it sometimes measures the same in depth, it being occupied for a great number of years in succession, and receiving some augmentation each season. When placed in a naked tree, between the forks of the branches, it is conspicuously seen at a great distance. The eggs, which are from two to four, more commonly two or three, are of a dull white colour, and equally rounded at both ends, some of them being occasionally granulated. Incubation lasts for more than three weeks, but I have not been able to ascertain its precise duration, as I have observed the female on different occasions sit for a few days in the nest, before laying the first egg. Of this I assured myself by climbing to the nest every day in succession, during her temporary absence,—a rather perilous undertaking when the bird is sitting.

I have seen the young birds when not larger than middle-sized pullets. At this time they are covered with a soft cottony kind of down, their bill and legs appearing disproportionately large. Their first plumage is of a greyish colour, mixed with brown of different depths of tint, and before the parents drive them off from the nest they are fully fledged. As a figure of the Young White-headed Eagle will appear in the course of the publication of my Illustrations, I shall not here trouble you with a description of its appearance. I once caught three young Eagles of this species, when fully fledged, by having the tree, on which their nest was, cut down. It caused great trouble to secure them, as they could fly and scramble much faster than any of our party could run. They, however, gradually became fatigued, and at length were so exhausted as to offer no resistance, when we were securing them with cords. This happened on the border of Lake Ponchartrain, in

the month of April. The parents did not think fit to come within gun-shot of the tree while the axe was at work.

The attachment of the parents to the young is very great, when the latter are yet of a small size; and to ascend to the nest at this time would be dangerous. But as the young advance, and, after being able to take wing and provide for themselves, are not disposed to fly off, the old birds turn them out, and beat them away from them. They return to the nest, however, to roost, or sleep on the branches immediately near it, for several weeks after. They are fed most abundantly while under the care of the parents, which procure for them ample supplies of fish, either accidentally cast ashore, or taken from the Fish Hawk, together with rabbits, squirrels, young lambs, pigs, opossums, or racoons. Every thing that comes in the way is relished by the young family, as by the old birds.

The young birds begin to breed the following spring, not always in pairs of the same age, as I have several times observed one of these birds in brown plumage mated with a full-coloured bird, which had the head and tail pure white. I once shot a pair of this kind, when the brown bird (the young one) proved to be the female.

This species requires at least four years before it attains the full beauty of its plumage when kept in confinement. I have known two instances in which the white of the head did not make its appearance until the sixth spring. It is impossible for me to say how much sooner this state of perfection is attained, when the bird is at full liberty, although I should suppose it to be at least one year, as the bird is capable of breeding the first spring after birth.

The weight of Eagles of this species varies considerably. In the males, it is from six to eight pounds, and in the females from eight to twelve. These birds are so attached to particular districts, where they have first made their nest, that they seldom spend a night at any distance from the latter, and often resort to its immediate neighbourhood. Whilst asleep, they emit a loud hissing sort of snore, which is heard at the distance of a hundred yards, when the weather is perfectly calm. Yet, so light is their sleep, that the cracking of a stick under the foot of a person immediately wakens them. When it is attempted to smoke them while thus roosted and asleep, they start up and sail off without uttering any sound, but return next evening to the same spot.

Before steam navigation commenced on our western rivers, these Eagles were extremely abundant there, particularly in the lower parts of the Ohio, the Mississippi, and the adjoining streams. I have seen hundreds while going down from the mouth of the Ohio to New Orleans, when it was not at all difficult to shoot them. Now, however, their number is considerably

diminished, the game on which they were in the habit of feeding, having been forced to seek refuge from the persecution of man farther in the wilderness. Many, however, are still observed on these rivers, particularly along the shores of the Mississippi.

In concluding this account of the White-headed Eagle, suffer me, kind reader, to say how much I grieve that it should have been selected as the Emblem of my Country. The opinion of our great Franklin on this subject, as it perfectly coincides with my own, I shall here present to you. "For my part," says he, in one of his letters, "I wish the Bald Eagle had not been chosen as the representative of our country. He is a bird of bad moral character; he does not get his living honestly; you may have seen him perched on some dead tree, where, too lazy to fish for himself, he watches the labour of the Fishing-Hawk; and when that diligent bird has at length taken a fish, and is bearing it to his nest for the support of his mate and young ones, the Bald Eagle pursues him, and takes it from him. With all this injustice, he is never in good case, but, like those among men who live by sharping and robbing, he is generally poor, and often very lousy. Besides, he is a rank coward: the little King Bird, not bigger than a Sparrow, attacks him boldly, and drives him out of the district. He is, therefore, by no means a proper emblem for the brave and honest Cincinnati of America, who have driven all the *King Birds* from our country; though exactly fit for that order of knights which the French call *Chevaliers d'Industrie.*"

BALD EAGLE, *Falco Haliaetus*, Wils. Amer. Orn., vol. iv. p. 89. Adult.
SEA EAGLE, *Falco ossifragus*, Wils. Amer. Orn., vol. vii. p. 16. Young.
FALCO LEUCOCEPHALUS, Bonap. Synops., p. 26.
AQUILA LEUCOCEPHALA, WHITE-HEADED EAGLE, Swains. & Rich. F. Bor. Amer., vol. ii.
 p. 15.
WHITE-HEADED or BALD EAGLE, *Falco leucocephalus*, Nutt. Man., vol. i. p. 72.
WHITE-HEADED EAGLE, *Falco leucocephalus*, Aud. Orn. Biog., vol. i. p. 160; vol. ii. p.
 160; vol. v. p. 354.

Adult Male.

Bill bluish-black, cere light blue, feet pale greyish-blue, tinged anteriorly with yellow. General colour of upper parts deep umber-brown, the tail barred with whitish on the inner webs; the upper part of the head and neck white, the middle part of the crown dark brown; a broad band of the latter colour from the bill down the side of the neck; lower parts white, the neck streaked with light brown; anterior tibial feather tinged with brown. Young with the feathers of the upper parts broadly tipped with brownish-white, the lower pure white.

Wings long, second quill longest, first considerably shorter. Tail of

ordinary length, much rounded, extending considerably beyond the tips of the wings; of twelve, broad, rounded feathers.

Bill, cere, edge of eyebrow, iris, and feet yellow; claws bluish-black. The general colour of the plumage is deep chocolate, the head, neck, tail, abdomen, and upper and under tail-coverts white.

Length 34 inches; extent of wings 7 feet; bill along the back $2\frac{3}{4}$ inches, along the under mandible $2\frac{3}{4}$, in depth $1\frac{7}{12}$; tarsus 3, middle toe $3\frac{1}{2}$.

Genus V.—PANDION, Sav. OSPREY.

Bill short, as broad as deep at the base, the sides convex, the dorsal outline straight at the base, decurved towards the end; upper mandible with a festoon on the edges at the curvature, the tip trigonal, very acute; lower mandible with the edges slightly arched, the tip obtusely truncate. Nostrils oval, oblique, large, half way between the ridge and the cere. Legs rather long; tarsus very short, remarkably thick, covered all round with hexagonal scales; toes also remarkably thick, the outer versatile larger than the inner, all scutellate only towards the end, and covered beneath with prominent, conical, acuminate scales; claws long, curved, convex beneath, tapering to a fine point. Plumage compact, imbricated; feathers of the head and neck narrow, acuminate; of the tarsus short and very narrow, without the elongated external tufts seen in all the other genera. Tail rather long, a little rounded. Intestine extremely long and slender, its greatest width $2\frac{1}{4}$ twelfths, the smallest $\frac{1}{2}$ twelfth.

THE FISH HAWK, OR OSPREY.

PANDION HALIAETUS, Savig.

PLATE XV.—MALE.

The habits of this famed bird differ so materially from those of almost all others of its genus, that an accurate description of them cannot fail to be highly interesting to the student of nature.

The Fish Hawk may be looked upon as having more of a social disposition than most other Hawks. Indeed, with the exception of the Swallow-tailed Hawk (*Falco furcatus*), I know none so gregarious in its habits. It migrates

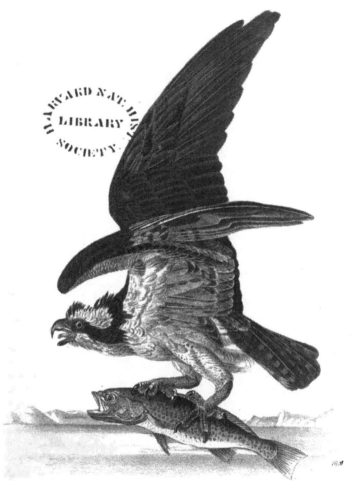

Common Osprey. Fish Hawk.

Drawn from Nature by J.J.Audubon F.R.S.F.L.S. Lith.d Printed & Col.d by J.T. Bowen Philad.

in numbers, both during spring, when it shews itself along our Atlantic
shores, lakes, and rivers, and during autumn, when it retires to warmer
climes. At these seasons, it appears in flocks of eight or ten individuals,
following the windings of our shores in loose bodies, advancing in easy
sailings or flappings, crossing each other in their gyrations. During the
period of their stay in the United States, many pairs are seen nestling,
rearing their young, and seeking their food within so short a distance of each
other, that while following the margins of our eastern shores, a Fish Hawk,
or a nest belonging to the species, may be met with at every short interval.

The Fish Hawk may be said to be of a mild disposition. Not only do
these birds live in perfect harmony together, but they even allow other birds
of very different character to approach so near to them as to build their nests
of the very materials of which the outer parts of their own are constructed.
I have never observed a Fish Hawk chasing any other bird whatever. So
pacific and timorous is it, that, rather than encounter a foe but little more
powerful than itself, it abandons its prey to the White-headed Eagle, which,
next to man, is its greatest enemy. It never forces its young from the nest,
as some other Hawks do, but, on the contrary, is seen to feed them even
when they have begun to procure food for themselves.

Notwithstanding all these facts, a most erroneous idea prevails among our
fishermen, and the farmers along our coasts, that the Fish Hawk's nest is
the best *scare-crow* they can have in the vicinity of their houses or grounds.
As these good people affirm, no Hawk will attempt to commit depredations
on their poultry, so long as the Fish Hawk remains in the country. But
the absence of most birds of prey from those parts at the time when the Fish
Hawk is on our coast, arises simply from the necessity of retiring to the
more sequestered parts of the interior for the purpose of rearing their young
in security, and the circumstance of their visiting the coasts chiefly at the
period when myriads of water-fowl resort to our estuaries at the approach of
winter, leaving the shores and salt-marshes at the return of spring, when the
Fish Hawk arrives. However, as this notion has a tendency to protect the
latter, it may be so far useful, the fisherman always interposing when he sees
a person bent upon the destruction of his favourite bird.

The Fish Hawk differs from all birds of prey in another important par-
ticular, which is, that it never attempts to secure its prey in the air, although
its rapidity of flight might induce an observer to suppose it perfectly able to
do so. I have spent weeks on the Gulf of Mexico, where these birds are
numerous, and have observed them sailing and plunging into the water, at a
time when numerous shoals of flying fish were emerging from the sea to
evade the pursuit of the dolphins. Yet the Fish Hawk never attempted to
pursue any of them while above the surface, but would plunge after one of

Genus VI.—ELANUS, *Sav.*

Bill short, small, very wide at the base, much compressed toward the end; upper mandible with the dorsal line convex and declinate to the end of the cere, then decurved, the sides slightly convex, the tip narrow and acute, the edges with a distinct festoon, lower mandible with the angle very wide and long, the dorsal line very short, and slightly convex, the tip obliquely truncate, and narrow. Nostrils elliptical, rather large, about half-way between the cere and ridge. Head rather large, broad, flattened above; neck short; body compact. Legs rather short; tarsus very short, stout, roundish, feathered anteriorly for half its length, the rest covered with small roundish scales; toes short, thick, scaly, with a few terminal scutella; claws long, curved, conical, rounded beneath, acute. Plumage very soft, and rather blended. Wings very long and pointed, the second quill longest. Tail of moderate breadth, long, emarginate, and rounded.

BLACK-SHOULDERED HAWK.

Elanus dispar, *Tem.*

PLATE XVI.—Male and Female.

I have traced the migration of this beautiful Hawk from the Texas as far east as the mouth of the Santee River in South Carolina. Charles Bonaparte first introduced it into our Fauna, on the authority of a specimen procured in East Florida by Titian Peale, Esq., of Philadelphia, who it seems had some difficulty in obtaining it. On the 8th of February, 1834, I received one of these birds alive from Dr. Ravenel, of Charleston, who had kept it in his yard for eight days previously, without being able to induce it to take any food. The beauty of its large eyes struck me at once, and I immediately made a drawing of the bird, which was the first I had ever seen alive. It proved to be a male, and was in beautiful plumage. Dr. Ravenel told me that it walked about his yard with tolerable ease, although one of its wings had been injured. On the 23d of the same month I received another fine specimen, a female, from Francis Lee, Esq., who had procured it on his plantation, forty miles west of Charleston, and with it the following note. "When first observed, it was perched on a tree in an erect posture. I saw

Pl. 16.

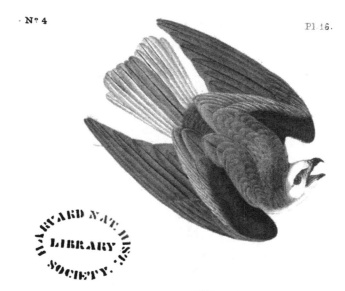

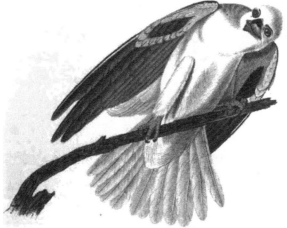

Black-shouldered Elanus.

Drawn from Nature by J.J. Audubon F.R.S. F.L.S. Lith Printed & Cold by J. T. Bowen, Philad.a

at once that it was one of the birds which you had desired me to procure for you, and went to the house for my gun. On returning I saw the Hawk very high in the air, sailing beautifully over a large wet meadow, where many Common Snipes were feeding. It would now and then poise itself for a while, in the manner of our Little Sparrow Hawk, and suddenly closing its wings plunge towards its prey with great velocity, making a rumbling noise as it passed through the air. Now and then, when about half way, it suddenly checked its descent, recommenced hovering, and at last marking its prey, rushed upon it and secured it. Its cries, on being wounded, so much resembled those of the Mississippi Kite, that I thought, as I was going to pick it up, that I had only got one of that species. It was so shy that I was obliged to get on horseback before I could approach it within gun shot."

Mr. H. WARD, who accompanied me on my expedition to the Floridas, found this species breeding on the plantation of ALEXANDER MAYZCK, Esq., on the Santee River, early in the month of March, and shot three, two of which, a male and a female, are now in my possession. Their nests were placed on low trees near the margins of the river, and resembled those of the American Crow, but had none of the substantial lining of that bird's nest. Mr. WARD states, that at this time they were seen flying over the cane brakes in pursuit of large insects, somewhat in the manner of the Mississippi Kite, and that they were very shy.

My friend JOHN BACHMAN has seen this species fly in groups, at a very great height, in the beginning of March, and thinks that it is only of late years that they have located themselves in South Carolina, where, however, five of them have been procured in one year.

The Black-shouldered Hawk appears to give a decided preference to low lands, not distant from the shores of the Atlantic. On our way toward the Texas, several of these birds were seen over the large marshes, flying at a small elevation, and coursing in search of prey, much in the manner of the Hen-harrier or Marsh Hawk, but all evidently bent on proceeding to the eastward. Whether this species winters there or not, I am unable to say, but that some remain all the year in Florida, and even in South Carolina, I am quite confident.

The difference between the food of this species and that of the Mississippi Kite is surprising to me. I have never seen the latter seize any bird, whereas the Black-shouldered Hawk certainly does so, as in the stomachs of two individuals which I examined were remains of birds as well as of coleopterous insects. These two birds agree nearly with the description of the one procured by Mr. TITIAN PEALE, excepting in the length of the wings, which in them and in several others that have come under my notice, have their tips fully an inch shorter than the end of the tail. A breeding female differed

from the rest in having the eyes dull yellowish-red; the tail-feathers had all been ash-grey, all the primaries were edged with white, and many of the secondaries were still of a light brownish-grey; the black spots under the wings were smaller than usual; the abdomen was also tinged with brownish-grey. I am therefore of opinion, that these birds undergo as many changes of plumage as the Mississippi Kite.

BLACK-WINGED HAWK, *Falco melanopterus*, Bonap. Amer. Orn., vol. ii.
FALCO MELANOPTERUS, Bonap. Syn., p. 31. *Falco dispar*, App. p. 435.
BLACK-SHOULDERED HAWK, *Falco dispar*, Aud. Amer. Orn., vol. iv. p. 397.

Adult Male.

Wings very long and pointed, the second quill longest, the third nearly as long, the first longer than the fourth; the first, second, and third with the outer web attenuated toward the end; the first and second with the inner web sinuated; secondaries very broad, rounded, the inner web exceeding the outer. Tail of twelve feathers, of moderate breadth, long, emarginate and rounded, the middle and lateral feathers being about equal, and eight-twelfths of an inch shorter than the second feather from the side.

Bill black; the cere and soft basal margins yellow. Iris bright red. Tarsi and toes yellow, of a darker tint than the cere; claws black. All the lower parts are pure white, with the exception of a patch on five or six of the larger wing-coverts; the forehead is also white, as are the cheeks; the superciliary bristles black, the white of the head gradually blends into the general colour of the upper parts, which is ash-grey; the smaller wing-coverts bluish-black; the shafts of the quills brownish-black; all the feathers of the tail, excepting the two middle, white; the shafts of the two middle feathers blackish-brown, of the rest white towards the end, the whole of that of the outer pure white.

Length to end of tail 16 inches, to end of claws 12¼, to end of wings 14⅞; extent of wings 40; wing from flexure 13; tail 7½⅔; bill along the ridge ¹¹⁄₁₂; along the edge of lower mandible 1¹⁄₁₂; tarsus 1⁴⁄₁₂; first toe ⁷⁄₁₂, its claw ¾; second toe ¹⁰¹⁄₁₂, its claw ¹²⁄₁₂; third toe ⅜, its claw ¹¹⁄₁₂; fourth toe ¹⁰¹⁄₁₂, its claw ⁷⁄₁₂. Weight 14 oz.

Adult Female.

The female is rather larger than the male, but in other respects similar.

Length to end of tail 16¾ inches, to end of wings 15¾, to end of claws 12⅝; extent of wings 41½; tail 8; wing from flexure 13½; bill along the ridge 1⅛, along the edge of lower mandible 1½; tarsus 1⅜; hind toe ¾, its claw ⅞; outer toe ⅞, its claw ½; middle toe 1⅜, its claw ⅝; inner toe ⅞, its claw ¾. Weight 17¼ oz.

Harvard Natural History
Society.

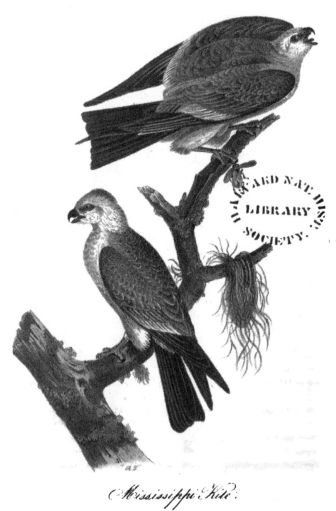

Mississippi Kite.

N

The young when fledged have the bill and claws black, the cere and feet dull yellow; the upper parts brownish-grey, the scapulars and quills tipped with white, the former also margined with yellowish-brown; the primary and secondary coverts are also tipped with white; the smaller wing-coverts are brownish-black; the outer webs of all the tail-feathers are more or less brownish-grey toward the end. The lower parts are white, the feathers on the breast tinged with brownish-yellow at the end, and with the shaft yellowish-brown. The lower wing-coverts are all white.

Genus VII.—ICTINIA, *Vieillot.*

Bill very short, wide at the base, much compressed toward the end; upper mandible with the dorsal line decurved in its whole length, the sides slightly convex, the tip narrow and acute, the edges with an obtuse lobe; lower mandible with the angle very wide, the dorsal line ascending and convex, the tip rather broad and obliquely truncate. Nostrils round, lateral, with a central papilla. Head rather large, roundish, broad, flattened; neck short, body compact. Legs rather short; tarsus stout, covered anteriorly with scutella; toes scutellate above, scabrous beneath, with pointed papillæ; claws rather long, curved, acuminate, flattened beneath. Plumage rather compact. Wings very long, the third quill longest. Tail long, emarginate.

This genus is easily distinguished from Elanus; the tarsi and toes being scutellate in this, and scaly in that; and the festoon on the upper mandible is much more prominent in the Ictinia, while the nostrils, instead of being elliptical, are round, as in the Falcons.

THE MISSISSIPPI KITE.

ICTINIA PLUMBEUS, *Gmel.*

PLATE XVII.—MALE AND FEMALE.

When, after many a severe conflict, the southern breezes, in alliance with the sun, have, as if through a generous effort, driven back for a season to their desolate abode the chill blasts of the north; when warmth and plenty are insured for awhile to our happy lands; when clouds of anxious Swallows, returning from the far south, are guiding millions of Warblers to their

and the extreme ease with which they seem to cleave the air, excite the admiration of him who views them while thus employed in searching for food.

A solitary individual of this species has once or twice been seen in Pennsylvania. Farther to the eastward the Swallow-tailed Hawk has never, I believe, been observed. Travelling southward, along the Atlantic coast, we find it in Virginia, although in very small numbers. Beyond that State it becomes more abundant. Near the Falls of the Ohio, a pair had a nest and reared four young ones, in 1820. In the lower parts of Kentucky it begins to become more numerous; but in the States farther to the south, and particularly in parts near the sea, it is abundant. In the large prairies of the Attacapas and Oppellousas it is extremely common.

In the States of Louisiana and Mississippi, where these birds are abundant, they arrive in large companies, in the beginning of April, and are heard uttering a sharp plaintive note. At this period I generally remarked that they came from the westward, and have counted upwards of a hundred in the space of an hour, passing over me in a direct easterly course. At that season, and in the beginning of September, when they all retire from the United States, they are easily approached when they have alighted, being then apparently fatigued, and busily engaged in preparing themselves for continuing their journey, by dressing and oiling their feathers. At all other times, however, it is extremely difficult to get near them, as they are generally on wing through the day, and at night rest on the highest pines and cypresses, bordering the river-bluffs, the lakes or the swamps of that district of country.

They always feed on the wing. In calm and warm weather, they soar to an immense height, pursuing the large insects called *Musquito Hawks*, and performing the most singular evolutions that can be conceived, using their tail with an elegance of motion peculiar to themselves. Their principal food, however, is large grasshoppers, grass-caterpillars, small snakes, lizards, and frogs. They sweep close over the fields, sometimes seeming to alight for a moment to secure a snake, and holding it fast by the neck, carry it off, and devour it in the air. When searching for grasshoppers and caterpillars, it is not difficult to approach them under cover of a fence or tree. When one is then killed and falls to the ground, the whole flock comes over the dead bird, as if intent upon carrying it off. An excellent opportunity is thus afforded of shooting as many as may be wanted, and I have killed several of these Hawks in this manner, firing as fast as I could load my gun.

The Fork-tailed Hawks are also very fond of frequenting the creeks, which, in that country, are much encumbered with drifted logs and accumulations of sand, in order to pick up some of the numerous water-snakes which lie basking in the sun. At other times, they dash along the trunks of trees,

and snap off the pupæ of the locust, or that insect itself. Although when on wing they move with a grace and ease which it is impossible to describe, yet on the ground they are scarcely able to walk.

I kept for several days one which had been slightly wounded in the wing. It refused to eat, kept the feathers of the head and rump constantly erect, and vomited several times part of the contents of its stomach. It never threw itself on its back, nor attempted to strike with its talons, unless when taken up by the tip of the wing. It died from inanition, as it constantly refused the food placed before it in profusion, and instantly vomited what had been thrust down its throat.

The Swallow-tailed Hawk pairs immediately after its arrival in the Southern States, and as its courtships take place on the wing, its motions are then more beautiful than ever. The nest is usually placed on the top branches of the tallest oak or pine tree, situated on the margin of a stream or pond. It resembles that of the Common Crow externally, being formed of dry sticks, intermixed with Spanish moss, and is lined with coarse grasses and a few feathers. The eggs are from four to six, of a greenish-white colour, with a few irregular blotches of dark brown at the larger end. The male and the female sit alternately, the one feeding the other. The young are at first covered with buff-coloured down. Their next covering exhibits the pure white and black of the old birds, but without any of the glossy purplish tints of the latter. The tail, which at first is but slightly forked, becomes more so in a few weeks, and at the approach of autumn exhibits little difference from that of the adult birds. The plumage is completed the first spring. Only one brood is raised in the season. The species leaves the United States in the beginning of September, moving off in flocks, which are formed immediately after the breeding season is over.

Hardly any difference as to external appearance exists between the sexes. They never attack birds or quadrupeds of any species, with the view of preying upon them. I never saw one alight on the ground. They secure their prey as they pass closely over it, and in so doing sometimes seem to alight, particularly when securing a snake. The common name of the Snake represented in the plate is the Garter Snake.

Swallow-tailed Hawk, *Falco furcatus*, Wils. Amer. Orn., vol. vi. p. 70.
Falco furcatus, Bonap. Syn., p. 31.
Swallow-tailed Hawk, *Falco furcatus*, Aud. Orn. Biog., vol. i. p. 368; vol. v. p. 371.

Adult Male.

Wings very long and acute, the third quill longest, the first equal to the fifth, the primaries widely graduated, the secondaries comparatively very

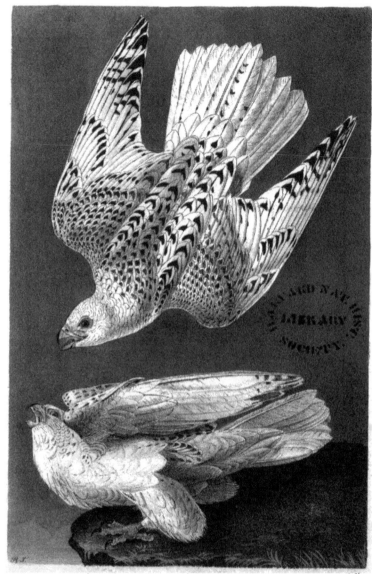

Iceland or Gyr Falcon.

short. Tail very deeply forked, of twelve feathers, the lateral ones extremely elongated.

Bill bluish-black above, light blue on the cere, and the edges of both mandibles. Edges of the eyelids light blue; iris black. Feet light blue, tinged with green; claws flesh-coloured. The head, the neck all round, and the under parts, are white, tinged with bluish-grey; the shafts of the head, neck, and breast blackish. The rest of the plumage is black, with blue and purple reflections.

Length 25 inches; extent of wings 51½; beak along the back 1¼.

The female is similar to the male.

Genus IX.—FALCO, *Linn.* FALCON.

Bill short, robust; its upper outline decurved from the base; cere short, bare; edge of upper mandible with a festoon and a prominent angular process. Nostrils round, with an internal ridge, ending in a central tubercle. Feet strong; tarsi moderate, reticulate; toes long, broadly scutellate, the anterior webbed at the base; claws long, well curved, very acute. Wings long, pointed; second quill longest, first and third nearly equal; outer toe abruptly cut out on the inner web. Tail rather long, nearly even.

THE ICELAND OR JER FALCON.

FALCO ISLANDICUS, *Lath.*

PLATE XIX.—MALE AND FEMALE.

On the 6th August, 1833, while my young friends, THOMAS LINCOLN and JOSEPH COOLEDGE, accompanied by my son JOHN, were rambling by the rushing waters of a brook banked by stupendous rocks, eight or ten miles from the port of Bras d'Or, on the coast of Labrador, they were startled by a loud and piercing shriek, which issued from the precipices above them. On looking up, my son observed a large Hawk plunging over and about him. It was instantly brought to the ground. A second Hawk dashed towards the dead one, as if determined to rescue it; but it quickly met the same fate, the contents of my son's second barrel bringing it to his feet.

extremity a brownish-black spot, generally arrow-shaped. The anterior feathers of the back have, moreover, a black streak on the shaft, which on those farther back becomes larger and lanceolate, and on the rump is accompanied by a third spot; the larger coverts and secondary quills have also three or more spots, and the primary quills have seven spots or partial bars toward their extremity, besides a large subterminal black space, their tips however being white. On the inner margin of the two middle tail-feathers are eight, and on the outer four dusky spots, and their shafts are also dusky, as are those of all the quills on their upper surface. There are also a few slight lanceolate dark spots on the sides of the body, and on the tibial feathers.

Length to end of tail 23½ inches, to end of wings 21½, to end of claws 18¾, to carpal joint 5½; extent of wings 51¼.

THE GREAT-FOOTED HAWK.

FALCO PEREGRINUS, *Gmel.*

PLATE XX.—MALE AND FEMALE.

The French and Spaniards of Louisiana have designated all the species of the genus Falco by the name of *"Mangeurs de Poulets;"* and the farmers in other portions of the Union have bestowed upon them, according to their size, the appellations of "Hen Hawk," "Chicken Hawk," "Pigeon Hawk," &c. This mode of naming these rapacious birds is doubtless natural enough, but it displays little knowledge of the characteristic manners of the species. No bird can better illustrate the frequent inaccuracy of the names bestowed by ignorant persons than the present, of which, on referring to the plate, you will see a pair enjoying themselves over a brace of ducks of different species. Very likely, were tame ducks as plentiful on the plantations in our States, as wild ducks are on our rivers, lakes and estuaries, these Hawks might have been named by some of our settlers *"Mangeurs de Canards."*

Look at these two pirates eating their *dejeuné à la fourchette*, as it were, congratulating each other on the savouriness of the food in their grasp. One might think them epicures, but they are in fact gluttons. The male has obtained possession of a Green-winged Teal, while his mate has procured a Gadwal Duck. Their appetites are equal to their reckless daring, and they well deserve the name of "Pirates," which I have above bestowed upon them.

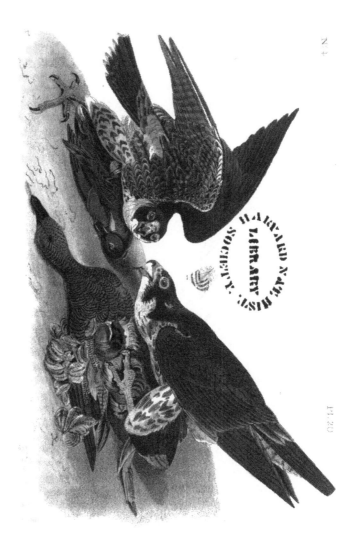

Peregrine Falcon.

The Great-footed Hawk, or Peregrine Falcon, is now frequently to be met with in the United States, but within my remembrance it was a very scarce species in America. I can well recollect the time when, if I shot one or two individuals of the species in the course of a whole winter, I thought myself a fortunate mortal; whereas of late years I have shot two in one day, and perhaps a dozen in the course of a winter. It is quite impossible for me to account for this increase in their number, the more so that our plantations have equally increased, and we have now three gunners for every one that existed twenty years ago, and all of them ready to destroy a Hawk of any kind whenever an occasion presents itself.

The flight of this bird is of astonishing rapidity. It is scarcely ever seen sailing, unless after being disappointed in its attempt to secure the prey which it has been pursuing, and even at such times it merely rises with a broad spiral circuit, to attain a sufficient elevation to enable it to reconnoitre a certain space below. It then emits a cry much resembling that of the Sparrow Hawk, but greatly louder, like that of the European Kestrel, and flies off swiftly in quest of plunder. The search is often performed with a flight resembling that of the tame pigeon, until perceiving an object, it redoubles its flappings, and pursues the fugitive with a rapidity scarcely to be conceived. Its turnings, windings and cuttings through the air are now surprising. It follows and nears the timorous quarry at every turn and back-cutting which the latter attempts. Arrived within a few feet of the prey, the Falcon is seen protruding his powerful legs and talons to their full stretch. His wings are for a moment almost closed; the next instant he grapples the prize, which, if too weighty to be carried off directly, he forces obliquely towards the ground, sometimes a hundred yards from where it was seized, to kill it, and devour it on the spot. Should this happen over a large extent of water, the Falcon drops his prey, and sets off in quest of another. On the contrary, should it not prove too heavy, the exulting bird carries it off to a sequestered and secure place. He pursues the smaller Ducks, Water-hens, and other swimming birds, and if they are not quick in diving, seizes them, and rises with them from the water. I have seen this Hawk come at the report of a gun, and carry off a Teal not thirty steps distant from the sportsman who had killed it, with a daring assurance as surprising as unexpected. This conduct has been observed by many individuals, and is a characteristic trait of the species. The largest duck that I have seen this bird attack and grapple with on the wing is the Mallard.

The Great-footed Hawk does not, however, content himself with water-fowl. He is sometimes seen following flocks of Pigeons and even Blackbirds. For several days I watched one of them that had taken a particular fancy to some tame pigeons, to secure which it went so far as to enter their house at

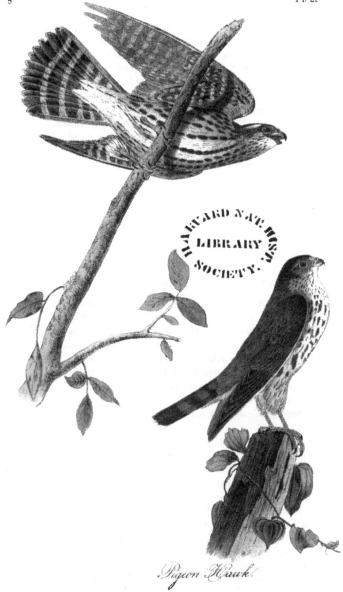

Pigeon Hawk.

Wings from two to three inches shorter than the tail, on the middle
feathers of which are five, on the lateral six, broad whitish bands. Adult
male with the cere greenish-yellow, the feet pale orange, the upper parts
light bluish-grey, each feather with a black central line; lower parts reddish
or yellowish-white, the breast and sides with large oblong brown spots; tibial
feathers light red, streaked with blackish-brown. Female with the cere and
legs greenish-yellow, the upper parts dark greyish-brown, the lower pale
red, spotted as in the male. Young with the head light reddish-brown,
streaked with dusky, the upper parts brownish-grey, the feathers margined
and spotted with pale red, throat white, lower parts pale red, streaked with
brown. The tail-bands vary from pale red to white.

———

THE AMERICAN SPARROW-HAWK.

FALCO SPARVERIUS, *Linn.*

PLATE XXII.—MALE AND FEMALE.

We have few more beautiful Hawks in the United States than this active
little species, and I am sure, none half so abundant. It is found in every
district from Louisiana to Maine, as well as from the Atlantic shores to the
western regions. Every one knows the Sparrow-Hawk, the very mention
of its name never fails to bring to mind some anecdote connected with its
habits, and, as it commits no depredations on poultry, few disturb it, so that
the natural increase of the species experiences no check from man. During
the winter months especially it may be seen in the Southern States about
every old field, orchard, barn-yard, or kitchen-garden, but seldom indeed in
the interior of the forest.

Beautifully erect, it stands on the highest fence-stake, the broken top of a
tree, the summit of a grain stack, or the corner of the barn, patiently and
silently waiting until it espies a mole, a field-mouse, a cricket, or a grasshopper,
on which to pounce. If disappointed in its expectation, it leaves its stand
and removes to another, flying low and swiftly until within a few yards of
the spot on which it wishes to alight, when all of a sudden, and in the most
graceful manner, it rises towards it and settles with incomparable firmness of
manner, merely suffering its beautiful tail to vibrate gently for awhile, its
wings being closed with the swiftness of thought. Its keen eye perceives
something beneath, when down it darts, secures the object in its talons,
returns to its stand, and devours its prey piece by piece. This done, the

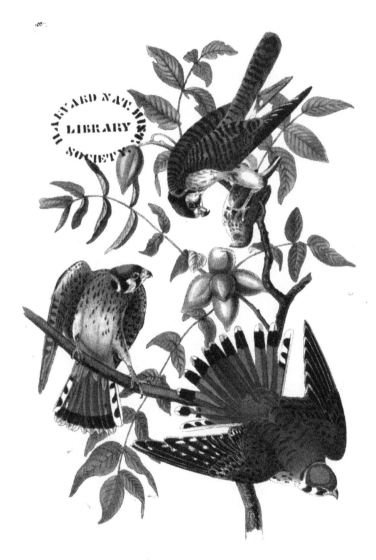

Sparrow Hawk.

Drawn from Nature by J.J.Audubon F.R.S.F.L.S.

Lith⁴ Printed & Col⁴ by J.T. Bowen Philad⁴

Harvard Natural History
Society.

little hunter rises in the air, describes a few circles, moves on directly, balances itself steadily by a tremulous motion of its wings, darts towards the earth, but, as if disappointed, checks its course, reascends and proceeds. Some unlucky Finch crosses the field beneath it. The Hawk has marked it, and, anxious to secure its prize, sweeps after it; the chase is soon ended, for the poor affrighted and panting bird becomes the prey of the ruthless pursuer, who, unconscious of wrong, carries it off to some elevated branch of a tall tree, plucks it neatly, tears the flesh asunder, and having eaten all that it can pick, allows the skeleton and wings to fall to the ground, where they may apprise the traveller that a murder has been committed.

Thus, reader, are the winter months spent by this little marauder. When spring returns to enliven the earth, each male bird seeks for its mate, whose coyness is not less innocent than that of the gentle dove. Pursued from place to place, the female at length yields to the importunity of her dear tormentor, when side by side they sail, screaming aloud their love notes, which, if not musical, are doubtless at least delightful to the parties concerned. With tremulous wings they search for a place in which to deposit their eggs secure from danger, and now they have found it.

On that tall mouldering headless trunk, the Hawks have alighted side by side. See how they caress each other! Mark! The female enters the deserted Woodpecker's hole, where she remains some time measuring its breadth and depth. Now she appears, exultingly calls her mate, and tells him there could not be a fitter place. Full of joy they gambol through the air, chase all intruders away, watch the Grakles and other birds to which the hole might be equally pleasing, and so pass the time, until the female has deposited her eggs, six, perhaps even seven in number, round, and beautifully spotted. The birds sit alternately, each feeding the other and watching with silent care. After awhile the young appear, covered with white down. They grow apace, and now are ready to go abroad, when their parents entice them forth. Some launch into the air at once, others, not so strong, now and then fall to the ground; but all continue to be well provided with food, until they are able to shift for themselves. Together they search for grasshoppers, crickets, and such young birds as, less powerful than themselves, fall an easy prey. The family still resort to the same field, each bird making choice of a stand, the top of a tree, or that of the *great mullein*. At times they remove to the ground, then fly off in a body, separate, and again betake themselves to their stands. Their strength increases, their flight improves, and the field-mouse seldom gains her retreat before the little Falcon secures it for a meal.

The trees, of late so richly green, now disclose the fading tints of autumn; the cricket becomes mute, the grasshopper withers on the fences, the mouse

at night to his favourite roost behind the window-shutter. His courageous disposition often amused the family, as he would sail off from his stand, and fall on the back of a tame duck, which, setting up a loud quack, would waddle off in great alarm with the Hawk sticking to her. But, as has often happened to adventurers of similar spirit, his audacity cost him his life. A hen and her brood chanced to attract his notice, and he flew to secure one of the chickens, but met one whose parental affection inspired her with a courage greater than his own. The conflict, which was severe, ended the adventures of poor Nero.

I have often observed birds of this species in the Southern States, and more especially in the Floridas, which were so much smaller than those met with in the Middle and Northern Districts, that I felt almost inclined to consider them different; but after studying their habits and voice, I became assured that they were the same. Another species allied to the present, and alluded to by WILSON, has never made its appearance in our Southern States.

AMERICAN SPARROW-HAWK, *Falco sparverius*, Wils. Amer. Orn., vol. ii. p. 117.
FALCO SPARVERIUS, Bonap. Syn., p. 27.
AMERICAN SPARROW-HAWK, *Falco sparverius*, Nutt. Man., vol. i. p. 58.
FALCO SPARVERIUS, *Little Rusty-crowned Falcon*, Swains. and Rich. F. Bor. Amer., vol. ii. p. 31.
AMERICAN SPARROW-HAWK, *Falco sparverius*, Aud. Orn. Biog., vol. ii. p. 246; vol. v. p. 370.

Adult Male.

Upper part of the head and wing-coverts light greyish-blue, seven black spots round the head, and a light red patch on the crown; back light red, spotted with black; tail red, with a broad subterminal black band. Female with the head nearly as in the male; the back, wing-coverts, and tail banded with light red and dusky. Young similar to the female, but with more red on the head, which is streaked with dusky.

Length 12 inches; extent of wings 22.

* * *

GENUS X.—ASTUR, *Cuv.* HAWK.

Bill short, robust; its upper outline sloping, and nearly straight at the base, then decurved; cere short, bare above; edge of upper mandible with a festoon, succeeded by a broad sinus. Nostrils elliptical. Feet of moderate length; tarsi moderate or slender, feathered at least one-third of their length, broadly scutellate before and behind; first and second toes strongest and

Pl.23.

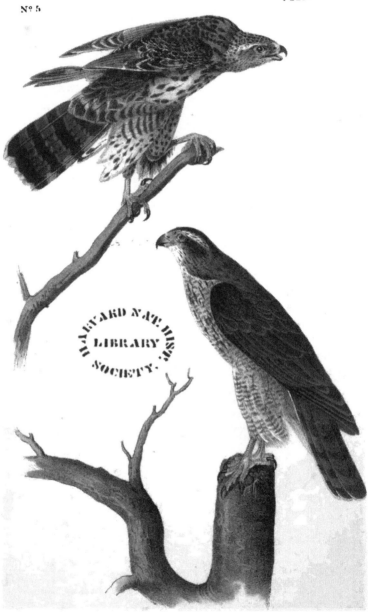

Goshawk.

equal, third much longer, and connected at the base by a web with the fourth, which is shortest; claws long, well curved, acuminate. Wings very broad, of moderate length, much rounded, fourth and fifth quills longest, first much shorter, outer four abruptly cut out on the inner web. Tail long, much exceeding the wings, rounded.

Those of more slender form, with proportionally longer tails and tarsi, are separated by many authors to form a group, to which the names of *Accipiter* and *Nisus* are given.

THE GOSHAWK.

ASTUR PALUMBARIUS, *Linn.*

PLATE XXIII.—ADULT MALE AND YOUNG.

The Goshawk is of rare occurrence in most parts of the United States, and the districts of North America to which it usually retires to breed are as yet unknown. Some individuals nestle within the Union, others in the British provinces of New Brunswick and Nova Scotia, but the greater part seem to proceed farther north. I saw none, however, in Labrador, but was informed that they are plentiful in the wooded parts of Newfoundland. On returning from the north, they make their appearance in the Middle States about the beginning of September, and after that season range to very great distances. I have found them rather abundant in the lower parts of Kentucky and Indiana, and in severe winters I have seen a few even in Louisiana. In the Great Pine Forest of Pennsylvania, and at the Falls of Niagara, I have observed them breeding. During autumn and winter, they are common in Maine, as well as in Nova Scotia, where I have seen six or seven specimens that were procured by a single person in the course of a season. At Pictou, Professor MacCulloch shewed me about a dozen well mounted specimens of both sexes, and of different ages, which he had procured in the neighbourhood. In that country, they prey on Hares, the Canada Grouse, the Ruffed Grouse, and Wild Ducks. In Maine, they are so daring as to come to the very door of the farmer's house, and carry off chickens and ducks with such rapidity as generally to elude all attempts to shoot them. When residing in Kentucky I shot a great number of these birds, particularly one cold winter, near Henderson, when I killed a dozen or more on the ice in Canoe Creek, where I generally surprised them by approaching the deep banks of that

stream with caution, and not unfrequently almost above them, when their escape was rendered rather difficult. They there caught Mallards with ease, and after killing them turned them belly upwards, and ate only the flesh of the breast, pulling the feathers with great neatness, and throwing them round the bird, as if it had been plucked by the hand of man.

The flight of the Goshawk is extremely rapid and protracted. He sweeps along the margins of the fields, through the woods, and by the edges of ponds and rivers, with such speed as to enable him to seize his prey by merely deviating a few yards from his course, assisting himself on such occasions by his long tail, which, like a rudder, he throws to the right or left, upwards or downwards, to check his progress, or enable him suddenly to alter his course. At times he passes like a meteor through the underwood, where he secures squirrels and hares with ease. Should a flock of Wild Pigeons pass him when on these predatory excursions, he immediately gives chase, soon overtakes them, and forcing his way into the very centre of the flock, scatters them in confusion, when you may see him emerging with a bird in his talons, and diving towards the depth of the forest to feed upon his victim. When travelling, he flies high, with a constant beat of the wings, seldom moving in large circles like other Hawks, and when he does this, it is only a few times, in a hurried manner, after which he continues his journey.

Along the Atlantic coast, this species follows the numerous flocks of ducks that are found there during autumn and winter, and greatly aids in the destruction of Mallards, Teals, Black Ducks, and other species, in company with the Peregrine Falcon. It is a restless bird, apparently more vigilant and industrious than many other Hawks, and seldom alights unless to devour its prey; nor can I recollect ever having seen one alighted for many minutes at a time without having a bird in its talons. When thus engaged with its prey, it stands nearly upright, and in general, when perched, it keeps itself more erect than most species of Hawk. It is extremely expert at catching Snipes on the wing, and so well do these birds know their insecurity, that, on his approach, they prefer squatting.

When the Passenger Pigeons are abundant in the western country, the Goshawk follows their close masses, and subsists upon them. A single Hawk suffices to spread the greatest terror among their ranks, and the moment he sweeps towards a flock, the whole immediately dive into the deepest woods, where, notwithstanding their great speed, the marauder succeeds in clutching the fattest. While travelling along the Ohio, I observed several Hawks of this species in the train of millions of these Pigeons. Towards the evening of the same day, I saw one abandoning its course, to give chase to a large flock of Crow Blackbirds (*Quiscalus versicolor*), then crossing the river. The Hawk approached them with the swiftness of an

arrow, when the Blackbirds rushed together so closely that the flock looked like a dusky ball passing through the air. On reaching the mass, he, with the greatest ease, seized first one, then another, and another, giving each a squeeze with his talons, and suffering it to drop upon the water. In this manner, he had procured four or five before the poor birds reached the woods, into which they instantly plunged, when he gave up the chase, swept over the water in graceful curves, and picked up the fruits of his industry, carrying each bird singly to the shore. Reader, is this instinct or reason?

The nest of the Goshawk is placed on the branches of a tree, near the trunk or main stem. It is of great size, and resembles that of our Crow, or some species of Owl, being constructed of withered twigs and coarse grass, with a lining of fibrous strips of plants resembling hemp. It is, however, much flatter than that of the Crow. In one I found, in the month of April, three eggs, ready to be hatched; they were of a dull bluish-white, sparingly spotted with light reddish-brown. In another, which I found placed on a pine tree, growing on the eastern rocky bank of the Niagara river, a few miles below the Great Cataract, the lining was formed of withered herbaceous plants, with a few feathers, and the eggs were four in number, of a white colour, tinged with greenish-blue, large, much rounded, and somewhat granulated. In another nest were four young birds, covered with buff coloured down, their legs and feet of a pale yellowish flesh colour, the bill light blue, and the eyes pale grey. They differed greatly in size, one being quite small compared with the rest. I am of opinion that few breed to the south of the State of Maine.

The variations of the plumage exhibited by the Goshawk are numerous. I have seen some with horizontal bars, of a large size, on the breast, and blotches of white on the back and shoulders, while others had the first of these parts covered with delicate transverse lines, the shaft of each feather being brown or black, and were of a plain cinereous tint above. The young, which at first have but few scattered dashes of brown beneath, are at times thickly mottled with that, and each feather of the back and wings is broadly edged with dull white.

My opinion respecting the identity of the American Goshawk and that of Europe, is still precisely the same as it was some years ago, when I wrote a paper on the subject, which was published in the Edinburgh Journal of Natural and Geographical Science. I regret differing on this point from such Ornithologists as CHARLES BONAPARTE and M. TEMMINCK; but, after due consideration, I cannot help thinking these birds the same.

The figure of the adult was drawn at Henderson, in Kentucky, many years ago. That of the young bird was taken from a specimen shot in the Great Pine Forest in Pennsylvania.

ASH-COLOURED or BLACK-CAPPED HAWK, *Falco atricapillus*, Wils. Amer. Orn., vol. vi.
p. 80.
FALCO PALUMBARIUS, Bonap. Syn., p. 28.
AMERICAN GOSHAWK, *Falco atricapillus*, Nutt. Man., vol. i. p. 85.
ACCIPITER (ASTUR) PALUMBARIUS, Swains. and Rich. F. Bor. Amer., vol. ii. p. 39.
GOSHAWK, *Falco palumbarius*, Aud. Orn. Biog., vol. ii. p. 241.

Adult male, dark bluish-grey above, the tail with four broad bands of
blackish-brown, the upper part of the head greyish-black; a white band,
with black lines, over the eyes; lower parts white, narrowly barred with
grey, and longitudinally streaked with dark brown. Young, brown above,
the feathers edged with reddish-white, the head and hind neck pale red,
streaked with blackish-brown, the lower parts yellowish-white, with oblong
longitudinal dark brown spots.

Length 24 inches; extent of wings 47.

COOPER'S HAWK.

ASTUR COOPERI, *Bonap.*

PLATE XXIV.—MALE AND FEMALE.

The flight of the Cooper's Hawk is rapid, protracted, and even. It is per-
formed at a short height above the ground or through the forest. It passes
along in a silent gliding manner, with a swiftness even superior to that of
the Wild Pigeon (*Columba migratoria*), seldom deviating from a straight-
forward course, unless to seize and secure its prey. Now and then, but
seldom unless after being shot at, it mounts in the air in circles, of which it
describes five or six in a hurried manner, and again plunging downwards,
continues its journey as before.

The daring exploits performed by this Hawk, which have taken place in
my presence, are very numerous, and I shall relate one or two of them.
This marauder frequently attacks birds far superior to itself in weight, and
sometimes possessed of courage equal to its own. As I was one morning
observing the motions of some Parakeets near Bayou Sara, in the State of
Louisiana, in the month of November, I heard a Cock crowing not far from
me, and in sight of a farm-house. The Cooper's Hawk the next moment
flew past me, and so close that I might have touched it with the barrel of
my gun, had I been prepared. Its wings struck with extraordinary rapidity,
and its tail appeared as if closed. Not more than a few seconds elapsed
before I heard the cackling of the Hens, and the war-cry of the Cock, and at

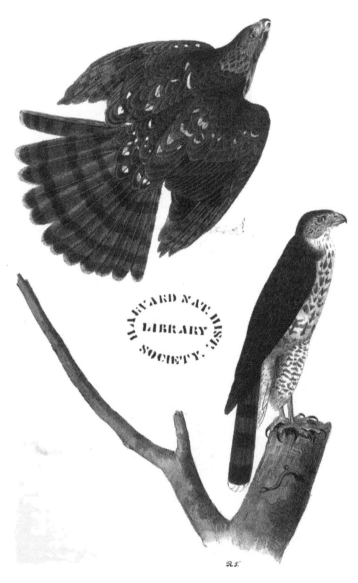

Cooper's Hawk.

Harvard Natural History
Society.

the same time observed the Hawk rising, as if without effort, a few yards in the air, and again falling towards the ground with the rapidity of lightning. I proceeded to the spot, and found the Hawk grappled to the body of the Cock, both tumbling over and over, and paying no attention to me as I approached. Desirous of seeing the result, I remained still, until perceiving that the Hawk had given a fatal squeeze to the brave Cock, I ran to secure the former; but the marauder had kept a hawk's eye upon me, and, disengaging himself, rose in the air in full confidence. The next moment I pulled a trigger, and he fell dead to the ground. It proved a young male, such as you see, kind reader, represented in the Plate, pursuing a lovely Blue-bird nearly exhausted. The Cock was also dead; its breast was torn, and its neck pierced in several places by the sharp claws of the Hawk.

Some years afterwards, not far from the famed Falls of Niagara, in the month of June, one of these Hawks, which on being examined proved to be a female, attacked a brood of young chickens, yet under the care of their mother. It had just struck one of the chickens, and was on the eve of carrying it off in its claws, when the hen, having perceived the murderous deed, flew against the Hawk with such force as to throw it fairly on its back, when the intrepid mother so effectually assailed the miscreant with feet and bill, as to enable me, on running up, to secure the latter.

This species frequently kills and eats the Grouse commonly called the Pheasant (*Tetrao umbellus*). Partridges and young hares are also favourite dainties. It also follows the Wild Pigeons in their migrations, and always causes fear and confusion in their ranks.

It breeds in the mountainous districts of the Middle and Northern States, to which it returns early in spring from the Southern States, where it spends the winter in considerable numbers, and is known by the name of the *Great Pigeon Hawk.*

The nest is usually placed in the forks of the branch of an oak tree, towards its extremity. In its general appearance it resembles that of the Common Crow, for which I have several times mistaken it. It is composed externally of numerous crooked sticks, and has a slight lining of grasses and a few feathers. The eggs are three or four, almost globular, large for the size of the bird, of a dullish white colour, strongly granulated, and consequently rough to the touch. It was on discovering one of these nests that I wounded the second adult male which I have seen, but which never returned to its nest, on which I afterwards shot the female represented in the Plate, in the act of pouncing. I have several times found other nests of birds of this species, but the owners were not in full plumage, and their eyes had not obtained the rich orange colouring of the adult birds.

Those which I have observed near the Falls of Niagara were generally

engaged in pursuing Red-winged Starlings over the marshes of the neigh-
bourhood. When this Hawk is angry, it raises the feathers of the upper
part of the head, so as to make them appear partially tufted. The cry at this
time may be represented by the syllable *kee, kee, kee*, repeated eight or ten
times in rapid succession, and much resembling that of the Pigeon-Hawk
(*Falco columbarius*) or the European Kestril. The young of this species
bear no resemblance to those of the Goshawk.

COOPER'S HAWK, *Falco Cooperii*, Bonap. Amer. Orn. Young.
FALCO COOPERII, Bonap. Syn., App., p. 433. Young.
STANLEY HAWK, *Falco Stanleii*, Aud. Orn. Biog., vol. ii. p. 245. Adult Male.
STANLEY HAWK, *Falco Stanleii,*, Aud. Orn. Biog., vol. i. p. 186. Young.

Adult Male.

Tail rounded, tarsi moderately stout. Adult male dull bluish-grey above;
the tail with four broad bands of blackish-brown, and tipped with white; the
upper part of the head greyish-black; lower parts transversely barred with
light red and white, the throat white, longitudinally streaked. Female simi-
lar, with the bands on the breast broader. Young umber-brown above, more
or less spotted with white, the tail with four blackish-brown bars; lower
parts white, each feather with a longitudinal narrow, oblong, brown spot.

Male, 20, 36. Female, 22, 38.

SHARP-SHINNED OR SLATE-COLOURED HAWK.

ASTUR FUSCUS, *Gmel.*

PLATE XXV.—MALE AND FEMALE.

It is mentioned in the Fauna Boreali-Americana, that a specimen of this
bird was killed in the vicinity of Moose Factory, and that it has been
deposited by the Hudson's Bay Company in the Zoological Museum of
London. This specimen I have not seen, but confiding entirely in the
accuracy of every fact mentioned by the authors of that work, I here adduce
it as a proof of the extraordinary range of this species in America, which
from the extreme north extends to our most southern limits, perhaps far
beyond them, during its autumnal and winter migrations. I have met with
it in every State or Territory of the Union that I have visited. In the spring
of 1837, it was abundant in Texas, where it appeared to be travelling east-

R. 5.

Sharp-shinned Hawk.

Lith⁴ Printed & Col⁴ by J. T. Bowen Philad⁴

Harvard Natural History
Society.

ward. I have a specimen procured by Mr. TOWNSEND in the neighbourhood of the Columbia river; and, when on my way towards Labrador, I met with it plentifully as far as the southern shores of the Gulf of St. Lawrence, beyond which, however, none were observed by me or any of my party.

I never saw this daring little marauder on wing without saying or think-ing "There goes the miniature of the Goshawk!" Indeed, reader, the shortness of the wings of the Sharp-shinned Hawk, its long tail, although almost perfectly even, instead of being rounded as in the Goshawk, added to its irregular, swift, vigorous, varied, and yet often undecided manner of flight, greatly protracted however on occasion, have generally impressed upon me the idea alluded to. While in search of prey, the Sharp-shinned Hawk passes over the country, now at a moderate height, now close over the land, in so swift a manner that, although your eye has marked it, you feel surprised that the very next moment it has dashed off and is far away. In fact it is usually seen when least expected, and almost always but for a few moments, unless when it has procured some prey, and is engaged in feeding upon it. The kind of vacillation or wavering with which it moves through the air appears perfectly adapted to its wants, for it undoubtedly enables this little warrior to watch and to see at a single quick glance of its keen eyes every object, whether to the right or to the left, as it pursues its course. It advances by sudden dashes, as if impetuosity of movement was essential to its nature, and pounces upon or strikes such objects as best suit its appetite; but so very suddenly that it appears quite hopeless for any of them to try to escape. Many have been the times, reader, when watching this vigilant, active, and industrious bird, I have seen it plunge headlong among the briary patches of one of our old fields, in defiance of all thorny obstacles, and, passing through, emerge on the other side, bearing off with exultation in its sharp claws a Sparrow or Finch, which it had surprised when at rest. At other times I have seen two or three of these Hawks, acting in concert, fly at a Golden-winged Woodpecker while alighted against the bark of a tree, where it thought itself secure, but was suddenly clutched by one of the Hawks throwing as it were its long legs forward with the quickness of thought, protruding its sharp talons, and thrusting them into the back of the devoted bird, while it was endeavouring to elude the harassing attacks of another, by hopping and twisting round the tree. Then down to the ground assailants and assailed would fall, the Woodpecker still offering great resistance, until a second Hawk would also seize upon it, and with claws deeply thrust into its vitals, put an end to its life; when both the marauders would at once commence their repast.

On several such occasions, I have felt much pleasure in rescuing different species of birds from the grasp of the little tyrant, as whenever it seizes one

our smaller snakes and lizards, and not unfrequently snatches up a frog while basking in the sun.

The difference of size observed between the males and females, as well as between individuals of the same sex, is very remarkable; and no doubt it was on account of this very great disparity that WILSON described specimens of each sex as distinct species. Its notes are short, shrill, and repeated in a hurried manner, when the bird is wounded and brought to the ground. It often emits cries of this kind while falling, but suddenly becomes silent when it comes to the earth, and then makes off swiftly, with long and light leaps, keeping silent until approached. Although a small bird, it possesses considerable muscular power, and its extremely sharp claws are apt to inflict severe pain, should a person lay hold of it incautiously.

SLATE-COLOURED HAWK, *Falco Pennsylvanicus*, Wils. Amer. Orn., vol. vi. p. 13. Adult
 Male.
SHARP-SHINNED HAWK, *Falco velox*, Wils. Amer. Orn., vol. vi. p. 116. Young Female.
FALCO VELOX, Bonap. Syn., p. 29.
FALCO FUSCUS, Bonap. Syn., Append., p. 433.
ACCIPITER PENNSYLVANICUS, *Slate-coloured Hawk*, Swains. and Rich. F. Bor. Amer.,
 vol. ii. p. 44.
AMERICAN BROWN or SLATE-COLOURED HAWK, Nutt. Man., vol. ii. p. 87.
SHARP-SHINNED or SLATE-COLOURED HAWK, *Falco fuscus*, Aud. Amer. Orn., vol. iv. p.
 522. Adult.

·Tail even, tarsi extremely slender. Adult male bluish-grey above; the tail with four broad bands of blackish-brown, and tipped with white; upper part of head darker; lower parts transversely barred with light red and white, the throat white, longitudinally streaked. Female similar, more tinged with yellow beneath, and with the bands on the breast broader. Young umber-brown above, more or less spotted with white, the tail with four dark brown bars; lower parts white, each feather with a longitudinal narrow, oblong, brown spot. Miniature of *Falco Cooperii*, and intimately allied to *Astur Nisus*.

Male 11¼, 20½. Female 14, 26.

Genus XI.—CIRCUS, *Bechst.* HARRIER.

Bill short, compressed; upper mandible with the dorsal line sloping to beyond the cere, then decurved, the sides sloping, the edge with a festoon a little anterior to the nostril, the tip acute; lower mandible with the dorsal line ascending and convex, the tip rounded. Nostrils large, ovato-oblong, with an oblique ridge from their upper edge. Head of moderate size, oblong, neck rather short; body slender. Legs long and slender; tarsi long, compressed, anteriorly and posteriorly scutellate; toes slender, scutellate unless at the base; claws long, compressed, moderately curved, flat beneath, acuminate. Plumage very soft; a distinct ruff of narrow feathers from behind the eye on each side to the chin, the aperture of the ear being very large. Wings long, much rounded, the fourth quill longest; outer four quills with their inner webs sinuate. Tail straight, long, slightly rounded. Quills and tail feathers covered with velvety down.

MARSH HAWK.

Circus cyaneus, *Linn.*

PLATE XXIV.

This species visits the greater part of the United States. Dr. Richardson procured some specimens in latitude 65° north, and Mr. Townsend found it on the plains of the Columbia river, as well as on the extensive prairies bordering on the Missouri. I have met with it in Newfoundland and Labrador on the one hand, in Texas on the other, and in every intermediate portion of the country.

The flight of the Marsh Hawk, although light and elegant, cannot be said to be either swift or strong; but it is well sustained, and this may be accounted for on comparing the small size and weight of its body with the great extent of its wings and tail, which are proportionally larger than those of any other American Hawk. While searching for prey, it performs most of its rambles by rather irregular sailings; by which I mean that it frequently deviates from a straight course, peeping hither and thither among the tall grasses of the marshes, prairies, or meadows, or along the briary edges of

our fields. It is seldom indeed seen to chase birds on wing, although I have met with a few instances; nor is it much in the habit of carrying its quarry to any distance; for generally as it observes an object suited to its appetite, it suddenly checks its speed, and almost poising itself by a few flaps of its wings, drops with astonishing quickness on its unfortunate victim, which it usually tears to pieces and devours on the spot. If disappointed, however, it rises as quickly as it dropped, and proceeds as before. Whilst engaged in feeding, it may very easily be approached, surprised, and shot, by an experienced sportsman, for it rises in a flurried manner, and generally cuts a few curious zig-zags at the outset. To obtain it, one has only to mark the spot with accuracy, keep his eye upon it, and advance with his gun in readiness, for he will probably get within a few yards before the bird rises. I have frequently seen it shot in this manner. At other times, by watching its beats over a field or meadow, one may obtain a good opportunity by concealing himself near a spot where he has seen it miss its object, as it is sure to repass there in a short time, at all events before it removes to another field. When wounded and brought to the ground, it makes off on the approach of its enemy by long leaps, and at times so swiftly that great exertion is requisite to overtake it; and when this is accomplished, it throws itself on its back, strikes furiously, and can inflict pretty severe wounds with its very sharp claws.

This species flies very high at times, and in a direct course, as if intent on proceeding to some great distance; but as I observed that this frequently occurred when the bird was satiated with food, I have thought that it preferred this method of favouring digestion, to its more usual mode of sitting on the top of a fence rail, and there remaining quiet until again roused by the feeling of hunger. I have often seen it, after sailing about in circles for a long while, half close its wings, and come towards the ground, cutting curious zig-zags, until within a few feet of it, when it would resume its usual elegant and graceful mode of proceeding.

I have observed it in our western prairies in autumn moving in flocks of twenty, thirty, or even so many as forty individuals, and appearing to be migrating, as they passed along at a height of fifty or sixty yards, without paying any attention to the objects below; but on all these occasions I could never find that they were bent on any general course more than another; as some days a flock would be proceeding southward, on the next to the northward or eastward. Many times have I seen them follow the grassy margins of our great streams, such as the Ohio and Mississippi, at the approach of winter, as if bent on going southward, but have become assured that they were merely attracted by the vast multitudes of Finches or Sparrows of various sorts which are then advancing in that direction.

In winter, the notes which the Marsh Hawk emits while on wing, are sharp, and sound like the syllables *pee, pee, pee,* the first slightly pronounced, the last louder, much prolonged, and ending plaintively. During the love-season, its cry more resembles that of our Pigeon Hawk, especially when the males meet, they being apparently tenacious of their assumed right to a certain locality, as well as to the female of their choice.

The Marsh Hawk breeds in many parts of the United States, as well as beyond our limits to the north and south in which it finds a place suited to its habits; as is the case with the Blue-winged Teal, and several other species, which have until now been supposed to retreat to high latitudes for the purpose. That many make choice of the more northern regions, and return southward in autumn, is quite certain; but in all probability an equal number remain within the confines of the United States to breed.

It is by no means restricted to the low lands of the sea-shores during the breeding season, for I have found its nest in the Barrens of Kentucky, and even on the cleared table-lands of the Alleghany Mountains and their spurs. In one instance, I found it in the high-covered pine-barrens of the Floridas, although I have never seen one on a tree; and the few cases of its nest having been placed on low trees or bushes, may have been caused by the presence of dangerous quadrupeds, or their having been more than once disturbed or robbed of their eggs or young, when their former nests had been placed on the ground.

Many birds of this species breed before they have obtained their full plumage. I have several times found a male bird in brown plumage paired with a female which had eggs; but such a circumstance is not singular, for the like occurs in many species of different families. I have never met with a nest in situations like those described by some European writers as those in which the Hen-Harrier breeds; but usually on level parts of the country, or flat pieces of land that are sometimes met with in hilly districts. As I am well aware, however, that birds adapt the place and even the form and materials of their nests to circumstances, I cannot admit that such a difference is by any means sufficient to prove that birds similar in all other respects, are really different from each other. If it be correct, as has been stated, that the male of the European bird deserts the female as soon as incubation commences, this indeed would form a decided difference; but as such a habit has not been observed in any other Hawk, it requires to be confirmed. Our Marsh Hawks, after being paired, invariably keep together, and labour conjointly for the support of their family, until the young are left to shift for themselves. This is equally the case with every Hawk with which I am acquainted.

Having considerable doubts as to whether any American writer who has

spoken of the Marsh Hawk ever saw one of its nests, I will here describe one found on Galveston Island by my son JOHN WOODHOUSE, and carefully examined by him as well as by my friend EDWARD HARRIS and myself. As is usually the case when in a low and flat district, this was placed about a hundred yards from a pond, on the ground, upon a broom-sedge ridge, about two feet above the level of the surrounding salt marsh. It was made of dry grass, and measured between seven and eight inches in its internal diameter, with a depth of two inches and a half, while its external diameter was twelve inches. The grass was pretty regularly and compactly disposed, especially in the interior, on which much care seemed to have been bestowed. No feathers or other materials had been used in its construction, not even a twig. The eggs were four, smooth, considerably rounded, or broadly elliptical, bluish-white, an inch and three-quarters in length, an inch and a quarter in breadth. The two birds were procured, and their measurements carefully entered in my journal, as well as those of others obtained in various parts of the United States and of the British Provinces. A nest found on the Alleghanies was placed under a low bush, in an open spot of scarcely half an acre. It was constructed in the same manner as the one described above, but was more bulky, the bed being about four inches from the earth. The eggs, although of the same form and colour, were slightly sprinkled with small marks of pale reddish-brown. In general, the Marsh Hawks scoop the ground, for the purpose of fixing their nest to the spot. On returning to London, in the summer of 1837, I shewed several of the eggs of the American bird to WILLIAM YARRELL, Esq., who at once pronounced them to belong to the Hen-Harrier; and on comparing their measurements with those of the eggs described by my friend WILLIAM MACGILLIVRAY, I find that they agree perfectly.

The young are at first covered with soft yellowish-white down, but in a few weeks shew the brownish and ferruginous tints of their female parent; the young males being distinguishable from the females by their smaller size.

I have found a greater number of barren females in this species than in any other; and to this I in part attribute their predominance over the males. The food of the Marsh Hawk consists of insects of various kinds, especially crickets, of small lizards, frogs, snakes, birds, principally the smaller sorts, although it will attack Partridges, Plovers, and even Green-winged Teals, when urged by excessive hunger. The only instance in which I have seen this bird carry any prey in its talons on wing, happened on the 2nd of April, 1837, at the South-West Pass of the Mississippi, when I was in company with EDWARD HARRIS, Esq. and my son JOHN WOODHOUSE. A Marsh Hawk was seen to seize a bird on its nest, perhaps a Marsh Wren, *Troglodytes palustris*, and carry it off in its talons with the nest! A pair were

hovering over the marsh during the whole of our stay, and probably had a nest thereabout. It is rather a cowardly bird however, for on several occasions when I was in the Floridas, where it is abundant, I saw it chase a Salt-water Marsh Hen, *Rullus crepitans*, which courageously sprung up, and striking at its enemy, forced it off. My friend JOHN BACHMAN has frequently observed similar occurrences in the neighbourhood of Charleston. Whenever it seizes a bird on wing, it almost at once drops to the ground with it, and if in an exposed place, hops off with its prey to the nearest concealment.

In autumn, after the young have left their parents, they hunt in packs. This I observed on several occasions when on my way back from Labrador. In Nova Scotia, on the 27th of August, we procured nearly a whole pack, by concealing ourselves, but did not see an adult male. These birds are fond of searching for prey over the same fields, removing from one plantation to another, and returning with a remarkable degree of regularity, and this apparently for a whole season, if not a longer period. My friend JOHN BACHMAN observed a beautiful old male, which had one of its primaries cut short by a shot, regularly return to the same rice-field during the whole of the autumn and winter, and believes that the same individual revisits the same spot annually. When satiated with food, the Marsh Hawk may be seen perched on a fence-stake for more than an hour, standing motionless. On horseback I have approached them on such occasions near enough to see the colour of their eyes, before they would reluctantly open their wings, and remove to another stake not far distant, where they would probably remain until digestion was accomplished.

I have never seen this species searching for food in the dusk. Indeed, in our latitudes, when the orb of day has withdrawn from our sight, the twilight is so short, and the necessity of providing a place of safety for the night so imperious in birds that are not altogether nocturnal, that I doubt whether the Marsh Hawk, which has perhaps been on wing the greater part of the day, and has had many opportunities of procuring food, would continue its flight for the sake of the scanty fare which it might perchance procure at a time when few birds are abroad, and when quadrupeds only are awakening from their daily slumber.

WILSON must have been misinformed by some one acquainted with the arrival and departure of this species, as well as of the Rice Bird, in South Carolina, when he was induced to say that the Marsh Hawk "is particularly serviceable to the rice-fields of the Southern States, by the havoc it makes among the clouds of Rice Buntings that spread such devastation among the grain, in its early stages. As it sails low, and swiftly, over the surface of the field, it keeps the flocks in perpetual fluctuation, and greatly interrupts

Pl. 27.

Hawk Owl.

Drawn from Nature by J. J. Audubon. F.R.S.F.L.S.

Lith⁴ Printed & Col⁴ by J. T. Bowen. Philad⁴

Harvard Natural History
Society.

Pl. 28

Snowy Owl.

Hawk Owl, *Strix funerea*, Nutt. Man., vol. i. p. 115.
Hawk Owl, *Strix funerea*, Aud. Orn. Biog., vol. iv. p. 550.

Male and Female.

Tail long, much rounded, the lateral feathers two inches shorter than the middle. Upper part of head brownish-black, closely spotted with white, hind neck black, with two broad longitudinal bands of white spots; rest of upper parts dark brown, spotted with white; tail with eight transverse bars of white, the feathers tipped with the same; facial disks greyish-white, margined with black; lower parts transversely barred with brown and dull white.

Male, 15¾, 31½. Female, 17½.

THE SNOWY OWL.

Surnia nyctea, *Linn.*

PLATE XXVIII.—Male and Female.

This beautiful bird is merely a winter visitor of the United States, where it is seldom seen before the month of November, and whence it retires as early as the beginning of February. It wanders at times along the sea coast, as far as Georgia. I have occasionally seen it in the lower parts of Kentucky, and in the State of Ohio. It is more frequently met with in Pennsylvania and the Jerseys; but in Massachusetts and Maine it is far more abundant than in any other parts of the Union.

The Snowy Owl hunts during the day, as well as in the dusk. Its flight is firm and protracted, although smooth and noiseless. It passes swiftly over its hunting ground, seizes its prey by instantaneously falling on it, and generally devours it on the spot. When the objects of its pursuit are on wing, such as ducks, grouse, or pigeons, it gains upon them by urging its speed, and strikes them somewhat in the manner of the Peregrine Falcon. It is fond of the neighbourhood of rivers and small streams, having in their course cataracts or shallow rapids, on the borders of which it seizes on fishes, in the manner of our wild cat. It also watches the traps set for musk-rats, and devours the animals caught in them. Its usual food, while it remains with us, consists of hares, squirrels, rats, and fishes, portions of all of which I have found in its stomach. In several fine specimens which I examined immediately after being killed, I found the stomach to be extremely thin,

and shot. It proved to be a fine old female, the plumage of which was almost pure white. I have heard of individuals having been seen as far down the Mississippi as the town of Memphis. Some Indians assured me that they had shot one at the mouth of the Red River; and, while on the Arkansas River, I was frequently told of a large White Owl that had been seen there during winter.

So much has been said to me of its breeding in the northern parts of the State of Maine, that this may possibly be correct. In Nova Scotia they are abundant at the approach of winter; and Professor MacCulloch, of the University of Pictou, shewed me several beautiful specimens in his fine collection of North American birds. Of its place and mode of breeding I know nothing; for, although every person to whom I spoke of this bird while in Labrador knew it, my party saw none there; and in Newfoundland we were equally unsuccessful in our search.

STRIX NYCTEA, Linn. Syst. Nat., vol. i. p. 132. Lath., Index Ornith., vol. i. p. '57.
 Ch. Bonaparte, Synops. of Birds of the United States, p. 36. Swains. and Richards.
 Fauna Bor. Americ., vol. i. p. 88.
SNOWY OWL, *Strix nyctea*, Wils. Amer. Orn., vol. iv. p. 53, pl. xxxii. fig. 1. Nutt. Man.,
 vol. i. p. 116.

Male and Female.
Tail rather long, moderately rounded; plumage white; head and back spotted; wings, tail, and lower parts barred with dusky brown. Young pure white. Individuals vary much in markings.
Male, 21, 53. Female, 26, 65.

————

LITTLE NIGHT OWL.

SURNIA PASSERINA, *Linn.*

PLATE XXIX.

The specimen from which my drawing of this bird was taken, was procured near Pictou in Nova Scotia, by my young friend THOMAS M'CULLOCH, Esq., who assured me that it is not very uncommon there. How far southward it may proceed in winter I have not been able to ascertain; nor have I ever met with it in any part of the United States. It is also said to be abundant in Newfoundland, and not rare in Labrador. My specimen is a female, and was shot in winter.

R.T

Little Night-Owl.

Drawn from Nature by J.J.Audubon F.R.S.F.L.S Lith.ᵈ Printed & Col.ᵈ by J.T. Bowen Philad.ᵃ

Harvard Natural History
Society

Harvard Natural History
Society.

Columbian Day Owl.

Drawn from Nature by J.J. Audubon F.R.S. F.L.S. Lith Printed & Cold by J.T. Bowen Philad

STRIX PASSERINA, Linn. Syst. Nat., vol. i. p. 133.
CHOUETTE CHEVECHE, *Strix passerina*, Temm. Man. d'Orn., p. 92.
LITTLE NIGHT OWL, *Strix passerina*, Aud., vol. v. p. 269.

Female.

Tail rather short, arched, nearly even; wings almost as long as the tail, the outer four quills cut out on the inner web, the outer five sinuated on the outer; filaments of the first free and slightly recurved, as are those of the second and third beyond the sinus. General colour of upper parts chocolate-brown, the feather of the head with an oblong median white mark; hind neck with very large white spots, forming a conspicuous patch; on the back most of the feathers with a single large subterminal roundish spot, as is the case with the scapulars and wing-coverts, most of which, however, have two or more spots; quills with marginal reddish-white spots on both webs, the third with six on the outer and four on the inner, with two very faint pale bars toward the end; the tail similarly marked with four bands of transversely oblong, reddish-white spots; feathers of the anterior part of the disk whitish, with black shafts, of the lower part whitish, of the hind part brown, tipped with greyish-white; a broad band of white crossing the throat, and curving upwards on either side to the ear; a patch of white on the lower part of the fore-neck; between these a brownish-grey band. Lower parts dull yellowish-white, each feather with a broad longitudinal band of chocolate-brown; abdomen and lower tail-coverts unspotted; tarsal feathers dull white.

Female, 10¼; wing from flexure 6¼; tail 3¾.

LITTLE COLUMBIAN OWL.

SURNIA PASSERINOIDES, *Temm.*

PLATE XXX.—MALE.

Of this pretty little Owl I can only say that the single specimen from which I made the two figures in the plate before you, was sent to me by Mr. TOWNSEND, along with the following notice respecting it:—"I shot this bird on the Columbia river, near Fort Vancouver, in the month of November. I first saw it on wing about mid-day, and its curious jerking or undulating flight struck me as extremely peculiar, and induced me to follow and secure it. It soon alighted upon a high branch of a pine tree, and I shot it with my rifle, the only gun I had with me, as I was at the time engaged in

shooting cranes along the banks of the river. The specimen is somewhat mutilated, in consequence of having lost one wing by the ball. The stomach contained nearly the whole body of a Ruby-crowned Wren, with a few small remnants of beetles and worms. It was a male; its irides bright yellow; and it measured 7 inches in length. The tail is exactly 3 inches long, and extends 2¼ inches beyond the closed wings."

I have seen several specimens of this Owl in the Edinburgh Museum, which had also been sent from Fort Vancouver by Dr. MERIDETH GAIRD-NER.

CHEVECHE CHEVECHOIDE, *Strix passerinoides,* Temm. Pl. Col. 344.
LITTLE COLUMBIAN OWL, *Strix passerinoides,* Aud. Orn. Biog., vol. v. p. 271.

Male.

Tail of moderate length, straight, slightly rounded; wings rather short, much rounded, fourth quill longest, outer three abruptly cut out on the inner web, the first with its filaments thickened but not recurvate, those of the second and third also thickened toward the end. General colour of the upper parts olivaceous brown; the head with numerous small, roundish, yellowish-white spots, margined with dusky, of which there are two on each feather; the rest of the upper parts marked with larger, angular, whitish spots; the quills generally with three small and five large white spots on the outer and inner webs; the tail barred with transversely oblong white spots, of which there are seven pairs on the middle feathers. Facial disk brown, spotted with white; throat white, then a transverse brown band, succeeded by white; the lower parts white, with longitudinal brownish-black streaks; the sides brown, faintly spotted with paler. Young with the upper parts rufous, the head with fewer and smaller white spots; those on the lower part of the hind neck very large; the back, scapulars, and wing-coverts unspotted; the wings marked as in the adult, but with pale red spots in the outer, and reddish-white on the inner webs; the tail with only five bands of spots; the lower parts white, longitudinally streaked with light red, of which colour are the sides of the body and neck, and a band across the throat.

Male, 7; wing 3¼½.

BURROWING OWL.

Surnia cunicularia, *Gmel.*

PLATE XXXI.—Male and Female.

This singular species was added to our Fauna by Mr. Thomas Say, who met with it in the course of Colonel Long's expedition to the Rocky Mountains. The observations of that zealous naturalist have been published in the first volume of the Continuation of Wilson's American Ornithology by the Prince of Musignano, and will be repeated below, after I have presented you with the notice transmitted to me by my friend Mr. Townsend. He says:—

"This species inhabits the plains near the Columbia river and the whole extent of the Rocky Mountains, residing in the forsaken burrows of the Marmots and American Badgers, but never lives on terms of intimacy with either of these animals, as has been so often stated. The burrow selected by this bird is usually found at the foot of a wormwood bush (*Artemisia*), upon the summit of which this Owl often perches, and stands for a considerable while. On their being approached, they utter a low chattering sound, start, and skim along the plain near the ground for a considerable distance. When winged, they make immediately for the nearest burrow; and when once within it, it is impossible to dislodge them. They are strictly diurnal, feed principally upon grasshoppers and crickets, and, according to the Indians, sometimes upon field-mice. The nest is composed of fine grass, and placed at the extremity of the hole. The eggs are uniformly four in number, pale white, and about the size of those of the common House-Pigeon, the great end, however, being remarkably large, and tapering abruptly. Nothing can be more unpleasant than the bagging of this species, on account of the fleas with which their plumage swarms, and which in all probability have been left in the burrow by the Badger or Marmot, at the time it was abandoned by these animals. I know of no other bird infested by that kind of vermin. This species suddenly disappears in the early part of the month of August, and the Indians assert with great confidence that it retires into its burrow, and spends the winter there in a torpid state."

Mr. Say's account, as presented in the Continuation of Wilson's American Ornithology, is as follows:—"In the Trans-Mississippian territories of the United States, the Burrowing Owl resides exclusively in the villages of the Marmot or Prairie Dog, whose excavations are so commodious as to render

Burrowing Day-Owl.

Drawn from Nature by J. J. Audubon, F.R.S.E.L.S. Lith⁴ Printed & Col⁴ by J. T. Bowen Philad⁴

one burrow, yet we are well assured by PIKE and others, that a common danger often drives them into the same excavation, where lizards and rattle-snakes also enter for concealment and safety.

The note of our bird is strikingly similar to the cry of the Marmot, which sounds like *cheh, cheh,* pronounced several times in rapid succession. Its food appears to consist entirely of insects, as, on examination of its stomach, nothing but parts of their hard wing-cases were found.

BURROWING OWL, *Strix cunicularia*, Say, in Long's Exped., vol. i. p. 200.
BURROWING OWL, *Strix cunicularia*, Bonap. Amer. Orn., vol. i. p. 68.
BURROWING OWL, *Strix cunicularia*, Aud. Orn. Biog., vol. v. p. 264.
BURROWING OWL, *Strix cunicularia*, Nutt. Man., vol. i. p. 118.

Feet rather long, slender; tarsus covered with short soft feathers, of which the shafts only remain toward the lower part; toes short, their upper surface covered with bristles or the shafts of feathers; tail short, arched, narrow, slightly rounded. Bill greyish-yellow; claws black. General colour of upper parts light yellowish-brown, or umber-brown, spotted with white; the quills with triangular reddish-white spots from the margins of both webs, there being five on each web of the first; the tail similarly barred, there being on the middle feathers four double spots, and the tips of all white. Face greyish-white; throat and ruff white, succeeded by a mottled brown band, beneath which is a patch of white; the rest of the lower parts yellowish-white, with broad bars of light reddish-brown, which are closer on the sides of the breast; abdomen, lower tail-coverts, and legs without spots.

Male, 10, 24. Female, 11.

GENUS II.—ULULA. NIGHT-OWL.

Bill short, strong, very deep, its upper outline decurved from the base; lower mandible abruptly rounded, with a notch on each side. Nostrils broadly elliptical, rather large. Conch of ear very large, elliptical, extending from the base of the lower jaw to near the top of the head, with an anterior semicircular operculum in its whole length. Feet rather short, strong; tarsi and toes covered with very soft downy feathers. Plumage full, and very soft; facial disks complete. Wings rather long, very broad, much rounded, the third quill longest; the filaments of the first, half of the second, and the terminal part of the third, free and recurved. Tail of moderate length, arched, slightly rounded.

Tengmalm's Night-Owl.

Drawn from Nature by J.J.Audubon F.R.S.F.L.S. Lithᵈ Printed & Colᵈ by J.T.Bowen. Philadᵃ

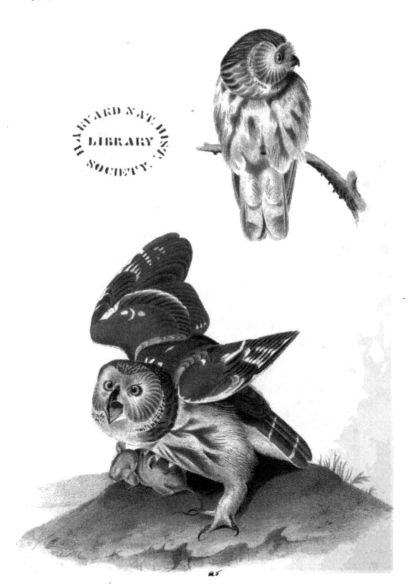

Little or Acadian Owl.

Common Mouse.

Drawn from Nature by J. J. Audubon F.R.S.F.L.S.

Lithd Printed & Cold by J. T. Bowen, Philada

THE LITTLE OR ACADIAN OWL.

ULULA ACADICA, *Gmel.*

PLATE XXXIII.—MALE AND FEMALE.

This lively and beautiful little Owl is found in almost every portion of the United States. I have observed it breeding in Louisiana, Kentucky, and along our Eastern States, as far as Maine, where, however, it becomes scarce, being, as it were, replaced by the Tengmalm Owl, which I have seen as far south as Bangor, in Maine. It is rare in the lower parts of South Carolina, where indeed my friend BACHMAN never observed it.

The Little Owl is known in Massachusetts by the name of the "Saw-whet," the sound of its love-notes bearing a great resemblance to the noise produced by filing the teeth of a large saw. These notes, when coming, as they frequently do, from the interior of a deep forest, produce a very peculiar effect on the traveller, who, not being aware of their real nature, expects, as he advances on his route, to meet with shelter under a saw-mill at no great distance. Until I shot the bird in the act, I had myself been more than once deceived in this manner. On one particular occasion, while walking near my saw-mill in Pennsylvania, to see that all was right there, I was much astonished to hear these sounds issuing from the interior of the grist-mill. The door having been locked, I had to go to my miller's house close by, to inquire if any one was at work in it. He, however, informed me that the sounds I had heard were merely the notes of what he called the Screech Owl, whose nest was close by, in a hollow tree, deserted by the Wood Ducks, a pair of which had been breeding there for several years in succession.

I have been thus particular in relating the above circumstance, from a desire to know if the European Little Owl (*Strix passerina*) emits the same curious sounds. The latter is said by several authors of eminence to lay only two white eggs, while I know, from my own observation, that ours has three, four, or five, and even sometimes six. The eggs are glossy-white, and of a short elliptical form, approaching to globular. It often takes the old nest of the Common Crow to breed in, and also lays in the hollows of trees a few feet above the ground. A nest of our Little Owl, which I found near the city of Natchez, was placed in the broken stump of a small decayed tree, not more than four feet from the ground. I was attracted to it by the snoring notes of the young, which sounded as if at a considerable elevation; and I was so misled by them that, had not my dog raised himself to smell at

the hole where the brood lay concealed, I might not have discovered them. In this instance the number was five. It was in the beginning of June, and the little things, which were almost ready to fly, looked exceedingly neat and beautiful. The Little Owl breeds more abundantly near the shores of the Atlantic than in the interior of the country, and is frequent in the swamps of the States of Maryland and New Jersey, during the whole year. Wherever I have found the young or the eggs placed in a hollow tree, they were merely deposited on the rotten particles of wood; and when in an old Crow's nest, the latter did not appear to have undergone any repair.

This species evinces a strong and curious propensity to visit the interior of our cities. I have known some caught alive in the Philadelphia Museum, as well as in that of Baltimore; and, whilst at Cincinnati, I had one brought to me which had been taken from the edge of a cradle, in which a child lay asleep, to the no small astonishment of the mother.

Being quite nocturnal, it shews great uneasiness when disturbed by day, and flies off in a hurried uncertain manner, throwing itself into the first covert it meets with, where it is not difficult to catch it, provided the necessary caution and silence be used. Towards dusk it becomes full of animation, flies swiftly, gliding, as it were, over the grounds, like a little spectre, and pounces on small quadrupeds and birds with the quickness of thought. Its common cry at night resembles that of the European Scops Owl, but is more like the dull sounds of a whistle than that of Owls generally is.

My friend Mr. T. MacCulloch, jun., has favoured me with the following curious notice respecting this bird. "In the beginning of April, when the snow was still lying in large patches in the woods, although it had entirely disappeared from the clear lands, I went out with my gun one afternoon, expecting to obtain some of the small birds which remove to the north on the first approach of spring. Having wandered about four miles from home without meeting with any thing worthy of notice, I had almost determined to return, when my attention was arrested by a sound which at first seemed to me like the faint tones of a distant bell. The resemblance was so exceedingly strong that I believe the mistake would not have been detected, had not a slight variation in it induced me to listen more attentively, and mark the direction in which it seemed to come. With the view of ascertaining its origin if possible, I crossed an intervening farm, and striking into a dense spruce wood, directed my course towards the point from which it seemed to proceed. Whilst listening to the singular note, the accounts which I had seen of the *Turdus tinniens* or Bell-bird of the southern portion of the continent forcibly recurred to my mind, and rendered me doubly eager to discover its source. This, however, I found to be no easy matter. After proceeding a considerable distance in the woods the sound became suddenly

sharp and shrill, and seemed so close behind me that I started involuntarily. Having carefully examined all the adjacent trees without success, I was about giving it up in despair, when the note which first attracted my attention seemed to come in the former direction. Before I had advanced many steps, the sound changed as before; at one moment it seemed behind me, the next upon the right hand, then upon the left, and then it resumed its former distant mellow tone. This occurred so often, that I was completely puzzled and tempted to give up the pursuit, but still the desire of finding out the origin of the sound urged me on. After proceeding a considerable distance farther, I found that the bell-like sound now came from the opposite direction, and seemed far beyond the spot where I first heard it. Retracing my steps I entered a small cleared spot, in the centre of which stood a black birch, whose dead and decayed top projected beyond a vigorous growth of fresh branches, by which its sides were clothed. As I seated myself upon a prostrate log, the shrill note was suddenly resumed, and from the direction of the sound I was convinced that it proceeded from the birch tree. Almost breathless with expectation, I carefully examined the tree from top to bottom, but the secret still remained concealed. Moving cautiously round, I examined the other side of the tree, but with no better success, until going to the root, and directing my eye along the trunk, I observed a small protuberance, which at first appeared to be a knot. Inspecting it more closely, however, I found it to be the head of the Little Grey Owl, protruded from a small aperture, which probably formed the entrance of its nest. Though standing directly beneath the bird, it did not seem to observe me, but continued to call for its mate. While watching the Owl, I observed with no little surprise that the sound which I thought came from a distance, as well as that which was near, actually proceeded from the same source. This singular power of altering the voice I have never found in any other bird, and to me it appeared analogous to that by which ventriloquists are able to make the voice seem near or remote. Having enjoyed the pleasing deception for some time, I left the little performer unmolested, feeling abundantly recompensed for my long tramp through mire and slush by the curious discovery. This was the only time I ever heard the note of this Owl. Frequently I have had it alive, but it was invariably silent, and, like the *Strix flammea,* would sometimes feign itself dead; and last winter I shot one which was placed upon its back in a scale, and handled a good deal, yet it shewed no signs of life until thrown into a box, when it started up, and looked about sharply enough."

In all parts of the United States where this species occurs it is a permanent resident.

LITTLE OWL, *Strix passerina*, Wils. Amer. Orn., vol. iv. p. 61.
STRIX ACADICA, Bonap. Syn. p. 38.
STRIX ACADICA, AMERICAN SPARROW OWL, Swains. and Rich. F. Bor. Amer., vol. ii. p. 97.
ACADIAN OWL, *Strix acadica*, Nutt. Man., vol. i. p. 137.
LITTLE or ACADIAN OWL, *Strix acadica*, Aud. Orn. Biog., vol. ii. p. 567; vol. v. p. 397.

General colour of upper part olivaceous brown; scapulars and some of the wing-coverts spotted with white; the first six primary quills obliquely barred with white; tail darker, with two narrow white bars; upper part of head streaked with greyish-white; disks pale yellowish-grey; ruff white, spotted with dusky. Lower parts whitish, the sides and breast marked with broad elongated patches of brownish-red.

Male, 7½, 17. Female, 8½, 18.

GENUS III.—STRIX, *Linn.* SCREECH-OWL.

Bill short, compressed, deep, strong; upper mandible with is dorsal outline straight to the end of the cere, then curved, the sides nearly flat and erect, the tip deflected, with a rounded but sharp-edged point; lower mandible with the dorsal line convex, the sides convex, the edges arched, the tip obliquely truncate. Conch of the ear semicircular, extending from over the anterior angle of the eye to the middle of the lower jaw; aperture large, somewhat square, with an anterior operculum fringed with feathers. Legs rather long, tarsus long, feathered, scaly at the lower part; toes large, the first short, the inner nearly as long as the middle, all with series of small tuberculiform oblong scales, intermixed with a few bristles, and three broad scutella at the end. Claws arched, long, extremely sharp, the edge of the third thin and transversely cracked in old birds. Plumage very soft and downy; facial disks complete. Wings long, ample, rounded; the first quill with the filaments recurved. Tail rather short, even.

Howard Natural History
Society.

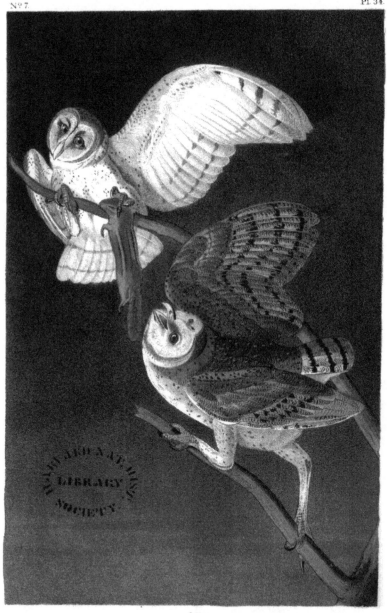

25

Barn Owl.

Drawn from Nature by J. J. Audubon F.R.G.F.L.S. Lithd Printed & Cold by J. T. Bowen Philad.a

Nº 7.

THE BARN OWL.

Strix Americana, *Aud.*

PLATE XXXIV.—Male and Female.

The Barn Owl of the United States is far more abundant in the Southern Districts than in the other parts. I never found it to the east of Pennsylvania, and only twice in that State, nor did I ever see, or even hear of one in the Western Country; but as soon as I have reached the maritime districts of the Carolinas, Georgia, the Floridas, and all along to Louisiana, the case has always been different. In Cuba they are quite abundant, according to the reports which I have received from that island. During my visit to Labrador I neither saw any of these birds, nor found a single person who had ever seen them, although the people to whom I spoke were well acquainted with the Snowy Owl, the Grey Owl, and the Hawk Owl.

Thomas Butler King, Esq., of St. Simon's Island, Georgia, sent me two very beautiful specimens of this Owl, which had been caught alive. One died shortly after their arrival at Charleston; the other was in fine order when I received it. The person to whose care they were consigned, kept them for many weeks at Charleston before I reached that city, and told me that in the night their cries never failed to attract others of the same species, which he observed hovering about the place of their confinement.

This species is altogether nocturnal or crepuscular, and when disturbed during the day, flies in an irregular bewildered manner, as if at a loss how to look for a place of refuge. After long observation, I am satisfied that our bird feeds entirely on the smaller species of quadrupeds, for I have never found any portions of birds about their nests, nor even the remains of a single feather in the pellets which they regurgitate, and which are always formed of the bones and hair of quadrupeds.

Owls which approach to the diurnal species in their habits, or which hunt for food in the morning and evening twilight, are apt to seize on objects which are themselves more diurnal than those which I have found to form the constant food of our Barn Owl. Thus the Short-eared, the Hawk, the Fork-tailed, the Burrowing, and other Owls, which hunt either during broad day, towards evening, or at the return of day, will be found to feed more on diurnal animals than the present species. I have no doubt that the anatomist will detect corresponding differences in the eye, as they have already been found in the ear. The stomach is elongated, almost smooth, and of a deep

Genus IV.—SYRNIUM, *Cuv.* HOOTING-OWL.

Bill short, stout, broad at the base; upper mandible with its dorsal outline convex to the end of the cere, then curved, the sides sloping and nearly flat, the tip compressed, decurved, acute; lower mandible small, with the dorsal line convex, the tip narrow, the edges decurved toward the end. Nostrils large, elliptical. Conch of the ear of medium size, and furnished with an anterior semicircular operculum, beset with slender feathers. Legs rather short; tarsi very short, and with the toes feathered. Claws slightly curved, long, slender, compressed, acuminate. Plumage very soft and downy; facial disks complete. Wings very large, much rounded, the outer quill with the tips of the filaments separated and recurved, as are those of the terminal portion of the next; the outer six with the inner webs sinuate. Tail broad, rounded.

GREAT CINEREOUS OWL.

Syrnium cinereum, *Linn.*

PLATE XXXV.

This fine Owl, which is the largest of the North American species, is nowhere common with us, although it ranges from the north-eastern coast of the United States to the sources of the Columbia river. It has been procured near Eastport in Maine, and at Marblehead in Massachusetts, where one of them was taken alive, perched on a wood pile, early in the morning, in February, 1831. I went to Salem for the purpose of seeing it, but it had died, and I could not trace its remains. The gentleman, Mr. Ives, in whose keeping it had been for several months, fed it on fish and small birds, of which it was very fond. Besides shewing me various marks of attention, he gave me a drawing of it made by his wife, which is still in my possession. It uttered at times a tremulous cry not unlike that of the Little Screech Owl, *Strix Asio*, and shewed a great antipathy to cats and dogs. In the winter of 1832, I saw one of these Owls flying over the harbour of Boston, Massachusetts, amid several Gulls, all of which continued teasing it until it disappeared. I have seen specimens procured on the Rocky Mountains by Mr.

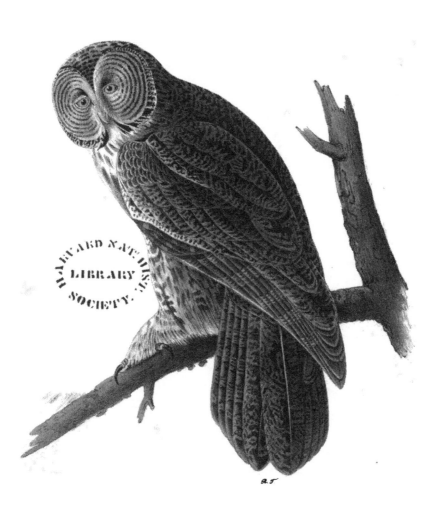

Great Cinereous Owl.

Drawn from Nature by J.J. Audubon F.R.S.F.L.S. Lith⁴ Printed & Col⁴ by J.T. Bowen Philad⁴

TOWNSEND, and several brought to London by the medical officer who accompanied Captain BACK in his late Arctic journey. Among the individuals which I have examined I have found considerable differences as to size and markings, which may be attributed to age and sex. My drawing was taken from a remarkably fine specimen in the collection of the Zoological Society of London.

The comparatively small size of this bird's eyes renders it probable that it hunts by day, and the remarkable smallness of its feet and claws induces me to think that it does not prey on large animals. Dr. RICHARDSON says that "it is by no means a rare bird in the Fur Countries, being an inhabitant of all the woody districts lying between Lake Superior and latitudes 67° or 68°, and between Hudson's Bay and the Pacific. It is common on the borders of Great Bear Lake; and there, and in the higher parallels of latitude, it must pursue its prey, during the summer months, by day-light. It keeps however within the woods, and does not frequent the barren grounds, like the Snowy Owl, nor is it so often met with in broad day-light as the Hawk Owl, but hunts principally when the sun is low; indeed, it is only at such times, when the recesses of the woods are deeply shadowed, that the American hare and the murine animals, on which the Cinereous Owl chiefly preys, come forth to feed. On the 23d of May I discovered a nest of this Owl, built on the top of a lofty balsam poplar, of sticks, and lined with feathers. It contained three young, which were covered with a whitish down. We got them by felling the tree, which was remarkably thick; and whilst this operation was going on, the two parent birds flew in circles round the objects of their cares, keeping, however, so high in the air as to be out of gunshot; they did not appear to be dazzled by the light. The young ones were kept alive for two months, when they made their escape. They had the habit, common also to other Owls, of throwing themselves back, and making a loud snapping noise with their bills, when any one entered the room in which they were kept."

GREAT GREY OF CINEREOUS OWL, *Strix cinerea*, Nutt. Man., vol. i. p. 128.
CINEREOUS OWL, *Strix cinerea*, Swains. and Rich., F. Bor. Amer., vol. ii. p. 77.
GREAT CINEREOUS OWL, *Strix cinerea*, Aud. Orn. Biog., vol. iv. p. 364.

Upper parts greyish-brown, variegated with greyish-white in irregular undulated markings; the feathers on the upper part of the head with two transverse white spots on each web; the smaller wing-coverts of a darker brown, and less mottled than the back; the outer scapulars with more white on their outer webs; primaries blackish-brown toward the end, in the rest of their extent marked with a few broad light-grey oblique bands, dotted and

undulated with darker; tail similarly barred; ruff-feathers white toward the
end, dark brown in the centre; disks on their inner sides grey, with black
tips, in the rest of their extent greyish-white, with six bars of blackish-brown
very regularly disposed in a concentric manner; lower parts greyish-brown,
variegated with greyish and yellowish-white; feet barred with the same.

Female, 30½, 48½.

———

THE BARRED OWL.

Syrnium nebulosum, *Linn.*

PLATE XXXVI.—Male.

Should you, kind reader, visit the noble forests of the lower parts of the
State of Louisiana, about the middle of October, when nature, on the eve of
preparing for approaching night, permits useful dews to fall and rest on
every plant, with the view of reviving its leaves, its fruits, or its lingering
blossoms ere the return of morn; when every night-insect rises on buzzing
wings from the ground, and the fire-fly, amidst thousands of other species,
appears as if purposely to guide their motions through the sombre atmosphere;
when numerous reptiles and quadrupeds commence their nocturnal prowl-
ings, and the fair moon, empress of the night, rises peacefully on the distant
horizon, shooting her silvery rays over the heavens and the earth, moving
slowly and majestically along; when the husbandman, just returned to his
home, after the labours of the day, is receiving the cheering gratulations of
his family, and the wholesome repast is about to be spread out;—it is at this
moment, kind reader, that your ear would suddenly be struck by the dis-
cordant screams of the Barred Owl. Its *whah, whah, whah, whah-aa* is
uttered loudly, and in so strange and ludicrous a manner, that I should not
be surprised were you to compare these sounds to the affected bursts of
laughter which you may have heard from some of the fashionable members
of our own species.

How often, when snugly settled under the boughs of my temporary
encampment, and preparing to roast a venison steak or the body of a squirrel,
have I been saluted with the exulting bursts of this nightly disturber of
the peace, that, had it not been for him, would have prevailed around me,
as well as in my lonely retreat! How often have I seen this nocturnal
marauder alight within a few yards of me, expose his whole body to the
glare of my fire, and eye me in such a curious manner that, had it been

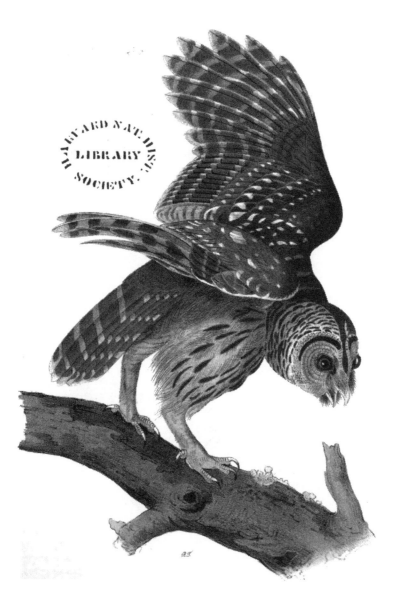

Barred Owl.

Drawn from Nature by J. J. Audubon F.R.S.F.L.S. Lith. Printed & Cold by J. T. Bowen Philada.

Harvard Natural History Society.

reasonable to do so, I would gladly have invited him to walk in and join me in my repast, that I might have enjoyed the pleasure of forming a better acquaintance with him. The liveliness of his motions, joined to their oddness, have often made me think that his society would be at least as agreeable as that of many of the buffoons we meet with in the world.

Such persons as conclude, when looking upon Owls in the glare of day, that they are, as they then appear, extremely dull, are greatly mistaken.

The Barred Owl is found in all those parts of the United States which I have visited, and is a constant resident. In Louisiana it seems to be more abundant than in any other state. It is almost impossible to travel eight or ten miles in any of the retired woods there, without seeing several of them even in broad day; and, at the approach of night, their cries are heard proceeding from every part of the forest around the plantations. Should the weather be lowering, and indicative of the approach of rain, their cries are so multiplied during the day, and especially in the evening, and they respond to each other in tones so strange, that one might imagine some extraordinary fête about to take place among them. On approaching one of them, its gesticulations are seen to be of a very extraordinary nature. The position of the bird, which is generally erect, is immediately changed. It lowers its head and inclines its body, to watch the motions of the person beneath, throws forward the lateral feathers of its head, which thus make the appearance of being surrounded by a broad ruff, looks towards him as if half blind, and moves its head to and fro in so extraordinary a manner, as almost to induce a person to fancy that part dislocated from the body. It follows all the motions of the intruder with its eyes; and should it suspect any treacherous intentions, flies off to a short distance, alighting with its back to the person, and immediately turning about with a single jump, to recommence its scrutiny. In this manner, the Barred Owl may be followed to a considerable distance, if not shot at, for to halloo after it does not seem to frighten it much. But if shot at and missed, it moves to a considerable distance, after which its *whah-whah-whah* is uttered with considerable pomposity. This Owl will answer the imitation of its own sounds, and is frequently decoyed by this means.

The flight of these Owls is smooth, light, noiseless, and capable of being greatly protracted. Once, whilst descending the Ohio, not far from the well-known *Cave-in-rock*, about two hours before sunset, in the month of November, I saw a Barred Owl teased by several Crows, and chased from the tree in which it was. On leaving the tree, it gradually rose in the air, in the manner of a Hawk, and at length attained so great a height that our party lost sight of it. It acted, I thought, as if it had lost itself, now and then describing small circles, and flapping its wings quickly, then flying in

extremely soft and downy, facial disks complete, ruff distinct. Two small tufts of elongated feathers on the head. Wings long and broad; the second quill longest; the outer in its whole length, the second toward the end, and the first alular feather with the filaments disunited and recurved at the ends. Tail rather short, a little rounded.

LONG-EARED OWL.

OTUS VULGARIS, *Fleming.*

PLATE XXXVII.—MALE.

This Owl is much more abundant in our Middle and Eastern Atlantic Districts than in the Southern or Western parts. My friend Dr. BACHMAN has never observed it in South Carolina; nor have I met with it in Louisiana, or any where on the Mississippi below the junction of the Ohio. It is not very rare in the upper parts of Indiana, Illinois, Ohio, and Kentucky, wherever the country is well wooded. In the Barrens of Kentucky its predilection for woods is rendered apparent by its not being found elsewhere than in the "Groves;" and it would seem that it very rarely extends its search for food beyond the skirts of those delightful retreats. In Pennsylvania, and elsewhere to the eastward, I have found it most numerous on or near the banks of our numerous clear mountain streams, where, during the day, it is not uncommon to see it perched on the top of a low bush or fir. At such times it stands with the body erect, but the tarsi bent and resting on a branch, as is the manner of almost all our Owls. The head then seems the largest part, the body being much more slender than it is usually represented. Now and then it raises itself and stands with its legs and neck extended, as if the better to mark the approach of an intruder. Its eyes, which were closed when it was first observed, are opened on the least noise, and it seems to squint at you in a most grotesque manner, although it is not difficult to approach very near it. It rarely on such occasions takes to wing, but throws itself into the thicket, and makes off on foot by means of pretty long leaps.

The Long-eared Owl is careless as to the situation in which its young are to be reared, and generally accommodates itself with an abandoned nest of some other bird that proves of sufficient size, whether it be high or low, in the fissure of a rock or on the ground. Sometimes however it makes a nest itself, and this I found to be the case in one instance near the Juniata river in Pennsylvania, where it was composed of green twigs with the leaflets

Pl.37.

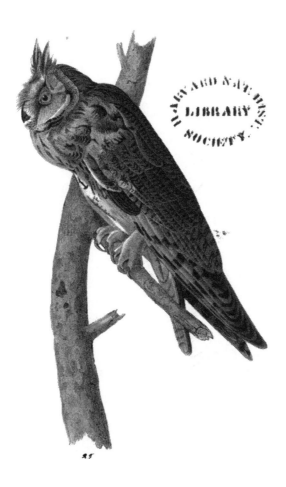

Long-eared Owl.

Drawn from Nature by J.J. Audubon F.R.S.F.L.S.

Lith.d Printed & Cold by J.T. Bowen, Philad.a

Harvard Natural History
Society.

adhering, and lined with fresh grass and sheep wool, but without feathers. The eggs are usually four, nearly equally rounded at both ends, thin-shelled, smooth, when newly deposited pure white, with a slight blush, which is no longer observable when they have been for some time sitten upon; their average length an inch and a half, their greatest breadth an inch and three-sixteenths. I found eggs of this bird on the 15th of April, and again on the 25th of June, which induces me to believe that it rears two broods in the season in the State of Pennsylvania, as it probably does also to the westward. WILSON relates the following instance of its indifference as to the place selected for its eggs. "About six or seven miles below Philadelphia, and not far from the Delaware, is a low swamp, thickly covered with trees, and inundated during great part of the year. This place is the resort of great numbers of the Qua-bird or Night Raven (*Ardea Nycticorax*), where they build in large companies. On the 25th of April, while wading among the dark recesses of this place, observing the habits of these birds, I discovered a Long-eared Owl, which had taken possession of one of their nests, and was sitting: on mounting to the nest, I found it contained four eggs, and breaking one of these, the young appeared almost ready to leave the shell. There were numbers of the Qua-birds' nests on the adjoining trees all around, and one of them actually on the same tree."

When encamped in the woods, I have frequently heard the notes of this bird at night. Its cry is prolonged and plaintive, though consisting of not more than two or three notes repeated at intervals.

Dr. RICHARDSON states that it has been found "as far north as lat. 60°, and probably exists as high as the forests extend. It is plentiful in the woods skirting the plains of the Saskatchewan, frequents the coasts of Hudson's Bay only in the summer, and retires into the interior in the winter. It resides all the year in the United States, and perhaps is not a rare bird in any part of North America; but as it comes seldom abroad in the day, fewer specimens are obtained of it than of the other Owls. It preys chiefly on quadrupeds of the genus *Arvicola*, and in summer destroys many beetles. It lays three or four roundish white eggs, sometimes on the ground, at other times in the deserted nests of other birds in low bushes. Mr. HUTCHINS says it lays in April, and that the young fly in May; and Mr. DRUMMOND found a nest on the ground, containing three eggs, on the 5th of July, and killed both the birds. On comparing the above mentioned eggs with those of the English Long-eared Owl, the American ones proved to be smaller, measuring only an inch and a half in length, and 1.27 inches in breadth; while the English ones measured 1.8 inch in length, and 1¼ in breadth. The form and colour were the same in both."

The food of this Owl consists of rats, mice, and other small quadrupeds,

as well as birds of various species; its stomach having been found by me crammed with feathers and other remains of the latter.

There is a marked difference between the sexes. The males are not only smaller than the females, but darker; and this has tempted me to consider the *Strix Mexicanus* of Mr. SWAINSON and the Prince of MUSIGNANO as merely a large female of our Long-eared Owl.

LONG-EARED OWL, *Strix otus*, Wils. Amer. Orn., vol. vi. p. 52.
STRIX OTUS, Bonap. Syn., p. 37.
LONG-EARED OWL, *Strix otus*, Nutt. Man., vol. i. p. 130.
LONG-EARED OWL, *Strix otus*, Aud. Orn. Biog., vol. iv. p. 573.

Tufts elongated; general colour of plumage buff, mottled and spotted with brown and greyish-white; dirty whitish anteriorly, with the tips black; posteriorly reddish-white; ruff mottled with red and black; upper part of head minutely mottled with whitish, brownish-black, and light red; the tufts light reddish towards the base, brownish-black in the centre toward the end, the inner edge white, dotted with dark brown; upper parts buff, variegated with brown and whitish-grey, minutely mottled or undulatingly barred; first row of coverts tipped with white; quills and scapulars pale grey, barred with dark brown; the primaries buff towards the base externally. Tail with ten bars on the middle and eight on the outer feathers; lower parts with more buff and fewer spots than the upper; each feather with a long dark brown streak, and several irregular transverse bars; legs and toes pure buff.

Male $14\frac{1}{2}$, 38. Female, 16, 40.

A male sent in spirits from Boston by Dr. BREWER:—The roof of the mouth is flat, with two longitudinal ridges, the sides ascending; the posterior aperture of the nares oblong, 4 twelfths long, with an interior fissure. The tongue is $7\frac{1}{2}$ twelfths long, deeply emarginate and papillate at the base, flattish above, with a faint median groove, the sides parallel, the tip narrowed and emarginate. The mouth is very wide, measuring 1 inch and $1\frac{1}{2}$ twelfths. The œsophagus is $5\frac{1}{2}$ inches long, of nearly uniform diameter throughout, as in all other Owls, its breadth being 1 inch. The proventricular glandules form a belt 9 twelfths in diameter. The stomach is large, round, 1 inch 9 twelfths long, 1 inch 7 twelfths broad, its walls thin, its muscular coat composed of rather coarse fasciculi, but without distinction into lateral muscles; the tendinous spaces circular, and about 8 twelfths in diameter; its epithelium soft and rugous. The duodenum is 3 twelfths in diameter, and curves at the distance of 3 inches from the pylorus. The intestine is 23 inches long, its smallest diameter only 1 twelfth. The cœca, Fig. 2, are in this individual unequal, as they very frequently are in Owls; the largest being 2 inches 10

twelfths in length, their greatest diameter $5\frac{1}{2}$ twelfths, their distance from the anus 3 inches and a quarter. The cloaca is of an enormous size, ovate, 2 inches long, 1 inch 2 twelfths broad. It contains a calculous concretion 9 twelfths long, 7 twelfths broad, and 3 twelfths thick.

The trachea, which is 3 inches long, is $3\frac{1}{4}$ twelfths in breadth at the upper part, $2\frac{1}{4}$ twelfths in the middle, and 3 twelfths at its lower extremity; its rings about 75 in number, cartilaginous, and considerably flattened. The lateral muscles are strong, the sterno-tracheal moderate, and there is a single pair of very slender inferior laryngeal muscles. Five of the lower rings are elongated, arched, and slit. The bronchi are rather long, of 12 half rings.

The conch of the ear, Fig. 1, is of enormous size, extending from the level of the forehead over the eye to the chin, in a semilunar form, of which the posterior curve is 3 inches, and the distance between the two extremities in a direct line 1 inch and a half. There is an anterior semicircular flap in its whole length, 5 twelfths in breadth at the middle. The aperture or meatus externus is of a rhomboidal form, $4\frac{1}{2}$ twelfths in length, $3\frac{1}{2}$ twelfths broad, bounded anteriorly by the eye, posteriorly by a ligament extended along the edge of the occipital bone, above by a ligament stretching to the operculum, below the articulation of the lower jaw. Above the meatus is a deep depression covered with skin, above which another ligament stretches across to the operculum.

In another specimen, a female, the œsophagus is $5\frac{1}{2}$ inches long, its average diameter 11 twelfths. The intestine is 21 inches long, from $2\frac{1}{4}$ twelfths to 1 twelfth in diameter; the cœca are $2\frac{1}{4}$ inches in length; their greatest diameter 4 twelfths; the cloaca still larger than that of the other individuals, being 2 inches long.

Fig. 1.

Fig. 2.

SHORT-EARED OWL.

Otus brachyotus, *Linn.*

PLATE XXXVIII.—Male.

Although this species is by no means scarce in almost any part of the United States, in the latter half of autumn and during winter, very few individuals spend the summer south of the Great Pine Swamp of Pennsylvania, where, however, some occasionally breed. In Nova Scotia, its nest has frequently been met with, and in Newfoundland it is as common as the Barred Owl is in Louisiana. In winter I have found it so plentiful in the Floridas, that I have shot seven in the course of a morning, while I was at General Hernandez'. Indeed I was surprised to see the great number of

Short-eared Owl.

from Nature by J.J.Audubon.F.R.S.F.L.S

Lith⁴ Printed & Col⁴ by J.T. Bowen.Philad⁴

these birds which at that period were to be found in the open prairies of that country, rising from the tall grass in a hurried manner, and zig-zagging for a few yards, as if suddenly wakened from sound sleep, then sailing to some distance in a direct course, and dropping among the thickest herbage. On such an occasion, when I had observed the bird to have thrust itself into a thicket formed of tangled palmettoes, I moved towards it with caution, approached it, and caught it in my hand. I observed, however, that these birds, on being pursued and repeatedly started from the ground, extended their flight so far as to be quite out of sight before alighting. I never started two birds at once, but always found them singly at distances of from twenty to a hundred yards; and although on several occasions as many as three were seen on wing, they having been put up by my companions and myself, they never flew towards each other, but went off in different directions, as if unaware of each other's presence.

Its predilection for the ground forms a very distinctive peculiarity in the habits of this Owl, as compared with the Long-eared; for although it alights on bushes and trees, this seems more a matter of necessity than of choice; and in this respect it resembles the Barn Owls which I found on Galveston Island. I have never observed it in the act of procuring food, although it appears to see pretty well by day, or at least sufficiently to enable it to discover the nature of the spot toward which it removes for security.

In America, the Short-eared Owl has been observed as far north as latitude 67° by Dr. RICHARDSON, who mentions a female having been killed at Fort Franklin, on the 20th of May, containing several pretty large eggs, nearly ready for being laid. It is also an inhabitant of the Rocky Mountains, and of the valley of the Columbia river, from which it has been sent to me by Mr. TOWNSEND; and is by no means scarce in Kentucky, Louisiana, and along the coast as far as the Texas.

Having so frequently met with many of these birds in an extent of ground not exceeding half a mile, I have been disposed to think, that during the migratory movements of this species, those which follow in the rear of the first, are attracted by their cries, and induced to alight in their vicinity; but of this I have no positive proof, nor have I ever seen them travelling from one part of the country to another.

The only nest of this bird that I have found was placed on one of the high mountain ridges of the Great Pine Forest. It contained four eggs, nearly ready to be hatched. They were of a dull bluish-white, covered with excrement, of a somewhat elongated or elliptical form, measuring an inch and a half in length, and an inch and an eighth in breadth. The nest, which I met with on the 17th of June, was placed under a low bush, and covered over by tall grass, through which a path had been made by the bird. It was formed

of dry grass, raked together in a slovenly manner, and quite flat, but cover-
ing a large space, on one side of which were found many pellets, and two
field-mice, which must have been brought there in the course of the preceding
night, as they were quite fresh. I should never have discovered their nest
had not the sitting bird made a noise by clicking its bill as I was passing
close by. The poor thing was so intent on her task that I almost put my
hand on her before she moved; and then, instead of flying off, she hopped
with great leaps until about ten yards from me, keeping up a constant click-
ing of her mandibles. Having satisfied myself as to the species, made an
outline of two of the eggs, and measured them, I proceeded slowly to a short
distance, and watched her movements. Having remained silent and still for
about ten minutes, I saw her hop toward the nest, and soon felt assured that
she had resumed her task. It was my intention to revisit the spot, and take
note of the growth of the young, but letters which came to me from Phila-
delphia a few days after, induced me to return thither; and since then I have
had no opportunity of examining either the eggs or young of the Short-eared
Owl.

On examining the pellets disgorged by this bird, I found them to be formed
of the remains of bones of small quadrupeds, mixed with hair, and the elytra
of various coleopterous insects. In its diurnal flight, the flappings of its
wings are noiseless, as in most other species, and it is apt to sail many yards
at a time before alighting. Like the rest of the family, when reposing, they
stand as if crouched on the full length of their tarsi, and the slight crests or
tufts of feathers on their head are, on such occasions, usually so lowered as
to be scarcely perceptible.

SHORT-EARED OWL, *Strix brachyotos*, Wils. Amer. Orn., vol. iv. p. 64.
STRIX BRACHYOTOS, Bonap. Syn., p. 37.
SHORT-EARED OWL, *Strix brachyotos*, Nutt. Man., vol. i. p. 132.
SHORT-EARED OWL, *Strix brachyotos*, Aud. Orn. Biog., vol. v. p. 273.

Tufts inconspicuous, general colour of plumage buff, variegated with dark
brown; eye surrounded by a ring of brownish-black, much broader behind;
anterior half of disk white, with the tips black, posterior yellowish; anterior
auricular ruff white, posterior yellowish, each feather with an oblong dark
brown spot; upper parts buff, longitudinally streaked with dark brown;
scapulars and wing-coverts spotted and banded in large patches, many with
a large yellowish-white spot on the outer web near the end; quills buff, with
two or three dark brown bands; tail similar, with five broad dark bands, the
tip yellowish-white; on the middle feathers the light coloured spaces have a
brown central patch; lower parts pale buff, whitish behind, the neck with
oblong, the breast and sides with linear dark brown streaks; chin, feet,
abdomen, and lower tail-coverts unspotted.

Harvard Natural History Society

Great Horned Owl.

Drawn from Nature by J.J.Audubon FRS FLS Lith Printed & Cold by J.T. Bowen Philad

Genus VI.—BUBO, *Cuvier.* HORNED-OWL.

Bill short, stout, broader than high at the base, compressed toward the end; upper mandible with its dorsal line curved from the base, the edges with a slight festoon, the tip trigonal, very acute; lower mandible with the dorsal line convex, the tip obliquely truncate. Nostrils broadly elliptical, aperture of ear elliptical, less than half the height of the head, without operculum. Feet of ordinary length; tarsi and toes feathered. Plumage full and very soft; facial disks complete; a tuft of elongated feathers on each side of the crown of the head. Wings ample, the first quill short, the fourth longest. Tail of ordinary length, rounded.

THE GREAT HORNED OWL.

BUBO VIRGINIANUS, *Gmel.*

PLATE XXXIX.—MALE AND FEMALE.

It is during the placid serenity of a beautiful summer night, when the current of the waters moves silently along, reflecting from its smooth surface the silver radiance of the moon, and when all else of animated nature seems sunk in repose, that the Great Horned Owl, one of the Nimrods of the feathered tribes of our forests, may be seen sailing silently and yet rapidly on, intent on the destruction of the objects destined to form his food. The lone steersman of the descending boat observes the nocturnal hunter, gliding on extended pinions across the river, sailing over one hill and then another, or suddenly sweeping downwards, and again rising in the air like a moving shadow, now distinctly seen, and again mingling with the sombre shades of the surrounding woods, fading into obscurity. The bark has now floated to some distance, and is opposite the newly cleared patch of ground, the result of a squatter's first attempt at cultivation, in a place lately shaded by the trees of the forest. The moon shines brightly on his hut, his slight fence, the newly planted orchard, and a tree, which, spared by the axe, serves as a roosting-place for the scanty stock of poultry which the new comer has procured from some liberal neighbour. Amongst them rests a Turkey-hen, covering her offspring with extended wings. The Great Owl, with eyes keen as those of any falcon, is now seen hovering above the place. He has

already espied the quarry, and is sailing in wide circles meditating his plan of attack. The Turkey-hen, which at another time might be sound asleep, is now, however, so intent on the care of her young brood, that she rises on her legs and purs so loudly, as she opens her wings and spreads her tail, that she rouses her neighbours, the hens, together with their protector. The cacklings which they at first emit soon become a general clamour. The squatter hears the uproar, and is on his feet in an instant, rifle in hand; the priming examined, he gently pushes open his half closed door, and peeps out cautiously, to ascertain the cause by which his repose has been disturbed. He observes the murderous Owl just alighting on the dead branch of a tall tree, when, raising his never-failing rifle, he takes aim, touches the trigger, and the next instant sees the foe falling dead to the ground. The bird, unworthy of his farther attention, is left a prey to some prowling opossum or other carniverous quadruped, and again all around is tranquillity.

Differences of locality are no security against the depredations of this Owl, for it occurs in the highest mountainous districts, as well as in the low alluvial lands that border the rivers, in the interior of the country, and in the neighbourhood of the sea-shore. Every where it finds abundance of food. It is, moreover, an extremely hardy bird, and stands the severest winters of our northernmost latitudes. It is consequently found dispersed over all parts of the United States.

The flight of the Great Horned Owl is elevated, rapid and graceful. It sails with apparent ease, and in large circles, in the manner of an eagle, rises and descends without the least difficulty, by merely inclining its wings or its tail, as it passes through the air. Now and then, it glides silently close over the earth, with incomparable velocity, and drops, as if shot dead, on the prey beneath. At other times, it suddenly alights on the top of a fence-stake or a dead stump, shakes its feathers, arranges them, and utters a shriek so horrid that the woods around echo to its dismal sound. Now, it seems as if you heard the barking of a cur-dog; again, the notes are so rough and mingled together, that they might be mistaken for the last gurglings of a murdered person, striving in vain to call for assistance; at another time, when not more than fifty yards distant, it utters its more usual *hoo, hoo, hoo-e*, in so peculiar an under tone, that a person unacquainted with the notes of this species might easily conceive them to be produced by an Owl more than a mile distant. During the utterance of all these unmusical cries, it moves its body, and more particularly its head, in various ways, putting them into positions, all of which appear to please it much, however grotesque they may seem to the eye of man. In the interval following each cry, it snaps its bill, as if by way of amusement; or, like the wild boar sharpening the edges of his tusks, it perhaps expects that the action will whet its mandibles.

The food of the Great Horned Owl consists chiefly of the larger species of gallinaceous birds, half-grown Wild Turkeys, Pheasants, and domestic poultry of all kinds, together with several species of Ducks. Hares, young Opossums and Squirrels are equally agreeable to it, and whenever chance throws a dead fish on the shore, the Great Owl feeds with peculiar avidity on it.

It is one of the most common species along the shores of the Ohio and Mississippi, where it is to be met with at all seasons, being fond of roosting amongst the thick-growing young cotton-wood trees and willows that cover the muddy sand-bars of these noble streams, as well as in the more retired woody swamps, where the gloomy cypress spreads its broad arms, covered with dangling masses of Spanish beard, which give way to the gentlest breeze. In both such situations I have frequently met with this Owl: its body erect, its plumage closed, its tufted head-feathers partially lowered, and its head half-turned and resting on one shoulder.

When the sun shines brightly, the bird is easily approached; but if the weather be cloudy, it rises on its feet, at the least noise, erects the tufts of its head, gives a knowing kind of nod, flies off in an instant, and generally proceeds to such a distance that it is difficult to find it again. When disturbed whilst at roost on willows near a river, it sails off low over the stream, as if aware that by so doing it renders its pursuit more difficult. I once nearly lost my life by going towards one that I had shot on a willow-bar, for, while running up to the spot, I suddenly found myself sunk in quicksand up to my arm-pits, and in this condition must have remained to perish, had not my boatmen come up and extricated me, by forming a bridge of their oars and some driftwood, during which operation I had to remain perfectly quiet, as any struggle would soon have caused me to sink overhead.

Early in February the Great Horned Owls are seen to pair. The curious evolutions of the male in the air, or his motions when he has alighted near his beloved, it is impossible to describe. His bowings, and the snappings of his bill, are extremely ludicrous; and no sooner is the female assured that the attentions paid her by the beau are the result of a sincere affection, than she joins in the motions of her future mate.

The nest, which is very bulky, is usually fixed on a large horizontal branch, not far from the trunk of the tree. It is composed externally of crooked sticks, and is lined with coarse grasses and some feathers. The whole measures nearly three feet in diameter. The eggs, which are from three to six, are almost globular in form, and of a dull white colour. The male assists the female in sitting on the eggs. Only one brood is raised in the season. The young remain in the nest until fully fledged, and afterwards follow the parents for a considerable time, uttering a mournful sound, to

induce them to supply them with food. They acquire the full plumage of the old birds in the first spring, and until then are considerably lighter, with more dull buff in their tints. I have found nests belonging to this species in large hollows of decayed trees, and twice in the fissures of rocks. In all these cases, little preparation had been made previous to the laying of the eggs, as I found only a few grasses and feathers placed under them.

The Great Horned Owl lives retired, and it is seldom that more than one is found in the neighbourhood of a farm, after the breeding season; but as almost every detached farm is visited by one of these dangerous and powerful marauders, it may be said to be abundant. The havoc which it commits is very great. I have known a plantation almost stripped of the whole of the poultry raised upon it during spring, by one of these daring foes of the feathered race, in the course of the ensuing winter.

This species is very powerful, and equally spirited. It attacks Wild Turkeys when half grown, and often masters them. Mallards, Guinea-fowls, and common barn fowls, prove an easy prey, and on seizing them it carries them off in its talons from the farm-yards to the interior of the woods. When wounded, it exhibits a revengeful tenacity of spirit, scarcely surpassed by any of the noblest of the Eagle tribe, disdaining to scramble away like the Barred Owl, but facing its enemy with undaunted courage, protruding its powerful talons, and snapping its bill, as long as he continues in its presence. On these occasions, its large goggle eyes are seen to open and close in quick succession, and the feathers of its body, being raised, swell out its apparent bulk to nearly double the natural size.

Great Horned-Owl, *Strix Virginiana*, Wils. Amer. Orn., vol. vi. p. 52.
Strix Virginiana, Bonap. Syn., p. 37.
Great Horned-Owl or Cat Owl, *Strix Virginiana*, Nutt. Man., vol. i. p. 124.
Great Horned Owl, *Strix Virginiana*, Aud. Orn. Biog., vol. i. p. 313; vol. v. p. 393.

Upper part of the head brownish-black, mottled with light brown, the tufts of the same colour, margined with brown; face brownish-red, with a circle of blackish-brown; upper parts undulatingly banded and minutely mottled with brownish-black and yellowish-red, behind tinged with grey; wings and tail light brownish-yellow, barred and mottled with blackish-brown and light brownish-red; chin white; upper part of throat light reddish, spotted with black, a band of white across the middle of fore neck; its lower part and the breast light yellowish-red, barred with deep brown, as are the lower parts generally; several longitudinal brownish-black patches on the lower fore neck; tarsal feathers light yellowish-red, obscurely barred.

Male, 23, 56. Female, 25, 60.

Harvard Natural History Society.

n. s

Little Screech Owl.
Jersey Pine. Pinus inops

Drawn from Nature by J. J. Audubon F.R.S.F.L.S. Lith⁴ Printed & Col⁴ by J. T. Bowen Philad⁴

, is there very rare.

t with more than two

f the Ohio and Missis-

above the Falls of the

advances towards the

eard in every quarter

nd, and all the Eastern

the autumnal and winter

ie of the *Screech Owl.*

ee figures of this species, the

ist between the young and the

g in these different stages I have

Owl of WILSON and other natu-

by the same authors the *Mottled*

species under consideration.

American Ornithology," for

e; and the specific identity

under the above names,

s LUCIEN BONAPARTE,

ividuals with whom I

ornat...t Hei...y VI.2 *.pa...*

ted and noiseless.

our forest trees,

w and swiftly

s, field-mice,

Sometimes

hends its

ers its

rey.

n-

r

THE LITTLE SCREECH OWL.

BUBO ASIO, *Linn.*

PLATE XL.—ADULT AND YOUNG.

This Owl, although found in the Southern States, is there very rare. During a long residence in Louisiana, I have not met with more than two individuals. On advancing towards the confluence of the Ohio and Mississippi, we find them becoming rather more numerous; above the Falls of the former they increase in number; and as the traveller advances towards the sources of that noble river, their mournful notes are heard in every quarter during mild and serene nights. In Virginia, Maryland, and all the Eastern Districts, the bird is plentiful, particularly during the autumnal and winter months, and is there well known under the name of the *Screech Owl.*

You are presented, kind reader, with three figures of this species, the better to shew you the differences which exist between the young and the full-grown bird. The contrast of colouring in these different stages I have thought it necessary to exhibit, as the *Red Owl* of WILSON and other naturalists is merely the young of the bird called by the same authors the *Mottled Owl,* and which, in fact, is the adult of the species under consideration. The error committed by the author of the "American Ornithology," for many years misled all subsequent students of nature; and the specific identity of the two birds which he had described as distinct under the above names, was first publicly maintained by my friend CHARLES LUCIEN BONAPARTE, although the fact was long before known to many individuals with whom I am acquainted, as well as to myself. Vide Boston Journal of Nat. Hist. Vl.2. page ie

The flight of the Mottled Owl is smooth, rapid, protracted and noiseless. It rises at times above the top branches of the highest of our forest trees, whilst in pursuit of large beetles, and at other times sails low and swiftly over the fields, or through the woods, in search of small birds, field-mice, moles or wood-rats, from which it chiefly derives its subsistence. Sometimes on alighting, which it does plumply, the Mottled Owl immediately bends its body, turns its head to look behind it, performs a curious nod, utters its notes, then shakes and plumes itself, and resumes its flight, in search of prey. It now and then, while on wing, produces a *clicking* sound with its mandibles, but more frequently when perched near its mate or young. This I have thought is done by the bird to manifest its courage, and let the hearer know that it is not to be meddled with, although few birds of prey are more

gentle when seized, as it will suffer a person to touch its feathers and caress it, without attempting to bite or strike with its talons, unless at rare intervals. I carried one of the young birds represented in the Plate, in my coat pocket, from Philadelphia to New York, travelling alternately by water and by land. It remained generally quiet, fed from the hand, and never attempted to escape.

The notes of this Owl are uttered in a tremulous, doleful manner, and somewhat resemble the chattering of the teeth of a person under the influence of extreme cold, although much louder. They are heard at a distance of several hundred yards, and by some people are thought to be of ominous import.

The little fellow is generally found about farm-houses, orchards, and gardens. It alights on the roof, the fence or the garden gate, and utters its mournful ditty at intervals for hours at a time, as if it were in a state of great suffering, although this is far from being the case, the song of all birds being an indication of content and happiness. In a state of confinement, it continues to utter its notes with as much satisfaction as if at liberty. They are chiefly heard during the latter part of winter, that being the season of love, when the male bird is particularly attentive to the fair one which excites his tender emotions, and around which he flies and struts much in the manner of the Common Pigeon, adding numerous nods and bows, the sight of which is very amusing.

The nest is placed in the bottom of the hollow trunk of a tree, often not at a greater height than six or seven feet from the ground, at other times as high as from thirty to forty feet. It is composed of a few grasses and feathers. The eggs are four or five, of a nearly globular form, and pure white colour. If not disturbed, this species lays only one set of eggs in the season. The young remain in the nest until they are able to fly. At first they are covered with a downy substance of a dull yellowish-white. By the middle of August they are fully feathered, and are then generally of the colour exhibited in the Plate, although considerable difference exists between individuals, as I have seen some of a deep chocolate colour, and others nearly black. The feathers change their colours as the pairing season advances, and in the first spring the bird is in its perfect dress.

The Mottled Owl rests or spends the day either in a hole of some decayed tree, or in the thickest part of the evergreens which are found so abundantly in the country, to which it usually resorts during the breeding season as well as in the depth of winter.

The branch on which you see three individuals of this species, an adult bird and two young ones, is that of the Jersey Pine (*Pinus inops*), a tree of moderate height and diameter, and of a scrubby appearance. The stem is

generally crooked, and the wood is not considered of great utility. It grows
in large groves in the state from which it has derived its name, and is now
mostly used for fuel on board our steam-vessels. The Mottled Owl is often
observed perched on its branches.

MOTTLED OWL, *Strix nævia*, Wils. Amer. Orn., vol. iii. p. 16. Adult.
RED OWL, *Strix Asio*, Wils. Amer. Orn., vol. v. p. 83. Young.
MOTTLED and RED OWL, *Strix Asio*, Nutt. Man., vol. i. p. 120.
LITTLE SCREECH OWL, *Strix Asio*, Aud. Orn. Biog., vol. i. p. 486; vol. v. p. 392.

Adult with the upper parts pale brown, spotted and dotted with brownish-
black; a pale grey line from the base of the upper mandible over each eye;
quills light brownish-grey, barred with brownish-black, their coverts dark
brown, secondary coverts with the tip white; throat yellowish-grey, lower
parts light grey, patched and sprinkled with brownish-black; tail-feathers
tinged with red. Young with the upper parts light brownish-red, each
feather with a central blackish-brown line; tail and quills barred with dull
brown; a line over the eye, and the tips of the secondary coverts reddish-
white; breast and sides light yellowish-grey, spotted and lined with brownish-
black and bright reddish-brown, the rest of the lower parts yellowish-grey,
the tarsal feathers pale yellowish-red.

Male, 10, 22. Female, 10, 23.

FAMILY IV. CAPRIMULGINÆ. GOATSUCKERS.

Mouth opening to beneath the centre of the eyes; bill much depressed, generally feeble, the horny part being small; upper mandible with the tip somewhat decurved. Nostrils elliptical, prominent, marginate. Eyes extremely large. Aperture of ear elliptical, very large. Head of extreme breadth, depressed; body very slender. Feet very small; tarsus partially feathered, scaly; anterior toes webbed at the base; hind toe small, and versatile, all scutellate above; claw of third toe generally elongated, with the inner margin thin and pectinate. Plumage very soft and blended. Wings very long, the second and third quills longest. Tail long, of ten feathers. Œsophagus rather wide, without crop; stomach very large, roundish, its muscular coat very thin, and composed of a single series of strong fasciculi; epithelium very hard, with longitudinal rugæ; intestine short and wide; cœca large, oblong, narrow at the base; cloaca globular. Trachea of nearly uniform width, without inferior laryngeal muscles. Nest on the ground, or in hollow trees. Eggs generally two. Young covered with down. Very nearly allied in some respects to the Owls.

Genus I.—CAPRIMULGUS, *Linn.* GOATSUCKER.

Bill feeble, gape extending to beneath the posterior angle of the eye. Nostrils elliptical, prominent. Wings long, pointed, the second quill longest; tail long. Claw of middle toe pectinate. Along the base of the bill on each side a series of feathers having very strong shafts, terminating in an elastic filamentous point, and with the barbs or lateral filaments extremely slender, distant, and not extended beyond the middle of the shaft. Plumage very soft and blended. Wings long and pointed, the second quill longest; tail long, rounded.

Chuck-will's Widow.
(Harlequin Snake)

Drawn from Nature by J. Audubon FRS FLS

Lithd Printed & Cold by J.T. Bowen Philad

CHUCK-WILL'S-WIDOW.

CAPRIMULGUS CAROLINENSIS, *Gmel.*

PLATE XLI.—MALE AND FEMALE.

Our Goatsuckers, although possessed of great power of wing, are particularly attached to certain districts and localities. The species now under consideration is seldom observed beyond the limits of the Choctaw Nation in the State of Mississippi, or the Carolinas, on the shores of the Atlantic, and may with propriety be looked upon as the southern species of the United States. Louisiana, Florida, the lower portions of Alabama and Georgia, are the parts in which it most abounds; and there it makes its appearance early in spring, coming over from Mexico, and probably still warmer climates.

About the middle of March, the forests of Louisiana are heard to echo with the well-known notes of this interesting bird. No sooner has the sun disappeared, and the nocturnal insects emerged from their burrows, than the sounds, "*chuck-will's-widow*," repeated with great clearness and power six or seven times in as many seconds, strike the ear, bringing to the mind a pleasure mingled with a certain degree of melancholy, which I have often found very soothing. The sounds of the Goatsucker, at all events, forbode a peaceful and calm night, and I have more than once thought, are conducive to lull the listener to repose.

The deep ravines, shady swamps, and extensive pine ridges, are all equally resorted to by these birds; for in all such places they find ample means of providing for their safety during the day, and of procuring food under night. Their notes are seldom heard in cloudy weather, and never when it rains. Their roosting places are principally the hollows of decayed trees, whether standing or prostrate, which they seldom leave during the day, excepting while incubation is in progress. In these hollows I have found them, lodged in the company of several species of bats, the birds asleep on the mouldering particles of the wood, the bats clinging to the sides of the cavities. When surprised in such situations, instead of trying to effect their escape by flying out, they retire backwards to the farthest corners, ruffle all the feathers of their body, open their mouth to its full extent, and utter a hissing kind of murmur, not unlike that of some snakes. When seized and brought to the light of day, they open and close their eyes in rapid succession, as if it were painful for them to encounter so bright a light. They snap their little bill in the manner of Fly-catchers, and shuffle along as if extremely desirous of

making their escape. On giving them liberty to fly, I have found them able to proceed until out of my sight. They passed between the trees with apparently as much ease and dexterity as if it had been twilight. I once cut two of the quill-feathers of a wing of one of these birds, and allowed it to escape. A few days afterwards I found it in the same log, which induces me to believe that they, like many other birds, resort to the same spot, to roost or spend the day.

The flight of the Chuck-will's-widow is as light as that of its relative, the well-known *Whip-poor-will,* if not more so, and is more graceful as well as more elevated. It somewhat resembles the flight of the Hen-harrier, being performed by easy flappings of the wings, interspersed with sailings and curving sweeps, extremely pleasing to the bystander. At the approach of night, this bird begins to sing clearly and loudly, and continues its notes for about a quarter of an hour. At this time it is perched on a fence-stake, or on the decayed branch of a tree in the interior of the woods, seldom on the ground. The sounds or notes which it emits seem to cause it some trouble, as it raises and lowers its head in quick succession at each of them. This over, the bird launches into the air, and is seen sweeping over the cotton fields or the sugar plantations, cutting all sorts of figures, mounting, descending, or sailing, with so much ease and grace, that one might be induced to call it the *Fairy of the night.* If it passes close to one, a murmuring noise is heard, at times resembling that spoken of when the bird is caught by day. It suddenly checks its course, inclines to the right or left, secures a beetle or a moth, continues its flight over the field, passes and repasses hundreds of times over the same ground, and now and then alights on a fence-stake, or the tallest plant in the place, from which it emits its notes for a few moments with increased vivacity. Now, it is seen following a road or path on the wing, and alighting here and there to pick up the beetle emerging from its retreat in the ground; again, it rises high in air, and gives chase to the insects that are flying there, perhaps on their passage from one wood to another. At other times, I have seen it poise itself on its wings opposite the trunk of a tree, and seize with its bill the insects crawling on the bark, in this manner inspecting the whole tree, with motions as light as those by which the Humming-bird flutters from one flower to another. In this manner the Chuck-will's-widow spends the greater part of the night.

The greatest harmony appears to subsist between the birds of this species, for dozens may be observed flying together over a field, and chasing insects in all directions, without manifesting any enmity or envy. A few days after the arrival of the male birds, the females make their appearance, and the love season at once commences. The male pays his addresses to the female with a degree of pomposity only equalled by the Tame Pigeon. The

female, perched lengthwise on a branch, appears coy and silent, whilst the male flies around her, alights in front of her, and with drooping wings and expanded tail advances quickly, singing with great impetuosity. They are soon seen to leave the branch together and gambol through the air. A few days after this, the female, having made choice of a place in one of the most retired parts of some thicket, deposits two eggs, which I think, although I cannot be certain, are all that she lays for the season. This bird forms no nest. A little space is carelessly scratched amongst the dead leaves, and in it the eggs, which are elliptical, dull olive, and speckled with brown, are dropped. These are not found without great difficulty, unless when by accident a person passes within a few feet of the bird whilst sitting, and it chances to fly off. Should you touch or handle these dear fruits of happy love, and, returning to the place, search for them again, you would search in vain; for the bird perceives at once that they have been meddled with, and both parents remove them to some other part of the woods, where chance only could enable you to find them again. In the same manner, they also remove the young when very small.

This singular occurrence has as much occupied my thoughts as the equally singular manner in which the *Cow Bunting* deposits her eggs, which she does, like the *Common Cuckoo* of Europe, one by one, in the nests of other birds, of different species from her own. I have spent much time in trying to ascertain in what manner the Chuck-will's-widow removes her eggs or young, particularly as I found, by the assistance of an excellent dog, that neither the eggs nor the young were to be met with within at least a hundred yards from the spot where they at first lay. The negroes, some of whom pay a good deal of attention to the habits of birds and quadrupeds, assured me that these birds push the eggs or young with their bill along the ground. Some farmers, without troubling themselves much about the matter, imagine the transportation to be performed under the wings of the old bird. The removal is, however, performed thus:

When the Chuck-will's-widow, either male or female, (for each sits alternately,) has discovered that the eggs have been touched, it ruffles its feathers and appears extremely dejected for a minute or two, after which it emits a low murmuring cry, scarcely audible at a distance of more than eighteen or twenty yards. At this time the other parent reaches the spot, flying so low over the ground that I thought its little feet must have touched it, as it skimmed along, and after a few low notes and some gesticulations, all indicative of great distress, takes an egg in its large mouth, the other bird doing the same, when they would fly off together, skimming closely over the ground, until they disappeared among the branches and trees. But to what distance they remove their eggs, I have never been able to ascertain; nor

have I ever had an opportunity of witnessing the removal of the young. Should a person, coming upon the nest when the bird is sitting, refrain from touching the eggs, the bird returns to them and sits as before. This fact I have also ascertained by observation.

I have not been able to discover the peculiar use of the *pectinated claw* which this bird has on each foot.

The Chuck-will's-widow manifests a strong antipathy towards all snakes, however harmless they may be. Although these birds cannot in any way injure the snakes, they alight near them on all occasions, and try to frighten them away, by opening their prodigious mouth, and emitting a strong hissing murmur. It was after witnessing one of these occurrences, which took place at early twilight, that the idea of representing these birds in such an occupation struck me. The beautiful little snake, gliding along the dead branch, between two Chuck-will's-widows, a male and a female, is commonly called the *Harlequin Snake*, and is, I believe, quite harmless. .

The food of the bird now under consideration consists entirely of all sorts of insects, among which the larger species of moths and beetles are very conspicuous. The long bristly feathers at the base of the mandibles of these birds no doubt contribute greatly to prevent the insects from escaping, after any portion of them has entered the mouth of the bird.

These birds become silent as soon as the young are hatched, but are heard again before their departure towards the end of summer. At this season, however, their cry is much less frequently heard than in spring. They leave the United States all of a sudden, about the middle of the month of August.

The occurrence of the remains of a bird in the stomach of an individual of this species is a very remarkable circumstance, as it had never been known, or even conjectured to feed on birds. If the larger and stronger species, and especially the Stout-billed Podargi, should thus be found to be carnivorous, their affinity to the Owls, so apparent in the texture and colours of their plumage, will be rendered more conspicuous.

Chuck-will's-widow, *Caprimulgus Carolinensis*, Wils. Amer. Orn,, vol. vi. p. 95.
. Caprimulgus Carolinensis, Bonap. Syn., p. 61.
Chuck-will's-widow, *Caprimulgus Carolinensis*, vol. i. p. 612.
Chuck-will's-widow, *Caprimulgus Carolinensis*, Aud. Orn. Biog., vol. i. p. 273; vol. v. p. 401.

Bristles with lateral filaments; tail slightly rounded. Head and back dark brown, minutely mottled with yellowish-red, and longitudinally streaked with black; three bands of the latter colour, from the lower mandible

Harvard Natural History Society.

Pl. 42

Whip-poor-will.

Black Oak or Quercitron Quercus tinctoria.

Drawn by J. J. Audubon F.R.S.F.L.S.

Lith. Printed & Col.d by J. T. Bowen, Philad.a

diverging along the head; a yellowish-white line over the eye; wings barred with yellowish-red and brownish-black, and minutely sprinkled with the latter colour, as are the wing-coverts, which, together with the scapulars, are largely spotted with black, and tinged with grey; tail similarly barred and dotted; terminal half of the inner webs of the three outer feathers white, their extremities light red; lower parts dull reddish-yellow, sprinkled with dusky; a band of whitish feathers barred with black on the fore neck. Female like the male, but without white on the tail.

Male, 12¾, 26. Female, 13½, 30.

————

WHIP-POOR-WILL.

CAPRIMULGUS VOCIFERUS, *Wils.*

PLATE XLII.—MALE AND FEMALE.

This bird makes its appearance in most parts of our Western and Southern Districts, at the approach of spring, but is never heard, and indeed scarcely ever occurs, in the State of Louisiana. The more barren and mountainous parts of the Union seem to suit it best. Accordingly, the open Barrens of Kentucky, and the country through which the Alleghany ridges pass, are more abundantly supplied with it than any other region. Yet, wherever a small tract of country, thinly covered with timber, occurs in the Middle Districts, there the *Whip-poor-will* is heard during the spring and early autumn.

This species of Night-jar, like its relative the Chuck-will's-widow, is seldom seen during the day, unless when accidentally discovered in a state of repose, when, if startled, it rises and flies off, but only to such a distance as it considers necessary, in order to secure it from the farther intrusion of the disturber of its noon-day slumbers. Its flight is very low, light, swift, noiseless, and protracted, as the bird moves over the places which it inhabits, in pursuit of the moths, beetles and other insects, of which its food is composed. During the day, it sleeps on the ground, the lowest branches of small trees and bushes, or the fallen trunks of trees so abundantly dispersed through the woods. In such situations, you may approach within a few feet of it; and, should you observe it whilst asleep, and not make any noise sufficient to alarm it, will suffer you to pass quite near without taking flight, as it seems to sleep with great soundness, especially about the middle of the

It is a remarkable fact that even the largest moths on which the Whip-poor-will feeds, are always swallowed tail foremost, and when swallowed, the wings and legs are found closely laid together, and as if partially glued by the saliva or gastric juice of the bird. The act of deglutition must be greatly aided by the long bristly feathers of the upper mandible, as these no doubt force the wings of the insects close together, before they enter the mouth.

I have represented a male and two females, as well as some of the insects on which they feed. The former are placed on a branch of *red oak*, that tree being abundant on the skirts of the Kentucky Barrens, where the Whip-poor-will is most plentiful.

Whip-poor-will, *Caprimulgus vociferus*, Wils. Amer. Orn., vol. v. p. 71.
Caprimulgus vociferus, Bonap. Syn., p. 62.
Whip-poor-will, *Caprimulgus vociferus*, Aud. Orn. Biog., vol. i. p. 422; vol. v. p. 405.
Whip-poor-will, *Caprimulgus vociferus*, Nutt. Man., vol. i. p. 614.

Bristles without lateral filaments; tail much rounded. General colour of upper parts dark brownish-grey, streaked and minutely sprinkled with brownish-black; quills and coverts dark brown, spotted in bars with light brownish-red; four middle tail-feathers like those of the back, the three lateral white in their terminal half; throat and breast similar to the back, with a transverse band of white on the fore neck, the rest of the lower parts paler and mottled. Female like the male, but with the lateral tail-feathers reddish-white toward the tip only, and the band across the fore neck pale yellowish-brown.

Male, 9½, 19. Female.

Genus II.—CHORDEILES, *Swains.* NIGHT-HAWK.

Mouth opening to beneath the centre of the eyes; bill extremely small; upper mandible with the tip decurved, and a deep lateral groove. Nostrils oblong, prominent, marginate. Eyes very large. Aperture of ear elliptical, very large. Head very large, depressed, but less so than in Caprimulgus. Claw of middle toe pectinate. No bristles at the base of the upper mandible. Wings very long, pointed, with the first quill longest, and the secondaries very short. Tail emarginate.

Night Hawk.
White Oak. Quercus Alba.

THE NIGHT-HAWK.

Chordeiles virginianus, *Briss.*

PLATE XLIII.—Male and Female.

The name of this bird disagrees with the most marked characteristics of its habits, for it may be seen, and has frequently been seen, on the wing, during the greater part of the day, even when the atmosphere is perfectly pure and clear, and while the sun is shining in all its glory. It is equally known that the Night-Hawk retires to rest shortly after dusk, at the very time when the loud notes of the Whip-poor-will, or those of the Chuck-will's-widow, both of which are nocturnal ramblers, are heard echoing from the places to which these birds resort.

About the 1st of April, the Night-Hawk makes its appearance in the lower parts of Louisiana, on its way eastward. None of them breed in that State, or in that of Mississippi, nor am I inclined to believe any where south of the neighbourhood of Charleston, in South Carolina. The species is, however, seen in all the Southern States, on its passage to and from those of the east. The Night-Hawks pass with so much comparative swiftness over Louisiana in the spring, that in a few days after their first appearance none are to be seen; nor are any to be found there until their return in autumn, when, on account of the ample supply of food they still meet with at this late season, they remain several weeks, gleaning the insects off the cotton fields, waste lands, or sugar plantations, and gambolling over the prairies, lakes or rivers, from morning till night. Their return from the Middle Districts varies according to the temperature of the season, from the 15th of August to late in October.

Their migrations are carried on over so great an extent, and that so loosely, that you might conceive it their desire to glean the whole country, as they advance with a front extending from the mouths of the Mississippi to the Rocky Mountains, passing in this manner from the south far beyond our eastern boundary lines. Thus they are enabled to disperse and breed throughout the whole Western and Eastern States, from South Carolina to Maine. On their way they may be seen passing over our cities and villages, alighting on the trees that embellish our streets, and even on chimney tops, from which they are heard to squeak their sharp notes, to the amusement or surprise of those who observe them.

I have seen this species in the British Provinces of New Brunswick and

Nova Scotia, where they remain so late as the beginning of October, but I observed none in Newfoundland, or on the shores of Labrador. In going north, their appearance in the Middle States is about the first of May; but they seldom reach Maine before June.

The Night-Hawk has a firm, light, and greatly prolonged flight. In dull cloudy weather, it may be seen on the wing during the whole day, and is more clamorous than at any other time. The motions of its wings while flying are peculiarly graceful, and the playfulness which it evinces renders its flight quite interesting. The bird appears to glide through the air with all imaginable ease, assisting its ascent, or supporting itself on high, by irregular hurried flappings performed at intervals, as if it had unexpectedly fallen in with its prey, pursued, and seized it. Its onward motion is then continued. It moves in this manner, either upwards in circles, emitting a loud sharp squeak at the beginning of each sudden start it takes, or straight downwards, then to the right or left, whether high or low, as it presses onward, now skimming closely over the rivers, lakes, or shores of the Atlantic, and again wending its way over the forests or mountain tops. During the love season its mode of flight is particularly interesting: the male may be said to court his mate entirely on the wing, strutting as it were through the air, and performing a variety of evolutions with the greatest ease and elegance, insomuch that no bird with which I am acquainted can rival it in this respect.

It frequently raises itself a hundred yards, sometimes much more, and apparently in the same careless manner already mentioned, its squeaking notes becoming louder and more frequent the higher it ascends; when, checking its course, it at once glides obliquely downwards, with wings and tail half closed, and with such rapidity that a person might easily conceive it to be about to dash itself against the ground. But when close to the earth, often at no greater distance than a few feet, it instantaneously stretches out its wings, so as to be nearly directed downwards at right angles with the body, expands its tail, and thus suddenly checks its downward career. It then brushes, as it were, through the air, with inconceivable force, in a semicircular line of a few yards in extent. This is the moment when the singular noise produced by this bird is heard, for the next instant it rises in an almost perpendicular course, and soon begins anew this curious mode of courtship. The concussion caused, at the time the bird passes the centre of its plunge, by the new position of its wings, which are now brought almost instantly to the wind, like the sails of a ship suddenly thrown aback, is the cause of this singular noise. The female does not produce this, although she frequently squeaks whilst on the wing.

Sometimes, when several males are paying their addresses to the same female, the sight of those beaux plunging through the air in different direc-

tions, is curious and highly entertaining. This play is quickly over, however, for no sooner has the female made her choice, than her approved gives chase to all intruders, drives them beyond his dominions, and returns with exultation, plunging and gambolling on the wing, but with less force, and without nearing the ground.

In windy weather, and as the dusk of the evening increases, the Night-Hawk flies lower and more swiftly than ever, making wide and irregular deviations from its general course, to overtake an insect which its keen eye has seen at a distance, after which it continues onward as before. When darkness comes on, it alights either on the ground or on a tree, where it spends the night, now and then uttering its squeak.

These birds can scarcely walk on the ground, on account of the small size and position of their legs, which are placed very far back, for which reason they cannot stand erect, but rest their breast on the ground, or on the branch of a tree, on which they are obliged to alight sidewise. They alight with ease, however, and squat on branches or fence-rails, now and then on the tops of houses or barns. In all such positions they are easily approached. I have neared them when on a fence or low wall to within a few feet, when they would look upon me with their large mild eyes more as a friend than an enemy, although they flew off the moment they observed any thing suspicious in my movements. They now and then squeak while thus seated, and if this happens when they are perched on the trees of our cities, they seldom fail to attract the attention of persons passing.

In Louisiana this species is called by the French Creoles "*Crapaud volant,*" in Virginia "*Bat;*" but the name by which it is most commonly known is "*Night-Hawk.*" The beauty and rapidity of its motions render it a tempting object to sportsmen generally, and its flesh is by no means unpalatable. Thousands are shot on their return to the south during the autumn, when they are fat and juicy. Now and then at this season, they plunge through the air, but the rustling sound of their wings at this or any other time after the love season is less remarkable.

In the Middle States, about the 20th of May, the Night-Hawk, without much care as to situation, deposits its two, almost oval, freckled eggs on the bare ground, or on an elevated spot in the ploughed fields, or even on the naked rock, sometimes in barren or open places in the skirts of the woods, never entering their depths. No nest is ever constructed, nor is the least preparation made by scooping the ground. They never, I believe, raise more than one brood in a season. The young are for some time covered with a soft down, the colour of which, being a dusky-brown, greatly contributes to their safety. Should the female be disturbed during incubation, she makes her escape, pretending lameness, fluttering and trembling, until she

THE CHIMNEY SWALLOW, OR AMERICAN SWIFT.

CHÆTURA PELASGIA, *Temm.*

PLATE XLIV.—MALE, FEMALE, AND NEST.

Since the progress of civilization in our country has furnished thousands of convenient places for this Swallow to breed in, safe from storms, snakes, or quadrupeds, it has abandoned, with a judgment worthy of remark, its former abodes in the hollows of trees, and taken possession of the chimneys which emit no smoke in the summer season. For this reason, no doubt, it has obtained the name by which it is generally known. I well remember the time when, in Lower Kentucky, Indiana, and Illinois, many resorted to excavated branches and trunks, for the purpose of breeding; nay, so strong is the influence of original habit, that not a few still betake themselves to such places, not only to roost, but also to breed, especially in those wild portions of our country that can scarcely be said to be inhabited. In such instances, they appear to be as nice in the choice of a tree, as they generally are in our cities in the choice of a chimney, wherein to roost. Sycamores of gigantic growth, and having a mere shell of bark and wood to support them, seem to suit them best, and wherever I have met with one of those patriarchs of the forest rendered habitable by decay, there I have found the Swallows breeding in spring and summer, and afterwards roosting until the time of their departure. I had a tree of this kind cut down, which contained about thirty of their nests in its trunk, and one in each of the hollow branches.

The nest, whether placed in a tree or chimney, consists of small dry twigs, which are procured by the birds in a singular manner. While on wing, the Chimney Swallows are seen in great numbers whirling round the tops of some decayed or dead tree, as if in pursuit of their insect prey. Their movements at this time are extremely rapid; they throw their body suddenly against the twig, grapple it with their feet, and by an instantaneous jerk, snap it off short, and proceed with it to the place intended for the nest. The Frigate Pelican sometimes employs the same method for a similar purpose, carrying away the stick in its bill, in place of holding it with its feet.

The Swallow fixes the first sticks on the wood, the rock, or the chimney wall, by means of its saliva, arranging them in a semicircular form, crossing and interweaving them, so as to extend the framework outwards. The whole is afterwards glued together with saliva, which is spread around it for an inch or more, to fasten it securely. When the nest is in a chimney, it is

American Swift.
(Nest.)

Drawn from Nature by J J Audubon F.R.S.P.L.S. Lith. Printed & Col.º by J.T. Bowen Philad.ª

Harvard Natural History
Society.

generally placed on the east side, and is from five to eight feet from the entrance; but in the hollow of a tree, where only they breed in communities, it is placed high or low according to convenience. The fabric, which is very frail, now and then gives way, either under the pressure of the parents and young, or during sudden bursts of heavy rain, when the whole is dashed to the ground. The eggs are from four to six, and of a pure white colour. Two broods are raised in the season.

The flight of this species is performed somewhat in the manner of the European Swift, but in a more hurried although continued style, and generally by repeated flappings, unless when courtship is going on, on which occasion it is frequently seen sailing with its wings fixed as it were; both sexes as they glide through the air issuing a shrill rattling twitter, and the female receiving the caresses of the male. At other times it is seen ranging far and wide at a considerable elevation over the forests and cities; again, in wet weather, it flies close over the ground; and anon it skims the water, to drink and bathe. When about to descend into a hollow tree or a chimney, its flight, always rapid, is suddenly interrupted as if by magic, for down it goes in an instant, whirling in a peculiar manner, and whirring with its wings, so as to produce a sound in the chimney like the rumbling of very distant thunder. They never alight on trees or on the ground. If one is caught and placed on the latter, it can only move in a very awkward fashion. I believe that the old birds sometimes fly at night, and have reason to think that the young are fed at such times, as I have heard the whirring sound of the former, and the acknowledging cries of the latter, during calm and clear nights.

When the young accidentally fall, which sometimes happens, although the nest should remain, they scramble up again, by means of their sharp claws, lifting one foot after another, in the manner of young Wood Ducks, and supporting themselves with their tail. Some days before the young are able to fly, they scramble up the walls to near the mouth of the chimney, where they are fed. Any observer may discover this, as he sees the parents passing close over them, without entering the funnel. The same occurrence takes place when they are bred in a tree.

In the cities, these birds make choice of a particular chimney for their roosting place, where, early in spring, before they have begun building, both sexes resort in multitudes, from an hour or more before sunset, until long after dark. Before entering the aperture, they fly round and over it many times, but finally go in one at a time, until hurried by the lateness of the hour, several drop in together. They cling to the wall with their claws, supporting themselves also by their sharp tail, until the dawn, when, with a roaring sound, the whole pass out almost at once. Whilst at St. Francisville

GENUS I.—HIRUNDO, *Linn.* SWALLOW.

Characters as above; tail emarginate or forked.

THE PURPLE MARTIN.

HIRUNDO PURPUREA, *Linn.*

PLATE XLV.—MALE AND FEMALE.

The Purple Martin makes its appearance in the City of New Orleans from the 1st to the 9th of February, occasionally a few days earlier than the first of these dates, and is then to be seen gambolling through the air, over the city and the river, feeding on many sorts of insects, which are there found in abundance at that period.

It frequently rears three broods whilst with us. I have had several opportunities, at the period of their arrival, of seeing prodigious flocks moving over that city or its vicinity, at a considerable height, each bird performing circular sweeps as it proceeded, for the purpose of procuring food. These flocks were loose, and moved either eastward, or towards the north-west, at a rate not exceeding four miles in the hour, as I walked under one of them with ease for upwards of two miles, at that rate, on the 4th of February, 1821, on the bank of the river below the city, constantly looking up at the birds, to the great astonishment of many passengers, who were bent on far different pursuits. My Fahrenheit's thermometer stood at 68°, the weather being calm and drizzly. This flock extended about a mile and a half in length, by a quarter of a mile in breadth. On the 9th of the same month, not far above the *Battle-ground,* I enjoyed another sight of the same kind, although I did not think the flock so numerous.

At the Falls of the Ohio, I have seen Martins as early as the 15th of March, arriving in small detached parties of only five or six individuals, when the thermometer was as low as 28°, the next day at 45°, and again, in the same week, so low as to cause the death of all the Martins, or to render them so incapable of flying as to suffer children to catch them. By the 25th of the same month, they are generally plentiful about that neighbourhood.

At St. Genevieve, in the State of Missouri, they seldom arrive before the

Pl. 45.

Purple Martin.
(Calabash.)

Drawn from Nature by J.J.Audubon, F.R.S.F.L.S.

Lithd Printed & Cold by J.T. Bowen, Philadª

Harvard Natural History Society.

10th or 15th of April, and sometimes suffer from unexpected returns of frost. At Philadelphia, they are first seen about the 10th of April. They reach Boston about the 25th, and continue their migration much farther north, as the spring continues to open.

On their return to the Southern States, they do not require to wait for warmer days, as in spring, to enable them to proceed, and they all leave the above-mentioned districts and places about the 20th of August. They assemble in parties of from fifty to a hundred and fifty, about the spires of churches in the cities, or on the branches of some large dead tree about the farms, for several days before their final departure. From these places they are seen making occasional sorties, uttering a general cry, and inclining their course towards the west, flying swiftly for several hundred yards, when suddenly checking themselves in their career, they return in easy sailings to the same tree or steeple. They seem to act thus for the purpose of exercising themselves, as well as to ascertain the course they are to take, and to form the necessary arrangements for enabling the party to encounter the fatigues of their long journey. Whilst alighted, during these days of preparation, they spend the greater part of the time in dressing and oiling their feathers, cleaning their skin, and clearing, as it were, every part of their dress and body from the numerous insects which infest them. They remain on their roosts exposed to the night air, a few only resorting to the boxes where they have been reared, and do not leave them until the sun has travelled an hour or two from the horizon, but continue, during the fore part of the morning, to plume themselves with great assiduity. At length, on the dawn of a calm morning, they start with one accord, and are seen moving due west or southwest, joining other parties as they proceed, until there is formed a flock similar to that which I have described above. Their progress is now much more rapid than in spring, and they keep closer together.

It is during these migrations, reader, that the power of flight possessed by these birds can be best ascertained, and more especially when they encounter a violent storm of wind. They meet the gust, and appear to slide along the edges of it, as if determined not to lose one inch of what they have gained. The foremost front the storm with pertinacity, ascending or plunging along the skirts of the opposing currents, and entering their undulating recesses, as if determined to force their way through, while the rest follow close behind, all huddled together into such compact masses as to appear like a black spot. Not a twitter is then to be heard from them by the spectator below; but the instant the farther edge of the current is doubled, they relax their efforts, to refresh themselves, and twitter in united accord, as if congratulating each other on the successful issue of the contest.

The usual flight of this bird more resembles that of the *Hirundo urbica*

of LINNÆUS, or that of the *Hirundo fulva* of VIEILLOT, than the flight of
any other species of Swallow; and, although graceful and easy, cannot be
compared in swiftness with that of the Barn Swallow. Yet the Martin is
fully able to distance any bird not of its own genus. They are very expert
at bathing and drinking while on the wing, when over a large lake or river,
giving a sudden motion to the hind part of the body, as it comes into contact
with the water, thus dipping themselves in it, and then rising and shaking
their body, like a water spaniel, to throw off the water. When intending to
drink, they sail close over the water, with both wings greatly raised, and
forming a very acute angle with each other. In this position, they lower
the head, dipping their bill several times in quick succession, and swallowing
at each time a little water.

They alight with comparative ease on different trees, particularly willows,
making frequent movements of the wings and tail as they shift their place,
in looking for leaves to convey to their nests. They also frequently alight
on the ground, where, notwithstanding the shortness of their legs, they move
with some ease, pick up a goldsmith or other insect, and walk to the edges
of puddles to drink, opening their wings, which they also do when on trees,
feeling as if not perfectly comfortable.

These birds are extremely courageous, persevering, and tenacious of what
they consider their right. They exhibit strong antipathies against cats, dogs,
and such other quadrupeds as are likely to prove dangerous to them. They
attack and chase indiscriminately every species of Hawk, Crow, or Vulture,
and on this account are much patronized by the husbandman. They fre-
quently follow and tease an Eagle, until he is out of sight of the Martin's
box; and to give you an idea of their tenacity, when they have made choice
of a place in which to rear their young, I shall relate to you the following
occurrences.

I had a large and commodious box built and fixed on a pole, for the
reception of Martins, in an enclosure near my house, where for some years
several pairs had reared their young. One winter I also put up several
small boxes, with a view to invite Blue-birds to build nests in them. The
Martins arrived in the spring, and imagining these smaller apartments more
agreeable than their own mansion, took possession of them, after forcing the
lovely Blue-birds from their abode. I witnessed the different conflicts, and
observed that one of the Blue-birds was possessed of as much courage as his
antagonist, for it was only in consequence of the more powerful blows of the
Martin, that he gave up his house, in which a nest was nearly finished, and
he continued on all occasions to annoy the usurper as much as lay in his
power. The Martin shewed his head at the entrance, and merely retorted
with accents of exultation and insult. I thought fit to interfere, mounted

the tree on the trunk of which the Blue-bird's box was fastened, caught the Martin, and clipped his tail with scissors, in the hope that such mortifying punishment might prove effectual in inducing him to remove to his own tenement. No such thing; for no sooner had I launched him into the air, than he at once rushed back to the box. I again caught him, and clipped the tip of each wing in such a manner that he still could fly sufficiently well to procure food, and once more set him at liberty. The desired effect, however, was not produced, and as I saw the pertinacious Martin keep the box in spite of all my wishes that he should give it up, I seized him in anger, and disposed of him in such a way that he never returned to the neighbourhood.

At the house of a friend of mine in Louisiana, some Martins took possession of sundry holes in the cornices, and there reared their young for several years, until the insects which they introduced to the house induced the owner to think of a reform. Carpenters were employed to clean the place, and close up the apertures by which the birds entered thè cornice. This was soon done. The Martins seemed in despair; they brought twigs and other materials, and began to form nests wherever a hole could be found in any part of the building; but were so chased off that after repeated attempts, the season being in the mean time advanced, they were forced away, and betook themselves to some Woodpeckers' holes on the dead trees about the plantation. The next spring, a house was built for them. The erection of such houses is a general practice, the Purple Martin being considered as a privileged pilgrim, and the harbinger of spring.

The note of the Martin is not melodious, but is nevertheless very pleasing. The twitterings of the male while courting the female are more interesting. Its notes are among the first that are heard in the morning, and are welcome to the sense of every body. The industrious farmer rises from his bed as he hears them. They are soon after mingled with those of many other birds, and the husbandman, certain of a fine day, renews his peaceful labours with an elated heart. The still more independent Indian is also fond of the Martin's company. He frequently hangs up a calabash on some twig near his camp, and in this cradle the bird keeps watch, and sallies forth to drive off the Vulture that might otherwise commit depredations on the deer-skins or pieces of venison exposed to the air to be dried. The slaves in the Southern States take more pains to accommodate this favourite bird. The calabash is neatly scooped out, and attached to the flexible top of a cane, brought from the swamp, where that plant usually grows, and placed close to their huts. Almost every country tavern has a Martin box on the upper part of its sign-board; and I have observed that the handsomer the box, the better does the inn generally prove to be.

mention the periods of its arrival or departure. In all parts of the country which are well wooded, it was, until lately, in the constant habit of breeding in the hollows of trees; now, however, this is not so much the case, as will be seen from the following note of Dr. Thomas M. Brewer of Boston:—
"The *Hirundo bicolor* arrives in New England the last of April or the first of May, and is principally occupied, preparatory to breeding, with obstinate contests with its own species, as well as with the Blue-bird, the Wren, and the Barn Swallow. In the vicinity of Boston, since the destruction of the Purple Martins already mentioned, they have taken their places, building in the boxes, jars, &c. originally intended for their relatives, so much so, that in this vicinity they are not now known to breed at all in the hollow trees; a change of habit very unusual, if not wholly unexampled. So much do they prefer their present mode of breeding, that I have known them to breed in a rude candle-box, of which one side had been knocked out, placed upon the top of the house. In the first part of August, they collect in large flocks about ten days before their departure for warmer climates. During that time they are to be seen in great quantities flying around and over the houses in Boston in quest of insects."

My friend Dr. Bachman says, "On the afternoon of the 16th of October, 1833, in company with Dr. Wilson and Mr. John Woodhouse Audubon, I saw such an immense quantity of this species of birds that the air was positively darkened. As far as the eye could reach, there were Swallows crowded thickly together, and winging their way southward; there must have been many millions!"

GREEN-BLUE or WHITE-BELLIED SWALLOW, *Hirundo viridis*, Wils. Amer. Orn., vol. iii.
 p. 44.
HIRUNDO BICOLOR, Bonap. Syn., p. 65.
WHITE-BELLIED SWALLOW, *Hirundo bicolor*, Nutt. Man., vol. i. p. 605.
WHITE-BELLIED SWALLOW, *Hirundo bicolor*, Aud. Orn. Biog., vol. i. p. 491; vol. v. p. 417.

Wings a little longer than the tail, which is deeply emarginate. Upper parts steel-blue, with green reflections, lower white; feet flesh coloured. Female similar to the male.

Male, 5¼ inches long, 10 in extent of wings.

Harvard ~ Natural History
Society.

White-bellied Swallow.

Drawn from Nature by J.J. Audubon F.R.S.F.L.S Lith. Printed & Col.d by J.T. Bowen Philad.a

Harvard Natural History
Society.

Pl. 47.

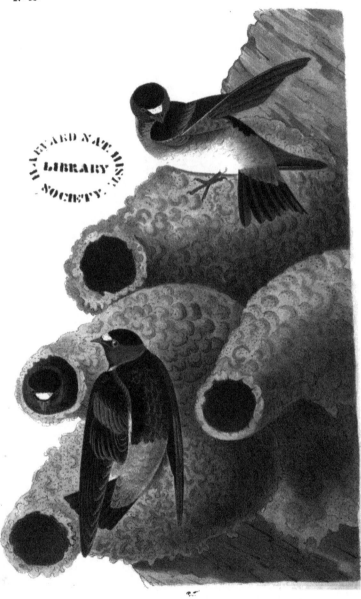

Cliff Swallow
(Nest.)

Drawn from Nature by J J Audubon FRS FLS

Lith⁴ Printed & col⁴ by J.T. Bowen Philad⁴

L

Cliff Swallow
(Male)

THE REPUBLICAN OR CLIFF SWALLOW.

HIRUNDO FULVA, *Vieill.*

PLATE XLVII.—MALE, FEMALE, AND NEST.

In the spring of 1815, I for the first time saw a few individuals of this species at Henderson, on the banks of the Ohio, a hundred and twenty miles below the Falls of that river. It was an excessively cold morning, and nearly all were killed by the severity of the weather. I drew up a description at the time, naming the species *Hirundo republicana*, the *Republican Swallow*, in allusion to the mode in which the individuals belonging to it associate, for the purpose of forming their nests and rearing their young. Unfortunately, through the carelessness of my assistant, the specimens were lost, and I despaired for years of meeting with others.

In the year 1819, my hopes were revived by Mr. ROBERT BEST, curator of the Western Museum at Cincinnati, who informed me that a strange species of bird had made its appearance in the neighbourhood, building nests in clusters, affixed to the walls. In consequence of this information, I immediately crossed the Ohio to Newport, in Kentucky, where he had seen many nests the preceding season; and no sooner were we landed than the chirruping of my long-lost little strangers saluted my ear. Numbers of them were busily engaged in repairing the damage done to their nests by the storms of the preceding winter.

Major OLDHAM of the United States Army, then commandant of the garrison, politely offered us the means of examining the settlement of these birds, attached to the walls of the building under his charge. He informed us, that, in 1815, he first saw a few of them working against the wall of the house, immediately under the eaves and cornice; that their work was carried on rapidly and peaceably, and that as soon as the young were able to travel, they all departed. Since that period, they had returned every spring, and then amounted to several hundreds. They usually appeared about the 10th of April, and immediately began their work, which was at that moment, it being then the 20th of that month, going on in a regular manner, against the walls of the arsenal. They had about fifty nests quite finished, and others in progress.

About day-break they flew down to the shore of the river, one hundred yards distant, for the muddy sand, of which the nests were constructed, and worked with great assiduity until near the middle of the day, as if aware that

the heat of the sun was necessary to dry and harden their moist tenements. They then ceased from labour for a few hours, amused themselves by performing aërial evolutions, courted and caressed their mates with much affection, and snapped at flies and other insects on the wing. They often examined their nests to see if they were sufficiently dry, and as soon as these appeared to have acquired the requisite firmness, they renewed their labours. Until the females began to sit, they all roosted in the hollow limbs of the sycamores (*Platanus occidentalis*) growing on the banks of the Licking river, but when incubation commenced, the males alone resorted to the trees. A second party arrived, and were so hard pressed for time, that they betook themselves to the holes in the wall, where bricks had been left out for the scaffolding. These they fitted with projecting necks, similar to those of the complete nests of the others. Their eggs were deposited on a few bits of straw, and great caution was necessary in attempting to procure them, as the slightest touch crumbled their frail tenement into dust. By means of a table-spoon, I was enabled to procure many of them. Each nest contained four eggs, which were white, with dusky spots. Only one brood is raised in a season. The energy with which they defended their nests was truly astonishing. Although I had taken the precaution to visit them at sun-set, when I supposed they would all have been at rest, yet a single female happening to give the alarm, immediately called out the whole tribe. They snapped at my hat, body and legs, passed between me and the nests, within an inch of my face, twittering their rage and sorrow. They continued their attacks as I descended, and accompanied me for some distance. Their note may be perfectly imitated by rubbing a cork damped with spirit against the neck of a bottle.

A third party arrived a few days after, and immediately commenced building. In one week they had completed their operations, and at the end of that time thirty nests hung clustered like so many gourds, each having a neck two inches long. On the 27th July, the young were able to follow their parents. They all exhibited the white frontlet, and were scarcely distinguishable in any part of their plumage from the old birds. On the 1st of August, they all assembled near their nests, mounted some three hundred feet in the air, and about 10 o'clock in the morning took their departure, flying in a loose body, in a direction due north. They returned the same evening about dusk, and continued these excursions, no doubt to exercise their powers, until the third, when, uttering a farewell cry, they shaped the same course at the same hour, and finally disappeared. Shortly after their departure, I was informed that several hundreds of their nests were attached to the court-house at the mouth of the Kentucky river. They had commenced building them in 1815. A person likewise informed me, that, along

the cliffs of the Kentucky, he had seen many *bunches*, as he termed them, of these nests attached to the naked shelving rocks overhanging that river.

Being extremely desirous of settling the long-agitated question respecting the migration or supposed torpidity of Swallows, I embraced every opportunity of examining their habits, carefully noted their arrival and disappearance, and recorded every fact connected with their history. After some years of constant observation and reflection, I remarked that among all the species of migratory birds, those that remove farthest from us, depart sooner than those which retire only to the confines of the United States; and, by a parity of reasoning, those that remain later return earlier in the spring. These remarks were confirmed as I advanced towards the south-west, on the approach of winter, for I there found numbers of Warblers, Thrushes, &c. in full feather and song. It was also remarked that the *Hirundo viridis* of Wilson (called by the French of Lower Louisiana *Le Petit Martinet à ventre blanc*) remained about the city of New Orleans later than any other Swallow. As immense numbers of them were seen during the month of November, I kept a diary of the temperature from the 3d of that month, until the arrival of *Hirundo purpurea*. The following notes are taken from my journal, and as I had excellent opportunities, during a residence of many years in that country, of visiting the lakes to which these Swallows were said to resort, during the transient frosts, I present them with confidence.

Nov. 11.—Weather very sharp, with a heavy white frost. Swallows in abundance during the whole day. On inquiring of the inhabitants if this was a usual occurrence, I was answered in the affirmative by all the French and Spaniards. From this date to the 22nd, the thermometer averaged 65°, the weather generally a drizzly fog. Swallows playing over the city in thousands.

Nov. 25.—Thermometer this morning at 30°. Ice in New Orleans a quarter of an inch thick. The Swallows resorted to the lee of the Cypress Swamp in the rear of the city. Thousands were flying in different flocks. Fourteen were killed at a single shot, all in perfect plumage, and very fat. The markets were abundantly supplied with these tender, juicy, and delicious birds. Saw Swallows every day, but remarked them more plentiful the stronger the breeze blew from the sea.

Jan. 14.—Thermometer 42°. Weather continues drizzly. My little favourites constantly in view.

Jan. 28.—Thermometer at 40°. Having seen the *Hirundo viridis* continually, and the *H. purpurea* or Purple Martin beginning to appear, I discontinued my observations.

During the whole winter many of them retired to the holes about the houses, but the greater number resorted to the lakes, and spent the night

among the branches of *Myrica cerifera*, the *Cirier*, as it is termed by the French settlers.

About sunset they began to flock together, calling to each other for that purpose, and in a short time presented the appearance of clouds moving towards the lakes, or the mouth of the Mississippi, as the weather and wind suited. Their aërial evolutions before they alight, are truly beautiful. They appear at first as if reconnoitering the place; when, suddenly throwing themselves into a vortex of apparent confusion, they descend spirally with astonishing quickness, and very much resemble a *trombe* or water-spout. When within a few feet of the *ciriers*, they disperse in all directions, and settle in a few moments. Their twittering, and the motions of their wings, are, however, heard during the whole night. As soon as the day begins to dawn, they rise, flying low over the lakes, almost touching the water for some time, and then rising, gradually move off in search of food, separating in different directions. The hunters who resort to these places destroy great numbers of them, by knocking them down with light paddles, used in propelling their canoes.

FULVOUS or CLIFF SWALLOW, *Hirundo fulva*, Bonap. Amer. Orn., vol. i. p. 63.
HIRUNDO FULVA, Bonap. Syn., p. 64.
FULVOUS or CLIFF SWALLOW, *Hirundo fulva*, Nutt. Man., vol. i. p. 603.
REPUBLICAN or CLIFF SWALLOW, Aud. Orn. Biog., vol. i. p. 353; vol. v. p. 415.

Bill shorter than in the last species; wings of the same length as the tail, which is slightly emarginate. Upper part of head, back, and smaller wing-coverts black, with bluish-green reflections; forehead white, generally tinged with red; loral space and a band on the lower part of the forehead black; chin, throat, and sides of the neck deep brownish-red; a patch of black on the fore-neck; rump light yellowish-red; lower parts greyish-white, anteriorly tinged with red. Female, similar to the male. Young, dark greyish-brown above, reddish-white beneath.

Male, 5$\frac{1}{2}$, 12. Female, 5$\frac{4}{11}$, 12$\frac{3}{4}$.

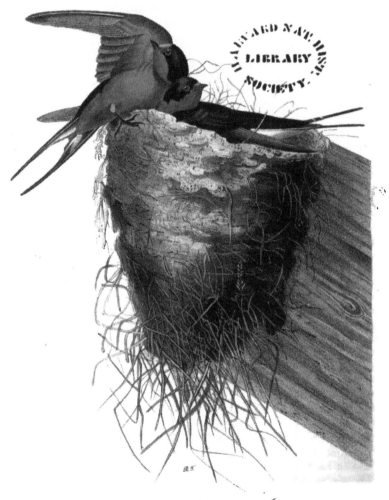

Barn or Chimney Swallow.

Drawn from Nature by J. J. Audubon F.R.S.F.L.S Lith⁴ Printed & Col⁴ by J.T. Bowen Philad⁴

THE BARN SWALLOW.

Hirundo rustica, *Linn.*

PLATE XLVIII.—Male, Female, and Nest.

The Barn Swallow makes its first appearance at New Orleans from the middle of February to the first of March. They do not arrive in flocks, but apparently in pairs, or a few together, and immediately resort to the places where they have bred before, or where they have been reared. Their progress over the Union depends much on the state of the weather; and I have observed a difference of a whole month, owing to the varying temperature, in their arrival at different places. Thus in Kentucky, Virginia, or Pennsylvania, they now and then do not arrive until the middle of April or the beginning of May. In milder seasons they reach Massachusetts and the eastern parts of Maine by the 10th of the latter month, when you may rest assured that they are distributed over all the intermediate districts. So hardy does this species seem to be, that I observed it near Eastport in Maine, on the 7th May, 1833, in company with the Republican or Cliff Swallow, pursuing its different avocations, while masses of ice hung from every cliff, and the weather felt cold to me. I saw them in the Gut of Cansso on the 10th of June, and on the Magdeleine Islands on the 13th of the same month. They were occupied in building their nests in the open cupola of a church. Not one, however, was observed in Labrador, although many Sand Martins were seen there. On our return, I found at Newfoundland some of the present species, and of the Cliff Swallow, all of which were migrating southward on the 14th of August, when Fahrenheit's thermometer stood at 41°.

In spring, the Barn Swallow is welcomed by all, for she seldom appears before the final melting of the snows and the commencement of mild weather, and is looked upon as the harbinger of summer. As she never commits depredations on any thing that men consider as their own, every body loves her, and, as the child was taught by his parents, so the man teaches his offspring, to cherish her. About a week after the arrival of this species, and when it has already resorted to its wonted haunts, examined its last year's tenement, or made choice of a place to which it may securely fix its nest, it begins either to build or to deposit its eggs.

The nest is attached to the side of a beam or rafter in a barn or shed, under a bridge, or sometimes even in an old well, or in a sink hole, such as those found in the Kentucky barrens. Whenever the situation is convenient

and affords sufficient room, you find several nests together, and in some instances I have seen seven or eight within a few inches of each other; nay, in some large barns I have counted forty, fifty, or more. The male and the female both betake themselves to the borders of creeks, rivers, ponds, or lakes, where they form small pellets of mud or moist earth, which they carry in their bill to the chosen spot, and place against the wood, the wall, or the rock, as it may chance to be. They dispose of these pellets in regular lays, mixing, especially with the lower, a considerable quantity of long slender grasses, which often dangle for several inches beneath the bottom of the nest. The first layers are short, but the rest gradually increase in length, as the birds proceed upwards with their work, until they reach the top, when the fabric resembles the section of an inverted cone, the length being eight inches, and the greatest diameter six, while that from the wall or other flat surface to the outside of the shell is three and a half, and the latter is fully an inch thick. I have never observed in a newly finished nest, the expansion of the upper layer mentioned by WILSON, although I have frequently seen it in one that has been repaired or enlarged. The average weight of such a nest as I have described is more than two pounds, but there is considerable difference as to size between different nests, some being shorter by two or three inches, and proportionally narrow at the top. These differences depend much on the time the birds have to construct their tenement previous to depositing the eggs. Now and then I have seen some formed at a late period, that were altogether destitute of the intermixture of grass with the mud observed in the nest described above, which was a perfect one, and had occupied the birds seven days in constructing it, during which period they laboured from sunrise until dusk, with an intermission of several hours in the middle of the day. Within the shell of mud is a bed, several inches thick, of slender grasses arranged in a circular form, over which is placed a quantity of large soft feathers. I never saw one of these nests in a chimney, nor have I ever heard of their occurring in such situations, they being usually occupied by the American Swift, which is a more powerful bird, and may perhaps prevent the Barn Swallow from entering. The eggs are from four to six, rather small and elongated, semi-translucent, white, and sparingly spotted all over with reddish-brown. The period of incubation is thirteen days, and both sexes sit, although not for the same length of time, the female performing the greater part of the task. Each provides the other with food on this occasion, and both rest at night beside each other in the nest. In South Carolina, where a few breed, the nest is formed in the beginning of April, and in Kentucky about the first of May.

When the young have attained a considerable size, the parents, who feed them with much care and affection, roost in the nearest convenient place.

This species seldom raises more than two broods in the Southern and Middle Districts, and never, I believe, more than one in Maine and farther north. The little ones, when fully fledged, are enticed to fly by their parents, who, shortly after their first essays, lead them to the sides of fields, roads or rivers, where you may see them alight, often not far from each other, on low walls, fence-stakes and rails, or the withered twigs or branches of some convenient tree, generally in the vicinity of a place in which the old birds can easily procure food for them. As the young improve in flying, they are often fed on the wing by the parent birds. On such occasions, when the old and young birds meet, they both rise obliquely in the air, and come close together, when the food is delivered in a moment, and they separate to continue their gambols. In the evening the family retires to the breeding place, to which it usually resorts until the period of their migration.

About the middle of August, the old and young birds form more extensive associations, flying about in loose flocks, which are continually increasing, and alighting in groups on tall trees, churches, court-houses, or barns, where they may be seen for hours pluming and dressing themselves, or removing the small insects which usually infest them. At such times they chirp almost continually, and make sallies of a few hundred yards, returning to the same place. These meetings and rambles often occupy a fortnight, but generally by the 10th of September great flocks have set out for the south, while others are seen arriving from the north. The dawn of a fair morning is the time usually chosen by these birds for their general departure, which I have no reason to believe is prevented by a contrary wind. They are seen moving off without rising far above the tops of the trees or towns over which they pass; and I am of opinion that most of them in large parties usually migrate either along the shores of the Atlantic, or along the course of large streams, such places being most likely to afford suitable retreats at night, when they betake themselves to the reeds and other tall grasses, if it is convenient to do so, although I have witnessed their migration during a fine, clear, quiet evening. Should they meet with a suitable spot, they alight close together, and for awhile twitter loudly, as if to invite approaching flocks or stragglers to join them. In such places I have seen great flocks of this species in East Florida;—and here, reader, I may tell you that the fogs of that latitude seem not unfrequently to bewilder their whole phalanx. One morning, whilst on board the United States Schooner "Spark," lieutenant commandant PIERCY and the officers directed my attention to some immense flocks of these birds flying only a few feet above the water for nearly an hour, and moving round the vessel as if completely lost. But when the morning is clear, these Swallows rise in a spiral manner from the reeds to

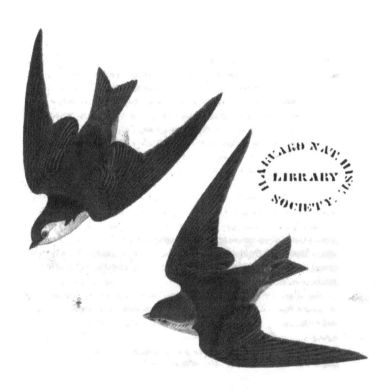

Violet-Green Swallow

Drawn from Nature by J.J.Audubon F.R.S.F.L.S

Lith⁴ Printed & Col⁴ by J.T.Bowen Phila⁴

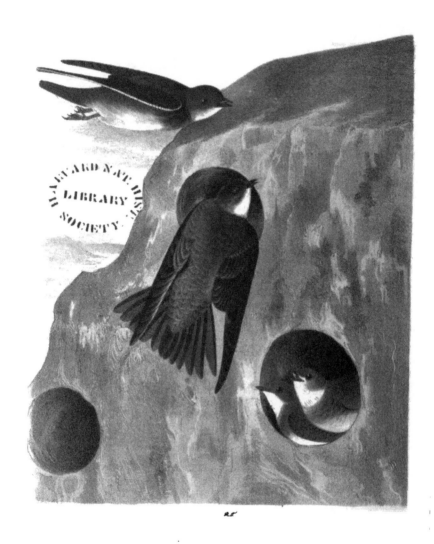

Bank Swallow

Drawn from Nature by J. J. Audubon F.R.S.F.L.S. Lith'd Printed & col'd by J.T. Bowen Philad'a

between species supposed by some to be different, and by others identical. To
give you some definite idea of what I would here impress upon your mind,
I need only say that I have seen nests of the Barn or Chimney Swallow
placed within buildings, under cattle-sheds, against the sides of wells, and in
chimneys; that while some were not more than three inches deep, others
measured nearly nine; while in some there was scarcely any grass, in others
it formed nearly half of their bulk. I have also observed some nests of the
Cliff Swallow in which the eggs had been deposited before the pendent neck
was added, and which remained so until the birds had reared their brood,
amidst other nests furnished with a neck, which was much longer in some
than in others. From this I have inferred that nests are formed more or
less completely, in many instances, in accordance with the necessity under
which the bird may be of depositing its eggs.

HIRUNDO THALASSINUS, Swains. Syn. of Mex. Birds, Phil. Mag. for 1827, p. 365.
VIOLET-GREEN SWALLOW, *Hirundo thalassina*, Aud. Orn. Biog., vol. iv. p. 597.

Bill narrower than in the preceding species; wings extremely long, ex-
tending far beyond the tail, which is emarginate. Upper part of head deep
green, gradually shaded into the dark purple of the hind neck; back rich
grass-green, rump and upper tail-coverts carmine purple; a line over the eye,
cheeks, and all the lower parts pure white, excepting the wing-coverts, which
are light grey. Female with the upper part of the head and hind neck light
greyish-brown, glossed with green; the back as in the male, the rump
greyish-brown; lower parts white, anteriorly tinged with grey.

Male, $4\frac{4}{8}$, wing $4\frac{6}{12}$.

BANK SWALLOW OR SAND MARTIN.

HIRUNDO RIPARIA, *Linn.*

PLATE L.—MALE, FEMALE, AND YOUNG.

Imagine, reader, how delighted I was when, in East Florida, in the winter
of 1831, I found thousands of Bank Swallows gaily skimming over the
waters, and along the shores of the rivers and inlets. So numerous indeed
were they that I felt inclined to think that the greater part of those which
are in summer dispersed over the United States, and the regions still farther
north, must have congregated to form those vast swarms. The first time I

saw them was before sunrise, when I stood by the side of Lieutenant PERCY of our Navy, on the deck of the United States' schooner the Spark, then at anchor opposite St. Augustine. The weather though warm, was thick and drizzly, so that we could not see to a great distance; but as probably some hundreds of thousands passed close to the vessel, in long and rather close flocks, I was well enabled to assure myself that the birds were of this species. On expressing my surprise and delight at beholding so vast a concourse, Lieutenant PERCY assured me, that he had seen them on all the streams which he had visited south of where we then were. The weather cleared up in a few hours, the sun shone brightly, and the little creatures were seen all around, dipping into the water to wash themselves, gambolling close over its surface, and busily engaged in procuring insects, which in that country are always abundant. In the course of the same season I also observed a good number of our Green-backed and Barn Swallows—but few compared with what are seen about New Orleans.

We can thus account for the early appearance of the Bank Swallows in our Middle Districts. That species always arrives there sooner than the rest, sometimes preceding them by a fortnight, and keeping equally in advance as far northward as its range extends. The Green-backed Swallow, *Hirundo bicolor*, follows closely after it; then the Purple Martin, *Hirundo purpurea*; after which are seen the Barn Swallow, *Hirundo rustica*, and lastly, on our eastern Atlantic coasts, the American Swift, *Cypselus Americanus*. It is probable that these species extend their autumnal migrations southward in a degree proportionate to the lateness of their appearance in spring. I have likewise observed the arrival of the Bank Swallows on the waters of the Serpentine river and those of the Regent's Park, in London, to be in the same proportion earlier than that of the other species which visit England in spring, and have thought that, as with us, the first mentioned species retire to a less distance in winter than the rest.

The Bank Swallow has been observed on both sides of North America, and in all intermediate places suited to its habits. This is easily accounted for, when we reflect how easy it is for these birds to follow our great water-courses to their very sources. Even the ponds and lakes of our vast forests are at times visited by them; but no person seems to have been aware of the existence of two species of Bank Swallows in our country, which, however, I shall presently shew to be the case.

Wherever, throughout the United States, sand-banks or artificial excavations occur, there is found the Bank Swallow during the breeding season, in greater or smaller numbers, according to the advantages presented by the different localities, not only along the shores of our rivers and lakes, but also on the coasts of the Atlantic, and not unfrequently in inland situa-

tions, at some distance from any water. High banks, composed of softish sandy earth, on the shores of rivers, lakes, or other waters, suit them best, and in such situations their colonies are far more numerous than elsewhere. The banks of the Ohio, and some parts of those of the Mississippi, called "Bluffs," have appeared to me to be most resorted to by this species in our western and southern districts, although I have met with considerable numbers in every State of the Union.

In Louisiana this species begins to breed early in March, and generally rears two, sometimes three broods in a season. In our Middle Districts it commences about a month later, or about the period at which it lays in Kentucky, and there produces two broods. In Newfoundland and Labrador, it rarely begins to breed before the beginning of June, and lays only once. Dr. RICHARDSON states, that he saw "thousands of these Swallows near the mouth of the Mackenzie, in the sixty-eighth parallel, on the 4th of July," and from the state of the weather at that period supposed that they had arrived there at least a fortnight prior to that date, but no specimens were brought to England, and the description given in the Fauna Boreali-Americana is a mere transcript of that which in itself is quite imperfect. Indeed, there is not in any work with which I am acquainted an account of the Sand Swallow sufficiently minute and accurate to characterize in an adequate manner that very common species.

The sociability and gentleness of these birds, the lightness and vigour with which they perform their various evolutions, the low and unobtrusive twittering of their voice, in short, all their actions and economy, are delightful to contemplate. Their flight is exceedingly graceful, light, yet firm, and capable of great continuance. They seem indeed as if created for the purpose of spending their time on wing, for they alight less often to rest when full grown than any other of our species, when not sitting on their eggs, and are seen abroad searching for food later in the dusk, retiring for the night as late, I think, as our Swift, *Cypselus Americanus.* As they procure their food more commonly than the other species along the margins or over the surface of pools, lakes, rivers, or even the sea, their flight is generally performed at a small elevation, which is the case with others only when the wind blows smartly, or the atmosphere is damp and chill. The movements of their wings are those common to the family of Swallows, which flap these members less frequently than perhaps any other small land birds. The wings act on the hinge formed by the carpal joint, opening and closing like the blades of scissors. Their sailings, though frequent, are not extensive, and their tail appears to be of great service to them, as you observe that on the least deviation from a straight course, it becomes suddenly more or less closed or inclined upward, downward, or sideways; and when you see some

same manner as Woodpeckers; and few ornithological occupations have proved more pleasing to me than that of watching several hundred pairs of these winged artificers all busily and equally engaged, some in digging the burrows, others in obtaining food, which they would now and then bring in their bills for the use of their mates, or in procuring bits of dry grass or large feathers of the duck or goose, for the construction of their nests.

So industrious are the little creatures that I have known a hole dug to the depth of three feet four inches, and the nest finished, in four days, the first egg being deposited on the morning of the fifth. It sometimes happens that soon after the excavation has been commenced, some obstruction presents itself, defying the utmost exertions of the birds; in which case they abandon the spot, and begin elsewhere in the neighbourhood. If these obstructions occur and are pretty general, the colony leave the place; and it is very seldom that, after such an occurrence, any Swallows of this species are seen near it. I have sometimes been surprised to see them bore in extremely loose sand. On the sea-coast, where soft banks are frequent, you might suppose that, as the burrows are only a few inches apart, the sand might fall in so as to obstruct the holes and suffocate their inmates; but I have not met with an instance of such a calamitous occurrence. Along the banks of small rivulets, I have found these birds having nests within a foot or two of the water, having been bored among the roots of some large trees, where I thought they were exposed to mice, rats, or other small predaceous animals. The nest is generally formed of some short bits of dry grass, and lined with a considerable number of large feathers. They lay from five to seven eggs for the first brood, fewer for the next. They are of an ovate, somewhat pointed form, pure white, eight-twelfths of an inch long, and six-twelfths in breadth.

The young, as soon as they are able to move with ease, often crawl to the entrance of the hole, to wait the return of their parents with food. On such occasions they are often closely watched by the smaller Hawks, as well as the common Crows, which seize and devour them, in spite of the clamour of the old birds. These depredations upon the young are in fact continued after they have left the nest, and while they are perched on the dry twigs of the low trees in the neighbourhood, until they are perfectly able to maintain themselves on wing without the assistance of their parents.

In Louisiana, or in any district where this species raises more than one brood in the season, the males, I believe, take the principal charge of the young that have left the nest, though both sexes alternately incubate, all their moments being thus rendered full of care and anxiety respecting both their offspring and the sitting bird. The young acquire the full brown plumage of the adult by the first spring, when there is no observable difference be-

Rough-winged Swallow.

Drawn from Nature by J.J.Audubon F.R.S.F.L.S. Lith.d Printed & Col.d by J.T.Bowen Phila.

tween them; but I am induced to think that they keep apart from the old birds during the first winter, when I have thought I could yet perceive an inferiority in their flight, as well as in the loudness of their notes.

This species has no song, properly so called, but merely a twitter of short lisping notes. In autumn it at times alights on trees preparatory to its departure. On such occasions the individuals, often collected in great numbers, take up the time chiefly in pluming themselves, in which occupation they continue for hours.

I must conclude with assuring you that in my opinion, no difference whatever exists between the Bank Swallow of America and that of Europe. The birds from which I made the drawing for my plate were procured on the banks of the Schuylkill river in 1824.

BANK SWALLOW or SAND MARTIN, *Hirundo riparia*, Wils. Amer. Orn., vol. v. p. 46.
HIRUNDO RIPARIA, Bonap. Syn., p. 65.
HIRUNDO RIPARIA, SAND MARTIN, Swains. and Rich. F. Bor. Amer., vol. ii. p. 333.
BANK SWALLOW, or SAND MARTIN, *Hirundo riparia*, Nutt. Man., vol. i. p. 607.
BANK SWALLOW or SAND MARTIN, *Hirundo riparia*, Aud. Orn. Biog., vol. iv. p. 584.

Tail slightly forked, margin of first quill smooth, tarsus with a tuft of feathers behind; upper parts greyish-brown, lower whitish, with a dusky band across the fore part of the neck. Young with the feathers of the upper parts margined with reddish-white.

Male, 5, 11. Female, 4⅞.

ROUGH-WINGED SWALLOW.

HIRUNDO SERRIPENNIS, *Aud.*

PLATE LI.

On the afternoon of the 20th of October, 1819, I was walking along the shores of a forest-margined lake, a few miles from Bayou Sara, in pursuit of some Ibises, when I observed a flock of small Swallows bearing so great a resemblance to our common Sand Martin, that I at first paid little attention to them. The Ibises proving too wild to be approached, I relinquished the pursuit, and being fatigued by a long day's exertion, I leaned against a tree, and gazed on the Swallows, wishing that I could travel with as much ease and rapidity as they, and thus return to my family as readily as they could

THE FORKED-TAILED FLYCATCHER.

MILVULUS TYRANNUS, *Linn.*

PLATE LII.—MALE.

In the end of June, 1832, I observed one of these birds a few miles below the city of Camden, New Jersey, flying over a meadow in pursuit of insects, after which it alighted on the top of a small detached tree, where I followed it and succeeded in obtaining it. The bird appeared to have lost itself: it was unsuspicious, and paid no attention to me as I approached it. While on the wing, it frequently employed its long tail, when performing sudden turns in following its prey, and when alighted, it vibrated it in the manner of the Sparrow-Hawk. The bird fell to the ground wounded, and uttering a sharp squeak, which it repeated, accompanied with smart clicks of its bill, when I went up to it. It lived only a few minutes, and from it the drawing transferred to the plate was made. This figure corresponds precisely with a skin shewn to me by my friend CHARLES PICKERING, at the Academy of Natural Sciences in Philadelphia, except in the general tint of the plumage, his specimen, which he had received from South America, having been much faded.

Many years ago, while residing at Henderson in Kentucky, I had one of these birds brought to me which had been caught by the hand, and was nearly putrid when I got it. The person who presented it to me had caught it in the Barrens, ten or twelve miles from Henderson, late in October, after a succession of white frosts, and had kept it more than a week. While near the city of Natchez, in the state of Mississippi, in August 1822, I saw two others high in the air, twittering in the manner of the King-bird; but they disappeared to the westward, and I was unable to see them again. These four specimens are the only ones I have seen in the United States, where individuals appear only at long intervals, and in far distant districts, as if they had lost themselves. I regret that I am unable to afford any information respecting their habits.

FORK-TAILED FLYCATCHER, *Muscicapa Savana*, Bonap. Amer. Orn., vol. i. p. 1.
MUSCICAPA SAVANA, Bonap. Syn., p. 67.
FORK-TAILED FLYCATCHER, *Muscicapa Savana*, Nutt. Man., vol. i. p. 274.
FORKED-TAILED FLYCATCHER, *Muscicapa Savana*, Aud. Orn. Biog., vol. ii. p. 387.

Tail more than twice the length of the body; upper part of head and

Fork-tailed Flycatcher.
Gordonia Lasianthus

Drawn from Nature by J.J.Audubon F.R.S.F.L.S. Lith⁴ Printed & Col⁴ by J.T.Bowen. Phila⁴

Harvard Natural History
Society.

Harvard Natural History
Society.

Swallow-tailed Flycatcher.

Drawn from Nature by J.J Audubon F.R.S F.L.S Lith² Printed & Col⁴ by J.T Bowen Philad²

cheeks deep black, the feathers of the crown bright yellow at the base; back ash-grey, rump bluish-black; wings and tail brownish-black, the lateral feathers of the latter with the outer web white for half its length; lower parts white.

Male, 14$\frac{1}{4}$, 14.

Gordonia lasianthus, *Willd.*, Sp. Pl., vol. iii. p. 480. *Pursch*, Fl. Amer. Sept., vol. ii· p. 451.—Monodelphia polyandria, *Linn.*

This beautiful small tree is met with in Georgia, South Carolina, and Florida, in moist lands near the coast, and never fails to attract the eye by its beautiful blossoms. The twig from which the drawing was made was procured from the garden of Mr. Noisette, who liberally afforded me all the aid in his power for embellishing my plates. The leaves are evergreen, lanceolate-oblong, shining and leathery; the flowers white, of the size of the common garden-rose, and placed on long peduncles; the capsules conical and acuminate.

SWALLOW-TAILED FLYCATCHER.

Milvulus forficatus, *Gmel.*

PLATE LIII.—Male.

Not having seen this handsome bird alive, I am unable to give you any account of its habits from my own observation; but I have pleasure in supplying the deficiency by extracting the following notice from the "Manual of the Ornithology of the United States and of Canada," by my excellent friend Thomas Nuttall.

"This very beautiful and singular species of Flycatcher is confined wholly to the open plains and scanty forests of the remote south-western regions beyond the Mississippi, where they, in all probability, extend their residence to the high plains of Mexico. I found these birds rather common near the banks of Red river, about the confluence of the Kiamesha. I again saw them more abundant near the Great Salt river of the Arkansas, in the month of August, when the young and old appeared, like our King-birds, assembling together previously to their departure for the south. They alighted repeatedly on the tall plants of the prairie, and were probably preying upon

the grasshoppers, which were now abundant. At this time also, they were wholly silent, and flitted before our path with suspicion and timidity. A week or two after, we saw them no more, they having retired probably to tropical winter-quarters.

In the month of May, a pair, which I daily saw for three or four weeks, had made a nest on the horizontal branch of an elm, probably twelve or more feet from the ground. I did not examine it very near, but it appeared externally composed of coarse dry grass. The female, when first seen, was engaged in sitting, and her mate wildly attacked every bird which approached their residence. The harsh chirping note of the male, kept up at intervals, as remarked by Mr. SAY, almost resembled the barking of the prairie marmot, *'tsh, 'tsh, 'tsh.* His flowing kite-like tail, spread or contracted at will while flying, is a singular trait in his plumage, and rendered him conspicuously beautiful to the most careless observer."

SWALLOW-TAILED FLYCATCHER, *Muscicapa forficata*, Bonap. Amer. Orn., vol. i. p. 15.
MUSCICAPA FORFICATA, Syn., p. 275.
SWALLOW-TAILED FLYCATCHER, *Muscicapa forficata*, Nutt. Man., vol. i. p. 275.
SWALLOW-TAILED FLYCATCHER, *Muscicapa forficata*, Aud. Orn. Biog., vol. iv. p. 426.

Tail longer than the body; upper part of the head, cheeks, and hind neck ash-grey; back brownish-grey, rump dusky; anterior wing-coverts scarlet, quills brownish-black, tail-feathers deep black, the three outer on each side rose-coloured to near the end; lower parts white before, rose-coloured behind.

Male, 11, wing 5⅛.

GENUS II.—MUSCICAPA, *Linn.* FLYCATCHER.

Bill moderate, or rather long, stout, straight, broad at the base, gradually compressed toward the end; upper mandible with the dorsal outline sloping, the edges sharp and overlapping, with a very small notch close to the small deflected tip; lower mandible with the ridge very broad at the base, the sides rounded, the tip minute and ascending. Nostrils basal, roundish. Head rather large, depressed; neck short; body rather slender. Feet short; tarsus very short, slender, with six very broad scutella, three of which almost meet behind; toes free, the hind toe large, all scutellate above; claws rather long, very slender, arched, finely pointed. Plumage soft and blended. Wings long, second and third quills longest; outer primaries generally attenuated at the end. Tail long, even, or emarginate.

Harvard Natural History
Society.

Pl. 54

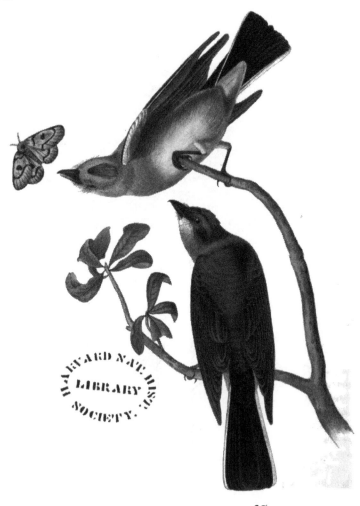

9.5

Arkansaw Flycatcher.

Drawn from Nature by J.J.Audubon F.R.S.F.L.S. Lith.ª Printed & Col.ª by J.T.Bowen Philad.ª

ARKANSAW FLYCATCHER.

Muscicapa verticalis, *Bonap.*

PLATE LIV.—Male and Female.

This species extends its range from the mouth of the Columbia river, across our continent, to the shores of the Gulf of Mexico; but how far north it may proceed is as yet unknown. On the 10th of April, 1837, whilst on Cayo Island, in the Gulf of Mexico, I found a specimen of this bird dead at the door of a deserted house, which had recently been occupied by some salt-makers. From its freshness I supposed that it had sought refuge in the house on the preceding evening, which had been very cold for the season. Birds of several other species we also found dead on the beaches. The individual thus met with was emaciated, probably in consequence of a long journey and scanty fare; but I was not the less pleased with it, as it afforded me the means of taking measurements of a species not previously described in full. In my possession are some remarkably fine skins, from Mr. Townsend's collection, which differ considerably from the figure given by Bonaparte, who first described the species. So nearly allied is it to the Green-crested Flycatcher, *M. crinita*, that after finding the dead bird, my son and I, seeing many individuals of that species on the trees about the house mentioned, shot several of them, supposing them to be the same. We are indebted to the lamented Thomas Say for the introduction of the Arkansaw Flycatcher into our Fauna. Mr. Nuttall has supplied me with an account of its manners.

"We first met with this bold and querulous species, early in July, in the scanty woods which border the north-west branch of the Platte, within the range of the Rocky Mountains; and from thence we saw them to the forests of the Columbia and the Wahlamet, as well as in all parts of Upper California, to latitude 32°. They are remarkably noisy and quarrelsome with each other, and in the time of incubation, like the King-bird, suffer nothing of the bird kind to approach them without exhibiting their predilection for battle and dispute. About the middle of June, in the dark swamped forests of the Wahlamet, we every day heard the discordant clicking warble of this bird, somewhat like *tsh'k, tsh'k, tshivait,* sounding almost like the creaking of a rusty door-hinge, somewhat in the manner of the King-bird, with a blending of the notes of the Blackbird or Common Grakle. Although I saw these birds residing in the woods of the Columbia, and near the St. Diego in

Upper California, I have not been able to find the nest, which is probably made in low thickets, where it would be consequently easily overlooked. In the Rocky Mountains they do not probably breed before midsummer, as they are still together in noisy quarrelsome bands until the middle of June."

Mr. TOWNSEND'S notice respecting it is as follows: "This is the *Chlow-ish-pil* of the Chinooks. It is numerous along the banks of the Platte, particularly in the vicinity of trees and bushes. It is found also, though not so abundantly, across the whole range of the Rocky Mountains; and along the banks of the Columbia to the ocean, it is a very common species. Its voice is much more musical than is usual with birds of its genus, and its motions are remarkably quick and graceful. Its flight is often long sustained, and like the Common King-bird, with which it associates, it is frequently seen to rest in the air, maintaining its position for a considerable time. The males are wonderfully belligerent, fighting almost constantly, and with great fury, and their loud notes of anger and defiance remind one strongly of the discordant grating and creaking of a rusty door-hinge. The Indians of the Columbia accuse them of a propensity to destroy the young and eat the eggs of other birds.

TYRANNUS VERTICALIS, Say, Long's Exped., vol. ii. p. 60.
ARKANSAW FLYCATCHER, *Muscicapa verticalis*, Bonap. Amer. Orn., vol. i. p. 18.
MUSCICAPA VERTICALIS, Bonap. Syn., p. 67.
ARKANSAW FLYCATCHER, *Muscicapa verticalis*, Nutt. Man., vol. i. p. 273.
ARKANSAW FLYCATCHER, *Muscicapa verticalis*, Aud. Orn. Biog., vol. iv. p. 422.

The outer five primaries much attenuated toward the end, the first more so, the fifth least, the third longest, but the outer four nearly equal; tail almost even. Upper parts ash-grey, the back tinged with yellow; a patch of bright vermilion on the top of the head; wing-coverts and quills chocolate-brown; upper tail-coverts and tail black, the outer web of the lateral feathers yellowish-white; throat greyish-white, sides and fore part of neck ash-grey, the rest of the lower parts pure yellow. Female similar.

Male, 9, 15½.

Harvard Natural History
Society.

Pl.55.

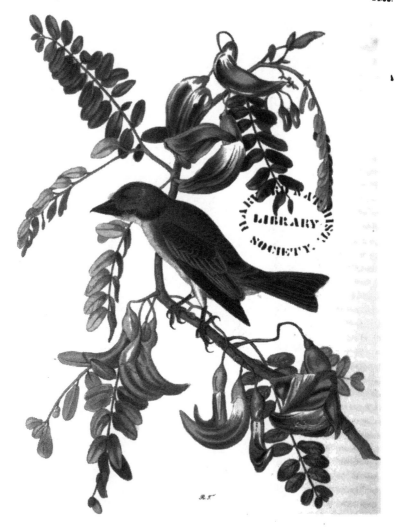

Pipiry Flycatcher.

Agati Grandiflora

THE PIPIRY FLYCATCHER.

MUSCICAPA DOMINICENSIS, *Briss.*

PLATE LV.—MALE.

Having landed on one of the Florida Keys, I scarcely had time to cast a glance over the diversified vegetation which presented itself, when I observed a pair of birds mounting perpendicularly in the air, twittering with a shrill continued note new to me. The country itself was new: it was what my mind had a thousand times before conceived a tropical scene to be. As I walked over many plants, curious and highly interesting to me, my sensations were joyous in the highest degree, for I saw that in a few moments I should possess a new subject, on which I could look with delight, as one of the great Creator's marvellous works.

I was on one of those yet unknown islets, which the foot of man has seldom pressed. A Flycatcher unknown to me had already presented itself, and the cooing of a Dove never before heard came on my ear. I felt some of that pride, which doubtless pervades the breast of the discoverer of some hitherto unknown land. Although desirous of obtaining the birds before me, I had no wish to shoot them at that moment. My gun lay loosely on my arms, my eyes were rivetted on the Flycatcher, my ears open to the soft notes of the Dove. Reader, such are the moments, amid days of toil and discomfort, that compensate for every privation. It is on such occasions that the traveller feels most convinced, that the farther he proceeds, the better will be his opportunities of observing the results of the Divine conception. What else, I would ask of you, can be more gratifying to the human intellect!

Delighted and amused, I stood for awhile contemplating the beautiful world that surrounded me, and from which man would scarcely retire with willingness, had not the Almighty ordained it otherwise. But action had now to succeed, and I quickly procured some of the Flycatchers. Their habits too, I subsequently studied for weeks in succession, and the result of my observations I now lay before you.

About the 1st of April, this species reaches the Florida Keys, and spreads over the whole of them, as far as Cape Florida, or perhaps somewhat farther along the eastern coast of the Peninsula. It comes from Cuba, where the species is said to be rather abundant, as well as in the other West India Islands. Its whole demeanour so much resembles that of the Tyrant

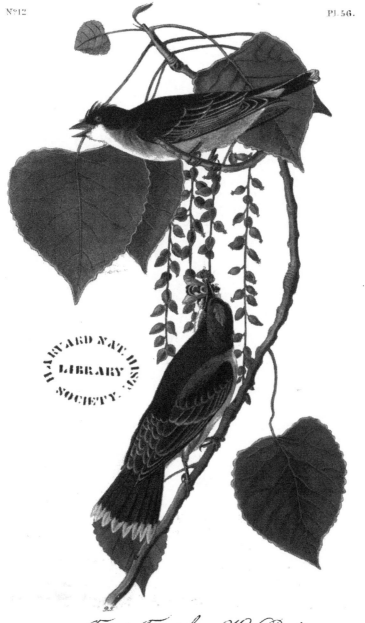

Tyrant Flycatcher or King Bird.
Cotton-wood. Populus candicans.

Drawn from Nature by J.J.Audubon FRSFL.S Engd Printd & Colrd by R. Havell London.

The Field Martin arrives in Louisiana, from the south, about the middle of March. Many individuals remain until the middle of September, but the greater number proceed gradually northwards, and are dispersed over every portion of the United States. For a few days after its arrival, it seems fatigued and doleful, and remains perfectly silent. But no sooner has it recovered its naturally lively spirits, than its sharp tremulous cry is heard over the fields, and along the skirts of all our woods. It seldom enters the forests, but is fond of orchards, large fields of clover, the neighbourhood of rivers, and the gardens close to the houses of the planters. In this last situation its habits are best observed.

Its flight has now assumed a different manner. The love-season is at hand. The male and female are seen moving about through the air, with a continued quivering motion of their wings, at a height of twenty or thirty yards above the ground, uttering a continual, tremulous, loud shriek. The male follows in the wake of the female, and both seem panting for a suitable place in which to form their nest. Meanwhile, they watch the motions of different insects, deviate a little from the course of their playful rounds, and with a sweeping dart secure and swallow the prey in an instant. Probably the next sees them perched on the twig of a tree, close together, and answering the calls of nature.

The choice of a place being settled by the happy pair, they procure small dry twigs from the ground, and rising to a horizontal branch, arrange them as the foundation of their cherished home. Flakes of cotton, wool or tow, and other substances of a similar nature, are then placed in thick and regular layers, giving great bulk and consistence to the fabric, which is finally lined with fibrous roots and horse-hair. The female then deposits her eggs, which are from four to six in number, broadly ovate, reddish-white, or blush colour, irregularly spotted with brown. No sooner has incubation commenced, than the male, full of ardour, evinces the most daring courage, and gallantly drives off every intruder. Perched on a twig not far from his beloved mate, in order to protect and defend her, he seems to direct every thought and action to these objects. His snow-white breast expands with the warmest feelings; the feathers of his head are raised and spread, the bright orange spot laid open to the rays of the sun; he stands firm on his feet, and his vigilant eye glances over the wide field of vision around him. Should he espy a Crow, a Vulture, a Martin, or an Eagle, in the neighbourhood or at a distance, he spreads his wings to the air, and pressing towards the dangerous foe, approaches him, and commences his attack with fury. He mounts above the enemy, sounds the charge, and repeatedly plunging upon the very back of his more powerful antagonist, essays to secure a hold. In this manner, harassing his less active foe with continued blows of his bill, he follows him

This bird has the mouth wide, the palate flat, with two longitudinal ridges, its anterior part horny, and concave, with a median and two slight lateral prominent lines; the posterior aperture of the nares oblongo-linear, papillate, $4\frac{1}{2}$ twelfths long. The tongue is six-twelfths long, triangular, very thin, sagittate and papillate at the base, flat above, pointed, but a little slit, and with the edges slightly lacerated. The œsophagus is $2\frac{1}{2}$ inches long, without dilatation, of the uniform width of 3 twelfths, and extremely thin; the proventriculus $3\frac{1}{2}$ twelfths across. The stomach is rather large, broadly elliptical, considerably compressed; its lateral muscles strong, the lower thin, its length 10 twelfths, its breadth 8 twelfths, its tendons $4\frac{1}{2}$ twelfths in breadth; the epithelium thin, tough, longitudinally rugous, reddish-brown. The stomach filled with remains of insects. The intestine is short and wide, 7 inches long, its width at the upper part 4 twelfths, at the lower 2 twelfths. The cœca are 2 twelfths long, $\frac{1}{2}$ twelfth in breadth, and placed at an inch and a half from the extremity. The rectum gradually dilates into the cloaca, which is 6 twelfths in width.

The trachea is 2 inches 2 twelfths long, considerably flattened, $2\frac{1}{2}$ twelfths broad at the upper part, gradually contracting to $1\frac{1}{4}$ twelfths; its rings 56, firm, with 2 dimidiate rings. It is remarkable that in this and the other Flycatchers, there is no bone of divarication, or ring divided by a partition; but two of the rings are slit behind, and the last two both behind and before. Bronchial rings about 15. The lateral muscles are slender, but at the lower part expand so as to cover the front of the trachea, and running down, terminate on the dimidiate rings, so that on each side of the inferior larynx there is a short thick mass of muscular fibres, which are scarcely capable of being divided into distinct portions, although three pairs may be in some degree traced, an anterior, a middle, and a posterior. These muscles are similarly formed in all the other birds of this family the *Muscicapinæ*, described in this work.

LANIUS TYRANNUS, Linn. Syst. Nat., vol. i. p. 136.
TYRANT FLYCATCHER, *Muscicapa tyrannus*, Wils. Amer. Orn., vol. i. p. 66.
MUSCICAPA TYRANNUS, Bonap. Syn., p. 66.
KING-BIRD OF TYRANT FLYCATCHER, *Muscicapa tyrannus*, Nutt. Man., vol. i. p. 265.
TYRANT FLYCATCHER, *Muscicapa tyrannus*, Aud. Orn. Biog., vol. i. p. 403; vol. v. p. 420.

The outer two primaries attenuated at the end, the second longest, the first longer than the third; tail even. Upper parts dark bluish-grey; the head greyish-black, with a bright vermilion patch margined with yellow; quills, coverts, and tail feathers brownish-black, the former margined with dull white, the latter largely tipped with white; lower parts greyish-white;

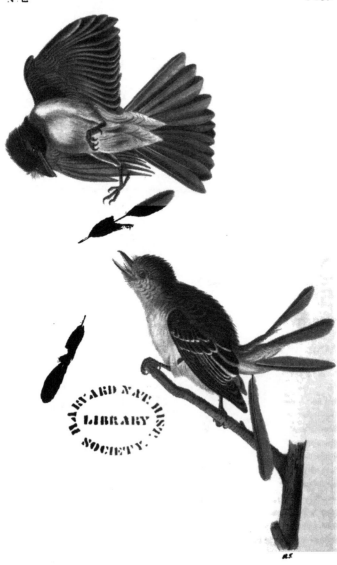

Great Crested Flycatcher.

Drawn from Nature by J. J. Audubon F. R. S. F. L. S.

the breast pale grey. Female duller; the upper parts tinged with brown;
the lower more dusky.

Male, 8½, 14½.

North America generally. Migratory. A few winter in the south of
Florida.

THE COTTON-WOOD.

POPULUS CANDICANS, *Willd.*, Sp. Pl., vol. iv. p. 806. *Pursch.*, Fl. Amer., vol. ii. p. 618.
Mich., Arbr. Forest. de l'Amér. Sept., vol. iii. pl. 13.—DIŒCIA OCTANDRIA, *Linn.*—
AMENTACEÆ, *Juss.*

This species of Poplar is distinguished by its broadly cordate, acuminate,
unequally and obtusely serrated venous leaves, hairy petioles, resinous buds,
and round twigs. The leaves are dark green above, whitish beneath. The
resinous substance with which the buds are covered has an agreeable smell.
The bark is smooth, of a greenish tint.

—————

THE GREAT CRESTED FLYCATCHER.

MUSCICAPA CRINITA, *Linn.*

PLATE LVII.—MALE.

How often whilst gazing on the nest of a bird, admiring the beauty of its
structure, or wondering at the skill displayed in securing it from danger,
have I been led to question myself why there is often so much difference in
the conformation and materials of the nests of even the same species, in dif-
ferent latitudes or localities. How often, too, while admiring the bird itself,
have I in vain tried to discover the causes why more mental and corporeal
hardihood should have been granted to certain individuals, which although
small and seemingly more delicate than others, are wont to force their way,
and that at an early season, quite across the whole extent of the United States;
while some, of greater bodily magnitude, equal powers of flight, and similar
courage, never reach so far, in fact merely enter our country or confine their
journeys to half the distance to which the others reach. The diminutive
Ruby-throated Humming-bird, the delicate Winter Wren, and many war-
blers, all birds of comparatively short flight, are seen to push their way from
the West India Islands, or the table-lands of Mexico and South America,

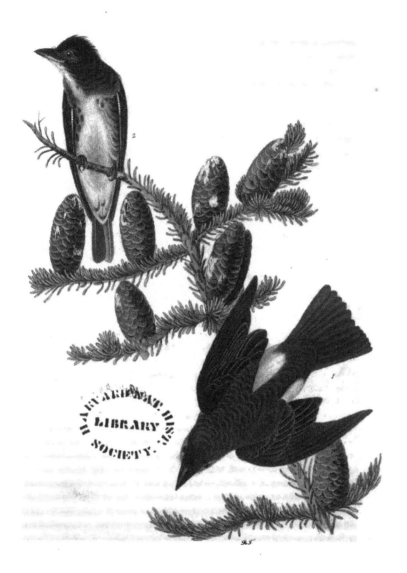

Cooper's Flycatcher.
(Balsam or Silver Fir. Pinus Balsamea.)

1. Male 2 Female.

Drawn from Nature by J. J. Audubon. R. N. Y. C. Lith. Printed & col.d by J. T. Bowen Philad.

Harvard Natural History Society.

The discovery of this species is due to my amiable and learned friend NUTTALL, part of whose account of its habits I have pleasure in laying before you. When, a few years ago, I rambled, as I do now, in quest of knowledge, scarcely an individual could be found in the United States conversant with birds. At the present day there are many, with whom I am personally acquainted, besides others, who have fully proved their zeal and activity by their discoveries and descriptions.

On the 8th of August, 1832, while walking out from Boston towards the country seat of the Honourable THOMAS H. PERKINS, along with my friend NUTTALL, we were suddenly saluted with the note of this bird. As I had never seen it, I leaped over the fence beside us, and cautiously approached the tree on which a male was perched and singing. Desiring my friend to go in search of a gun, I watched the motions of the devoted bird. He returned with a large musket, a cow's horn filled with powder, and a handful of shot nearly as large as peas; but, just as I commenced charging this curious piece, I discovered that it was flintless! We were nearly a mile distant from Mr. PERKINS' house, but as we were resolved to have the bird, we proceeded to it with all despatch, procured a gun, and returning to the tree, found the Flycatcher, examined its flight and manners for awhile, and at length shot it. As the representative of a species, I made a drawing of this individual, which you will find copied in the plate indicated above. But now let us attend to NUTTALL's account.

"This undescribed species, which appertains to the group of Pewees, was obtained in the woods of Mount Auburn, in this vicinity, by Mr. JOHN BETHUNE, of Cambridge, on the 7th of June, 1830. This and the second specimen acquired soon afterwards, were females on the point of incubation. A third individual of the same sex was killed on the 21st of June, 1831. They were all of them fat, and had their stomach filled with torn fragments of wild bees, wasps, and other similar insects. I have watched the motions of two other living individuals, who appeared tyrannical and quarrelsome, even with each other. The attack was always accompanied with a whining querulous twitter. Their dispute was apparently, like that of savages, about the rights of their respective hunting-grounds. One of the birds, the female, whom I usually saw alone, was uncommonly sedentary. The territory she seemed determined to claim was circumscribed by the tops of a cluster of Virginian junipers or red cedars, and an adjoining elm and decayed cherry-tree. From this sovereign station, in the solitude of a barren and sandy piece of forest, adjoining Mount Auburn, she kept a sharp look-out for passing insects, and pursued them with great vigour and success as soon as they appeared, sometimes chasing them to the ground, and generally resuming her perch with an additional mouthful, which she swallowed at leisure. On

ascending to her station, she occasionally quivered her wings and tail, erected her blowzy cap, and kept up a whistling, oft-repeated, whining call of *pŭ*, *pŭ*, then varied to *pŭ, pip*, and *pip, pŭ*, also at times *pip, pip, pŭ, pip, pip, pip, pŭ, pŭ, pip*, or *tŭ, tŭ, tŭ*, and sometimes *tŭ, tŭ*. This shrill, pensive, and quick whistle, sometimes dropped almost to a whisper, or merely *pŭ*. The tone is, in fact, much like that of the *phŭ, phŭ, phŭ*, of the Fish Hawk. The male, however, besides this note, at long intervals had a call of *eh phèbēē*, or *h'phebéa*, almost exactly in the tone of the circular tin whistle or bird call, being loud, shrill, and guttural at the commencement. The nest of this pair I at length discovered in the horizontal branch of a tall red cedar, forty or fifty feet from the ground. It was formed much in the manner of the King-bird's, externally made of interlaced dead twigs of the cedar, internally of wiry stolons of the common cinquefoil, dry grass, and some fragments of branching lichen or *usnea*. It contained three young, and had probably four eggs. The eggs had been hatched about the 20th of June, so that the pair had arrived in this vicinity about the close of May. The young remained in the nest no less than twenty-three days, and were fed from the first on beetles and perfect insects, which appeared to have been wholly digested, without any regurgitation. Towards the close of this protracted period, the young could fly with all the celerity of their parents, and they probably went to and from the nest before abandoning it. The male was at this time extremely watchful, and frequently followed me from his usual residence, after my paying him a visit, nearly half a mile. These birds, which I watched on several successive days, were no way timid, and allowed me for some time previous to visiting their nest, to investigate them and the premises they had chosen, without showing any sign of alarm or particular observation."

I received from my friend the following additional account, in a letter dated September 12, 1833. "Something serious has happened to our pair of the new Flycatchers (*Muscicapa Cooperi*), which have for three years at least, bred and passed the summer in the grounds of Mount Auburn. This summer they were no longer seen. It is true they were not very well used last year; for, in the first place, I took two of the four eggs they had laid, when they deserted the nest, and soon, within little more than a stone's-throw, they renewed their labours, and made a second, which was also visited; but from this I believe they raised a small brood. The nest, as before, was placed on a horizontal branch of a red cedar, and made chiefly of the smallest interlaced twigs collected from the dead limbs of the same tree, in all cases so thin, like that of the Tanager, as to let the light readily through its interstices. An egg you have, which, as to size, so completely resembles that of the *Wood Pewee*, as to make one and the same description serve for

both; that is to say, a yellowish cream-white, with spots of reddish-brown, of a light and dark shade. All the nests, three in number, were within 150 yards of each other respectively. I saw another pair once in a small piece of dry pine wood in Mount Auburn one year; but they did not stay long. A third pair I saw the summer before the last, on the edge of the marsh towards West Cambridge Pond; these appeared resident. The next pair I had the rare good fortune to see in your company, by which means they have been masterly figured. It is beyond a doubt *M. borealis* of RICHARDSON, but I believe Mr. COOPER and myself discovered it previously, at least before the appearance of Dr. RICHARDSON's Northern Zoology.''

In the course of my journey farther eastward, I found this species here and there in Massachusetts and the state of Maine, as far as Mars Hill, and subsequently on the Magdeleine Islands, and the coast of Labrador; but I have not yet been able to discover its line of migration, or the time of its arrival in the Southern States.

This species has never been observed in South Carolina, although I met with it in Georgia, as well as in the Texas, in the month of April. According to Mr. NUTTALL, it is "a common inhabitant of the dark fir woods of the Columbia, where they arrive towards the close of May. We again heard," he continues, "at intervals, the same curious call, like *'gh-phebéa*, and sometimes like the guttural sound of *p h p-phebeé*, commencing with a sort of suppressed chuck; at other times the notes varied into a lively and sometimes quick *p t-petoway*. This no doubt is the note which WILSON attributed to the Wood Pewee. When approached, as usual, or when calling, we heard the *pu pu pu*." A single specimen was shot on the banks of the Saskatchewan, and has been described in the Fauna Boreali-Americana under the name of *Tyrannus borealis*.

Dr. BREWER has sent me the following note:—"A female specimen obtained by me measures $6\frac{1}{2}$ inches in length, being fully half an inch shorter than the male. Nape of the neck, belly, vent, throat, and flanks white; in the latter, continued to the back, so as to be visible above the fold of the wings; a broad olive band across the breast; in all other respects it resembles the male. A nest, which I have examined, measures five inches in external diameter, and three and a half inches in internal, and is about half an inch deep. It is composed entirely of roots and fibres of moss. It is, moreover, very rudely constructed, and is almost wholly flat, resembling the nest of no other Flycatcher I have seen, but having some similitude to that of the Cuckoo."

OLIVE-SIDED FLYCATCHER OR PE-PE, *Muscicapa Cooperi*, Nutt. Man., vol. i. p. 282.
TYRANNUS BOREALIS, NORTHERN TYRANT, Swains. and Rich. F. Bor. Amer., vol. ii. p. 141.

OLIVE-SIDED FLYCATCHER, *Muscicapa Cooperi*, Aud. Orn. Biog., vol. ii. p. 422; vol. v. p. 422.

Wing pointed, second quill longest, first longer than third; tail emarginate, the three first primaries very slightly attenuated at the ends; upper parts, cheeks, and sides of the neck, dusky brown, tinged with greyish-olive, the head darker; quills and tail blackish-brown, the secondaries margined with brownish-white; downy feathers on the sides of the rump white; lower parts greyish-white, the sides dusky grey. Young similar to adult.

Male, $7\frac{1}{2}$, $12\frac{3}{4}$.

From Texas northward along the Atlantic. Never seen far in the interior. Columbia river. Migratory.

THE BALSAM OR SILVER FIR.

PINUS BALSAMEA, *Willd.*, Sp. Pl., vol. iv. p. 504. *Pursch*, Fl. Amer. Sept., vol. ii. p. 639. —ABIES BALSAMIFERA, *Mich.*, Fl. Amer., vol. ii. p. 207.—MONŒCIA MONADELPHIA, *Linn.* —CONIFERÆ, *Juss.*

This beautiful fir is abundant in the State of Maine, where I made a drawing of the twig before you. It grows on elevated rocky ground, often near streams or rivers. Its general form is conical, the lower branches coming off horizontally near the ground, and the succeeding ones becoming gradually more oblique, until the uppermost are nearly erect. The leaves and cones become so resinous in autumn, that, in climbing one of these trees, a person is besmeared with the excreted juice, which is then white, transparent, and almost fluid. The leaves are solitary, flat, emarginate, or entire, bright green above, and glaucous or silvery beneath; the cones cylindrical, erect, with short obovate, serrulate, mucronate scales. It is abundant in the British provinces, the Northern States, and in the higher parts of the Alleghany Mountains. The height does not exceed fifty feet. The bark is smooth, the wood light and resinous. The resin is collected and sold under the names of Balm of Gilead and Canada Balsam.

Harvard Natural History
Society

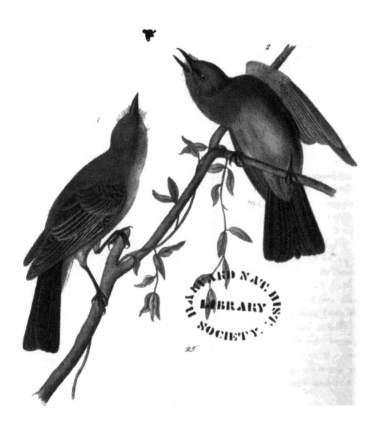

Say's Flycatcher.

1. *Male.* 2. *Female.*

Drawn from Nature by J.J. Audubon FRS L.S.

Lith⁴Printed & Col⁴ by J.T. Bowen, Philad⁴

SAY'S FLYCATCHER.

MUSCICAPA SAYA, *Bonap.*

PLATE LIX.—MALE AND FEMALE.

This species was first discovered by TITIAN PEALE, Esq. of Philadelphia, and named after Mr. THOMAS SAY by BONAPARTE, who described and figured it in his continuation of WILSON's American Ornithology. It appears to range over a very extensive portion of country, lying between Mexico and the settlements of the British Fur Companies, a pair having been procured at Carlton House, as mentioned by Dr. RICHARDSON. Little is yet known of the habits of this species, but it would seem, from Mr. NUTTALL's remarks, to be a rupestrine Flycatcher, and not strictly arboreal, as supposed by Mr. SWAINSON.

"We first observed this bird," says Mr. NUTTALL, "in our route westward, about the 14th of June, within the first range of the Rocky Mountains called the Black Hills, and in the vicinity of that northern branch of the Platte known by the name of Larimie's Fork. At the time, we saw a pair perched as usual on masses of rocks, from which, like the Pewee, though occasionally alighted, they flew after passing insects, without uttering any note that we heard; and from their predilection, it is probable they inhabit among broken hills and barren rocks, where we have scarcely a doubt, from their behaviour, they had at this time a brood in a nest among these granite cliffs. They appeared very timorous on our approach, and seemed very limited in their range. Except among the Blue Mountains of the Columbia, we scarcely ever saw them again. Their manners appear to be very much like those of the Common Pewee; but they are much more silent and shy."

SAY'S FLYCATCHER, *Muscicapa Saya*, Bonap. Amer. Orn., vol. i. p. 20.
MUSCICAPA SAYA, Bonap. Syn., p. 67.
TYRANNULA SAYA, Swains. and Rich. F. Bor. Amer., vol. ii. p. 142.
SAY'S FLYCATCHER, *Muscicapa Saya*, Nutt. Man., vol. i. p. 277.
SAY'S FLYCATCHER, *Muscicapa Saya*, Aud. Orn. Biog., vol. iv. p. 428.

Third quill longest, second and fourth scarcely shorter, first a little longer than sixth; tail very slightly emarginate; upper parts greyish-brown; upper tail-coverts and tail brownish-black; wings of a darker tint than the back, the feathers margined with brownish-white; a dusky spot before the eye;

VOL. I. 33

fore part and sides of neck light greyish-brown, shaded with pale brownish-red on the breast and abdomen; lower wing-coverts reddish-white.

Male, 7, wing 4$\frac{2}{11}$.

Arkansas. Columbia river. Fur Countries. Never seen along the Atlantic. Abundant. Migratory.

ROCKY-MOUNTAIN FLYCATCHER.

MUSCICAPA NIGRICANS, *Swains.*

PLATE LX.—MALE.

The only specimen of this Flycatcher in my possession was given to me by my esteemed friend THOMAS NUTTALL, Esq., who procured it in North California, but was unable to give me any account of its habits. It has been briefly characterized by Mr. SWAINSON in his Synopsis of the Birds of Mexico.

TYRANNULA NIGRICANS, Swains. Syn. of Mex. Birds, Phil. Mag. N. S., vol. i. p. 367.
ROCKY-MOUNTAIN FLYCATCHER, *Muscicapa nigricans,* Aud. Orn. Biog., vol. v. p. 302.

Third quill longest, second and fourth a little shorter, first and sixth about equal; tail very slightly emarginate; head, hind neck, fore part of back, fore neck, a portion of the head, and sides, dark sooty brown; the rest of the upper parts greyish-brown; secondary coverts tipped, and secondaries margined with greyish-white, of which colour is the greater part of the outer web of the lateral tail-feathers; middle of breast, abdomen, and lower tail-coverts white; lower wing-coverts greyish-brown, edged with white.

Male, 7, wing 3$\frac{7}{4}$.

Mexico and California. Rare. Migratory.

SWAMP OAK.

QUERCUS AQUATICA, WATER OAK, *Mich.* Arb. Forest., vol. ii. p. 90, Pl. 17.—MONŒCIA POLYANDRIA, *Linn.*—AMENTACEÆ, *Juss.*

Leaves oblongo-cuneate, tapering at the base, rounded or apiculate, sometimes three-lobed.

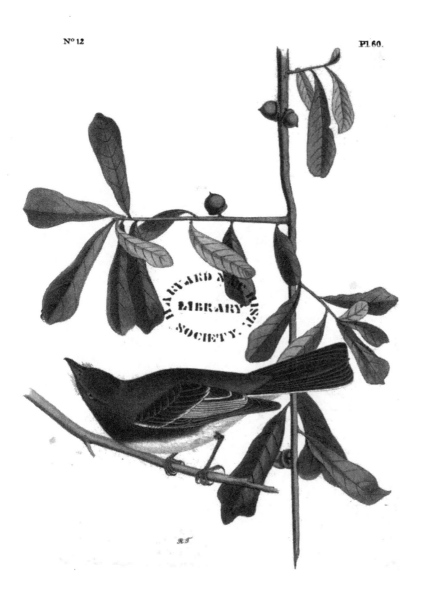

Rocky Mountain Flycatcher.
(Swamp Oak. Quercus Aquatica:)
Male.

Drawn from Nature by J.J.Audubon F.R.S. F.L.S. Lith⁴ Printed & Col⁴ by J.T. Bowen Philad⁴

Harvard Natural History Society.

SHORT-LEGGED PEWIT FLYCATCHER.

MUSCICAPA PHŒBE, *Lath.*

PLATE LXI.—MALE.

I found this species plentiful on the coast of Labrador, where, for awhile, I thought it so nearly allied to our Common Pewee Flycatcher, as almost to render me indifferent to its notes, movements, and nidification, all of which, however, I at length discovered to differ considerably, especially the latter. On this particular subject, on which I have already said so much, I may here repeat, that birds of the same species may in some localities form nests extremely different from those constructed by them in others. Indeed, accustomed as I have been to this for a considerable number of years, I thought it in no way remarkable to find the nest of what I then considered as our Common Pewee placed in a bush, instead of being placed against a rock or under a shed, for I thought the difference less than that presented by the nidification of our Common Crow Blackbird, which in Louisiana deposits its eggs in the hollow of a tree, while in Pennsylvania and other districts, it constructs as regular a nest as our *Turdus migratorius.* It was not long, however, before I discovered material differences in the deportment, habits, and voice of this Flycatcher and the Pewee; the larger size of the latter of which rendered me confident that I could not be mistaken, as I frequently saw both birds in the course of my daily rambles.

Although it is very difficult to distinguish preserved skins of our many plain-coloured Flycatchers, yet to one who has traversed the woods, and listened to their voices, there is little difficulty in recognising the sounds of any of them, for the cries of all are different, and may be known with certainty, however alike they may seem to one who has seldom heard them. The notes of the present species differ from those of the Common Pewee, being as it were hoarse or harsh. It never jerks up its tail, as is the common habit of that species, and in this respect differs from all our Flycatchers. Again, this Flycatcher, instead of standing on an eminence for an hour at a time, as the Pewee does, pouring forth its ditty, is continually in motion; and never alights on rocks or the higher parts of trees, but keeps on low bushes at all times. Its flight too is different, for instead of launching upward after its prey, it flies low, proceeding immediately over the tops of the plants, from which it sweeps the insects before they are aware of the presence or purpose of the little depredator that skippingly passes over them.

After this, it betakes itself to the tallest and rankest weed of the open space, whether a narrow valley, or the environs of one of those small ponds so abundant in Labrador, and which in summer displays a most luxuriant growth of aquatic plants. The Common Pewee, on the contrary, which also breeds in that country, frequents rocks and the tallest fir trees.

Whilst in Labrador, I examined several nests of the Short-legged Pewee, all of which were placed on low bushes, and almost as bulky as those of the Pipiry Flycatcher, or about double the size of that of our Common Pewee. They were all formed of a quantity of such dry mosses as are commonly found hanging from the stems of all low bushes in the vicinity of the places in which this species breeds, together with feathers of the Eider Duck and Willow Grouse. They were suspended between the forks of two twigs, and in this respect resembled the nests of the Orchard Oriole. The eggs varied from five to seven, measured six-eighths of an inch in length, four-eighths in breadth, and instead of being pure white, like those of the Pewee, were spotted nearly all over with minute brown specks on a light bluish ground. On the 21st of July I saw the first young on wing, and as at that time they were fully fledged, I thought that even in that cold region, this species may perhaps breed twice in the season.

The migratory movements of this bird are very peculiar. I feel almost confident that none pass southward over our Atlantic districts, and it would appear that they must advance along the eastern base of the Rocky Mountains, as I have not heard of their having been found to the westward of that range.

TYRANNULA RICHARDSONII, SWAINSON's SHORT-LEGGED PEWIT, Swains. and Rich. F. Bor. Amer., vol. ii. p. 146.
SHORT-LEGGED PEWEE FLYCATCHER, *Muscicapa Richardsonii*, Aud. Orn. Biog. vol. v. p. 299.

Second quill longest, third almost equal, first and fourth nearly equal; tail slightly emarginate; upper parts dark olivaceous brown; the head darker, wings and tail blackish-brown, secondary coverts tipped with brownish-white, and secondary quills margined with the same; outer edges of lateral tail-feathers pale brownish-grey; fore part of neck, breast, and sides light dusky grey, tinged with olive; abdomen pale dull yellow; lower tail-coverts brownish-grey, margined with yellowish-white.

Male, $6\frac{9}{12}$, wing, $3\frac{1}{4}$.

Columbia river. Fur Countries. Labrador. Rare. Migratory.

Harvard Natural History
Society.

Pl 61

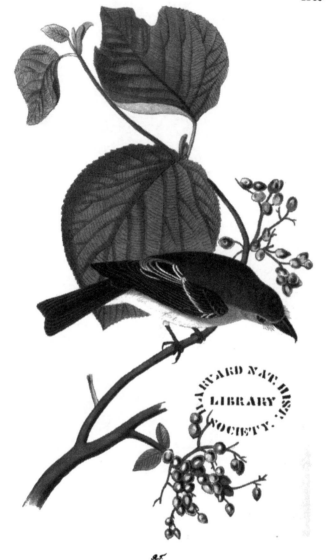

3.5.

Short-legged Pewit Flycatcher.
(*Hobble Bush. Viburnum Lantanoides*)
Male

Drawn from Nature by J.J. Audubon FRS FLS Lith. Printed & Cold by J.T. Bowen Philad.

Harvard Natural History
Society

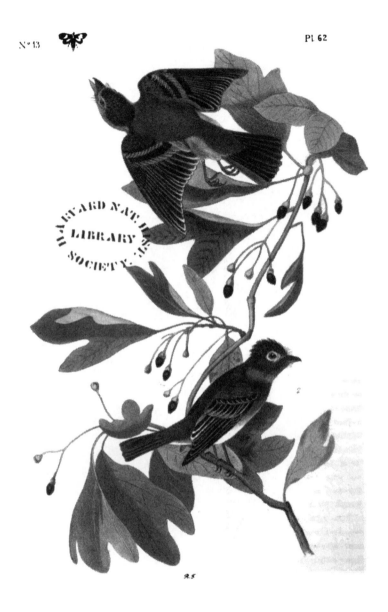

Small Green-crested Flycatcher.
Sassafras Laurus Sassafras
1. Male 2 Female

HOBBLE BUSH.

VIBURNUM LANTANOIDES, *Mich.*, Fl. Amer., vol. i. p. 179. *Pursch.*, Fl. Amer. Sept., vol. i. p. 202.—PETANDRIA MONOGYNIA, *Linn.*

This species, which grows in the woods, from Canada to Virginia, is characterized by its large, suborbicular, subcordate, unequally serrate, acute leaves, its dense cymes, and ovate berries, which are at first red, but ultimately black.

SMALL GREEN CRESTED FLYCATCHER.

MUSCICAPA ACADICA, *Gmel.*

PLATE LXII.—MALE AND FEMALE.

The Small Green Crested Flycatcher is not abundant, even in South Carolina, in the maritime parts of which it occasionally breeds. It merely passes through Louisiana, in early spring and in autumn; but it is found distributed from Maryland to the eastern extremities of Nova Scotia, proceeding perhaps still farther north, although neither I nor any of my party observed a single individual in Newfoundland or Labrador.

It is a usual inhabitant of the most gloomy and secluded parts of our deep woods, although now and then a pair may be found to have taken possession of a large orchard near the house of the farmer. Almost as pugnacious as the King-bird, it is seen giving chase to every intruder upon its premises, not only during the season of its loves, but during its whole stay with us. As soon as it has paired, it becomes so retired that it seldom goes farther from its nest than is necessary for procuring food.

Perched on some small spray or dry twig, it stands erect, patiently eyeing the objects around. When it perceives an insect, it sweeps after it with much elegance, snaps its bill audibly as it seizes the prey, and on realighting, utters a disagreeable squeak. While perched it is heard at intervals repeating its simple, guttural, gloomy notes, resembling the syllables *queae, queae, tchooe, tchewee.* These notes are often followed, as the bird passes from one tree to another, by a low murmuring chirr or twitter, which it keeps up until it alights, when it instantly quivers its wings, and jerks its tail a few times. At intervals it emits a sweeter whistling note, sounding like *weet, weet, weet, will;* and when angry it emits a loud *chirr.*

Early in May, in our Middle Districts, the Small Green Crested Fly-catcher constructs its nest, which varies considerably in different parts of the country, being made warmer in the northern localities, where it breeds almost a month later. It is generally placed in the darkest shade of the woods, in the upright forks of some middle-sized tree, from eight to twenty feet above the ground, sometimes so low as to allow a man to look into it. In some instances I have found it on the large horizontal branches of an oak, when it looked like a knot. It is always neat and well-finished, the inside measuring about two inches in diameter, with a depth of an inch and a half. The exterior is composed of stripes of the inner bark of various trees, vine fibres and grasses, matted together with the down of plants, wool, and soft moss. The lining consists of fine grass, a few feathers, and horse hair. The whole is light, elastic, and firmly coherent, and is glued to the twigs or saddled on the branch with great care. The eggs are from four to six, small, and pure white. While the female is sitting, the male often emits a scolding *chirr* of defiance, and rarely wanders far from the nest, but relieves his mate at intervals. In the Middle States they often have two broods in the season, but in Maine or farther north only one. The young follow their parents in the most social manner; but before these birds leave us entirely, the old and the young form different parties, and travel in small groups towards warmer regions.

I have thought that this species throws up pellets more frequently than most others. Its food consists of insects during spring and summer, such as moths, wild bees, butterflies, and a variety of smaller kinds; but in autumn it greedily devours berries and small grapes. Although not shy with respect to man, it takes particular notice of quadrupeds, following a minx or polecat to a considerable distance, with every manifestation of anger. The mutual affection of the male and female, and their solicitude respecting their eggs or young, are quite admirable.

The flight of the Small Green Flycatcher is performed by short glidings, supported by protracted flaps of the wings, not unlike those of the Pewee Flycatcher; and it is often seen, while passing low through the woods or following the margins of a creek, to drink in the manner of Swallows, or sweep after its prey, until it alights. Like the King-bird, it always migrates by day.

SMALL GREEN CRESTED FLYCATCHER, *Muscicapa querula*, Wils. Amer. Orn., vol. ii. p. 77.
SMALL PEWEE, Nutt. Man., vol. i. p. 288.
MUSCICAPA ACADICA, Bonap. Syn., p. 68.
SMALL GREEN CRESTED FLYCATCHER, *Muscicapa acadica*, Aud. Orn. Biog., vol. ii. p. 256; vol. v. p. 427.

Harvard Natural History
Society.

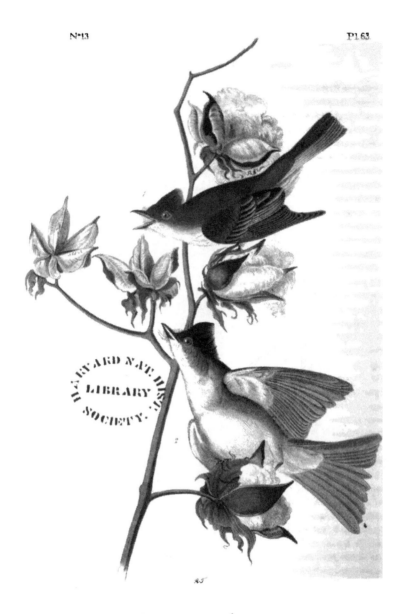

Pewee Flycatcher
Cotton Plant. Gossypium Herbaceum

1 Male 2 Female

Drawn from Nature by J.J.Audubon F.R.S.F.L.S. Lith'd Printed & Col'd by J.T.Bowen Phila'

shorter,
eenish-
ll pale
th the
vhite;
parts

Bill broad and much depressed; second quill longest, third a little shorter, first shorter than fourth; tail scarcely emarginate, upper parts dull greenish-olive, the head darker; wings and tail dusky-brown; two bands of dull pale yellow on the wing, the secondary quills broadly edged and tipped with the same; a narrow ring of yellowish-white round the eye; throat greyish-white; sides of neck and fore part of breast greyish-olive, the rest of the lower parts yellowish-white.

Male, 5½, 8¼.

From Texas northward. Migratory.

SASSAFRAS.

LAURUS SASSAFRAS, *Willd.* Sp. Pl., vol. ii. p. 485. *Pursch*, Fl. Amer. Sept., vol. i. p. 277.
—ENNEANDRIA MONOGYNIA, *Linn.*—LAURI, *Juss.*

The Sassafras grows on almost every kind of soil in the Southern and Western States, where it is of common occurrence. Along the Atlantic States it extends as far as New Hampshire, and still farther north in the western country. The beauty of its foliage and its medicinal properties . render it one of our most interesting trees. It attains a height of fifty or sixty feet, with a proportionate diameter. The leaves are alternate, petiolate, oval, and undivided, or three-lobed. The flowers, which appear before the leaves, are of a greenish-yellow colour, and the berries are of an oval form and bluish-black tint, supported on cups of a bright red, having long filiform peduncles.

THE PEWEE FLYCATCHER.

MUSCICAPA FUSCA, *Gmel.*

PLATE LXIII.—MALE AND FEMALE.

Connected with the biography of this bird are so many incidents relative to my own, that could I with propriety deviate from my proposed method, the present number would contain less of the habits of birds than of those of the youthful days of an American woodsman. While young, I had a plantation that lay on the sloping declivities of the Perkiomen creek. I was extremely fond of rambling along its rocky banks, for it would have been difficult to do so either without meeting with a sweet flower, spreading open

its beauties to the sun, or observing the watchful King-fisher perched on some projecting stone over the clear water of the stream. Nay, now and then, the Fish Hawk itself, followed by a White-headed Eagle, would make his appearance, and by his graceful aërial motions, raise my thoughts far above them into the heavens, silently leading me to the admiration of the sublime Creator of all. These impressive, and always delightful, reveries often accompanied my steps to the entrance of a small cave scooped out of the solid rock by the hand of nature. It was, I then thought, quite large enough for my study. My paper and pencils, with now and then a volume of EDGE-WORTH's natural and fascinating Tales or LAFONTAINE's Fables, afforded me ample pleasures. It was in that place, kind reader, that I first saw with advantage the force of parental affection in birds. There it was that I studied the habits of the Pewee; and there I was taught most forcibly, that to destroy the nest of a bird, or to deprive it of its eggs or young, is an act of great cruelty.

I had observed the nest of this plain-coloured Flycatcher fastened, as it were, to the rock immediately over the arched entrance of this calm retreat. I had peeped into it: although empty, it was yet clean, as if the absent owner intended to revisit it with the return of spring. The buds were already much swelled, and some of the trees were ornamented with blossoms, yet the ground was still partially covered with snow, and the air retained the piercing chill of winter. I chanced one morning early to go to my retreat. The sun's glowing rays gave a rich colouring to every object around. As I entered the cave, a rustling sound over my head attracted my attention, and, on turning, I saw two birds fly off, and alight on a tree close by:—the Pewees had arrived! I felt delighted, and fearing that my sudden appearance might disturb the gentle pair, I walked off; not, however, without frequently looking at them. I concluded that they must have just come, for they seemed fatigued:—their plaintive note was not heard, their crests were not erected, and the vibration of the tail, so very conspicuous in this species, appeared to be wanting in power. Insects were yet few, and the return of the birds looked to me as prompted more by their affection to the place, than by any other motive. No sooner had I gone a few steps than the Pewees, with one accord, glided down from their perches and entered the. cave. I did not return to it any more that day, and as I saw none about it, or in the neighbourhood, I supposed that they must have spent the day within it. I concluded also that these birds must have reached this haven, either during the night, or at the very dawn of that morn. Hundreds of observations have since proved to me that this species always migrates by night.

I went early next morning to the cave, yet not early enough to surprise them in it. Long before I reached the spot, my ears were agreeably saluted

by their well-known note, and I saw them darting about through the air, giving chase to some insects close over the water. They were full of gaiety, frequently flew into and out of the cave, and while alighted on a favourite tree near it, seemed engaged in the most interesting converse. The light fluttering or tremulous motions of their wings, the ·jetting of their tail, the erection of their crest, and the neatness of their attitudes, all indicated that they were no longer fatigued, but on the contrary refreshed and happy. On my going into the cave, the male flew violently towards the entrance, snapped his bill sharply and repeatedly, accompanying this action with a tremulous rolling note, the import of which I soon guessed. Presently he flew into the cave and out of it again, with a swiftness scarcely credible: it was like the passing of a shadow.

Several days in succession I went to the spot, and saw with pleasure that as my visits increased in frequency, the birds became more familiarized to me, and, before a week had elapsed, the Pewees and myself were quite on terms of intimacy. It was now the 10th of April; the spring was forward that season, no more snow was to be seen, Redwings and Grakles were to be found here and there. The Pewees, I observed, began working at their old nest. Desirous of judging for myself, and anxious to enjoy the company of this friendly pair, I determined to spend the greater part of each day in the cave. My presence no longer alarmed either of them. They brought a few fresh materials, lined the nest anew, and rendered it warm by adding a few large soft feathers of the common goose, which they found strewn along the edge of the water in the creek. There was a remarkable and curious twittering in their note while both sat on the edge of the nest at those meetings, and which is never heard on any other occasion. It was the soft, tender expression, I thought, of the pleasure they both appeared to anticipate of the future. Their mutual caresses, simple as they might have seemed to another, and the delicate manner used by the male to please his mate, rivetted my eyes on these birds, and excited sensations which I can never forget.

The ·female one day spent the greater part of the time in her nest; she frequently changed her position; her mate exhibited much uneasiness, he would alight by her sometimes, sit by her side for a moment, and suddenly flying out, would return with an insect, which she took from his bill with apparent gratification. About three o'clock in the afternoon, I saw the uneasiness of the female increase; the male showed an unusual appearance of despondence, when, of a sudden, the female rose on her feet, looked sidewise under her, and flying out, followed by her attentive consort, left the cave, rose high in the air, performing evolutions more curious to me than any I had seen before. They flew about over the water, the female leading her mate, as it were, through her own meanderings. Leaving the Pewees to

their avocations, I peeped into their nest, and saw there their first egg, so white and so transparent—for I believe, reader, that eggs soon loose this peculiar transparency after being laid—that to me the sight was more pleasant than if I had met with a diamond of the same size. The knowledge that in an enclosure so frail, life already existed, and that ere many weeks would elapse, a weak, delicate, and helpless creature, but perfect in all its parts, would burst the shell, and immediately call for the most tender care and attention of its anxious parents, filled my mind with as much wonder as when, looking towards the heavens, I searched, alas! in vain, for the true import of all that I saw.

In six days, six eggs were deposited; but I observed that as they increased in number, the bird remained a shorter time in the nest. The last she deposited in a few minutes after alighting. Perhaps, thought I, this is a law of nature, intended for keeping the eggs fresh to the last. About an hour after laying the last egg, the female Pewee returned, settled in her nest, and, after arranging the eggs, as I thought, several times under her body, expanded her wings a little, and fairly commenced the arduous task of incubation.

Day after day passed by. I gave strict orders that no one should go near the cave, much less enter it, or indeed destroy any bird's nest on the plantation. Whenever I visited the Pewees, one or other of them was on the nest, while its mate was either searching for food, or perched in the vicinity, filling the air with its loudest notes. I not unfrequently reached out my hand near the sitting bird; and so gentle had they both become, or rather so well acquainted were we, that neither moved on such occasions, even when my hand was quite close to it. Now and then the female would shrink back into the nest, but the male frequently snapped at my fingers, and once left the nest as if in great anger, flew round the cave a few times, emitting his querulous whining notes, and alighted again to resume his labours.

At this very time, a Pewee's nest was attached to one of the rafters of my mill, and there was another under a shed in the cattle-yard. Each pair, any one would have felt assured, had laid out the limits of its own domain, and it was seldom that one trespassed on the grounds of its neighbour. The Pewee of the cave generally fed or spent its time so far above the mill on the creek, that he of the mill never came in contact with it. The Pewee of the cattle-yard confined himself to the orchard, and never disturbed the rest. Yet I sometimes could hear distinctly the notes of the three at the same moment. I had at that period an idea that the whole of these birds were descended from the same stock. If not correct in this supposition, I had ample proof afterwards that the brood of young Pewees, raised in the cave, returned the following spring, and established themselves farther up on the creek, and among the outhouses in the neighbourhood.

On some other occasion, I will give you such instances of the return of birds, accompanied by their progeny, to the place of their nativity, that perhaps you will become convinced, as I am at this moment, that to this propensity every country owes the augmentation of new species, whether of birds or of quadrupeds, attracted by the many benefits met with, as countries become more open and better cultivated: but now I will, with your leave, return to the Pewees of the cave.

On the thirteenth day, the little ones were hatched. One egg was unproductive, and the female, on the second day after the birth of her brood, very deliberately pushed it out of the nest. On examining this egg, I found it contained the embryo of a bird partly dried up, with its vertebræ quite fast to the shell, which had probably occasioned its death. Never have I since so closely witnessed the attention of birds to their young. Their entrance with insects was so frequently repeated, that I thought I saw the little ones grow as I gazed upon them. The old birds no longer looked upon me as an enemy, and would often come in close by me, as if I had been a post. I now took upon me to handle the young frequently; nay, several times I took the whole family out, and blew off the exuviæ of the feathers from the nest. I attached light threads to their legs: these they invariably removed, either with their bills, or with the assistance of their parents. I renewed them, however, until I found the little fellows habituated to them; and at last, when they were about to leave the nest, I fixed a light silver thread to the leg of each, loose enough not to hurt the part, but so fastened that no exertions of theirs could remove it.

Sixteen days had passed, when the brood took to wing; and the old birds, dividing the time with caution, began to arrange the nest anew. A second set of eggs were laid, and in the beginning of August a new brood made its appearance.

The young birds took much to the woods, as if feeling themselves more secure there than in the open fields; but before they departed, they all appeared strong, and minded not making long sorties into the open air, over the whole creek, and the fields around it. On the 8th of October, not a Pewee could I find on the plantation: my little companions had all set off on their travels. For weeks afterwards, however, I saw Pewees arriving from the north, and lingering a short time, as if to rest, when they also moved southward.

At the season when the Pewee returns to Pennsylvania, I had the satisfaction to observe those of the cave in and about it. There again, in the very same nest, two broods were raised. I found several Pewees nests at some distance up the creek, particularly under a bridge, and several others in the adjoining meadows, attached to the inner parts of sheds erected for the

protection of hay and grain. Having caught several of these birds on the nest, I had the pleasure of finding that two of them had the little ring on the leg.

I was now obliged to go to France, where I remained two years. On my return, which happened early in August, I had the satisfaction of finding three young Pewees in the nest of the cave; but it was not the nest which I had left in it. The old one had been torn off from the roof, and the one which I found there was placed above where it stood. I observed at once that one of the parent birds was as shy as possible, while the other allowed me to approach within a few yards. This was the male bird, and I felt confident that the old female had paid the debt of nature. Having inquired of the miller's son, I found that he had killed the old Pewee and four young ones, to make bait for the purpose of catching fish. Then the male Pewee had brought another female to the cave! As long as the plantation of Mill Grove belonged to me, there continued to be a Pewee's nest in my favourite retreat; but after I had sold it, the cave was destroyed, as were nearly all the beautiful rocks along the shores of the creek, to build a new dam across the Perkiomen.

This species is so peculiarly fond of attaching its nest to rocky caves, that, were it called the Rock Flycatcher, it would be appropriately named. Indeed I have seldom passed near such a place, particularly during the breeding season, without seeing the Pewee, or hearing its notes. I recollect that, while travelling in Virginia with a friend, he desired that I would go somewhat out of our intended route, to visit the renowned Rock Bridge of that State. My companion, who had passed over this natural bridge before, proposed a wager that he could lead me across it before I should be aware of its existence. It was early in April; and, from the descriptions of this place which I had read, I felt confident that the Pewee Flycatcher must be about it. I accepted the proposal of my friend and trotted on, intent on proving to myself that, by constantly attending to one subject, a person must sooner or later become acquainted with it. I listened to the notes of the different birds, which at intervals came to my ear, and at last had the satisfaction to distinguish those of the Pewee. I stopped my horse, to judge of the distance at which the bird might be, and a moment after told my friend that the bridge was short of a hundred yards from us, although it was impossible for us to see the spot itself. The surprise of my companion was great. "How do you know this?" he asked, "for," continued he, "you are correct."— "Simply," answered I, "because I hear the notes of the Pewee, and know that a cave, or a deep rocky creek, is at hand." We moved on; the Pewees rose from under the bridge in numbers; I pointed to the spot and won the wager.

This rule of observation I have almost always found to work, as arithmeticians say, both ways. Thus the nature of the woods or place in which the observer may be, whether high or low, moist or dry, sloping north or south, with whatever kind of vegetation, tall trees of particular species, or low shrubs, will generally disclose the nature of their inhabitants.

The flight of the Pewee Flycatcher is performed by a fluttering light motion, frequently interrupted by sailings. It is slow when the bird is proceeding to some distance, rather rapid when in pursuit of prey. It often mounts perpendicularly from its perch after an insect, and returns to some dry twig, from which it can see around to a considerable distance. It then swallows the insect whole, unless it happens to be large. It will at times pursue an insect to a considerable distance, and seldom without success. It alights with great firmness, immediately erects itself in the manner of Hawks, glances all around, shakes its wings with a tremulous motion, and vibrates its tail upwards as if by a spring. Its tufty crest is generally erected, and its whole appearance is neat, if not elegant. The Pewee has its particular stands, from which it seldom rambles far. The top of a fence stake near the road is often selected by it, from which it sweeps off in all directions, returning at intervals, and thus remaining the greater part of the morning and evening. The corner of the roof of the barn suits it equally well, and if the weather requires it, it may be seen perched on the highest dead twig of a tall tree. During the heat of the day it reposes in the shade of the woods. In the autumn it will choose the stalk of the mullein for its stand, and sometimes the projecting angle of a rock jutting over a stream. It now and then alights on the ground for an instant, but this happens principally during winter, or while engaged during spring in collecting the materials of which its nest is composed, in our Southern States, where many spend their time at this season.

I have found this species abundant in the Floridas in winter, in full song, and as lively as ever, also in Louisiana and the Carolinas, particularly in the cotton fields. None, however, to my knowledge, breed south of Charleston in South Carolina, and very few in the lower parts of that State. They leave Louisiana in February, and return to it in October. Occasionally during winter they feed on berries of different kinds, and are quite expert at discovering the insects impaled on thorns by the Loggerhead Shrike, and which they devour with avidity. I met with a few of these birds on the Magdeleine Islands, on the coast of Labrador, and in Newfoundland.

The nest of this species bears some resemblance to that of the Barn Swallow, the outside consisting of mud, with which are firmly impacted grasses or mosses of various kinds deposited in regular strata. It is lined with delicate fibrous roots, or shreds of vine bark, wool, horse-hair, and sometimes a

few feathers. The greatest diameter across the open mouth is from five to
six inches, and the depth from four to five. Both birds work alternately,
bringing pellets of mud or damp earth, mixed with moss, the latter of which
is mostly disposed on the outer parts, and in some instances the whole
exterior looks as if entirely formed of it. The fabric is firmly attached to
a rock, or a wall, the rafter, of a house, &c. In the barrens of Kentucky I
have found the nests fixed to the side of those curious places called *sink-
holes*, and as much as twenty feet below the surface of the ground. I have
observed that when the Pewees return in spring, they strengthen their
tenement by adding to the external parts attached to the rock, as if to prevent
it from falling, which after all it sometimes does when several years old.
Instances of their taking possession of the nest of the Republican Swallow
(*Hirundo fulva*) have been observed in the State of Maine. The eggs are
from four to six, rather elongated, pure white, generally with a few reddish
spots near the larger end.

In Virginia, and probably as far as New York, they not unfrequently raise
two broods, sometimes three, in a season.

This species ejects the hard particles of the wings, legs, abdomen, and
other parts of insects, in small pellets, in the manner of Owls, Goatsuckers
and Swallows.

The following characters presented by the digestive organs and trachea,
are common to all the North American small Flycatchers, varying only in
their relative dimensions. The roof of the mouth is flat and somewhat
diaphanous; its anterior part with three prominent lines, the palate with
longitudinal ridges; the posterior aperture of the nares linear-oblong, mar-
gined with papillæ. The tongue is $4\frac{1}{2}$ twelfths long, rather broad, very thin,
emarginate and papillate at the base, the tip slit. The mouth is rather wide,
measuring $4\frac{3}{4}$ twelfths across. There is a very narrow oblong salivary gland
in the usual place, and opening by three ducts. The œsophagus is 2 inches
1 twelfth long, $2\frac{1}{2}$ twelfths wide, without dilatation. The stomach is rather
small, 6 twelfths long, 5 twelfths broad, considerably compressed, the lateral
muscles distinct and of moderate size, the lower very thin; the epithelium
thin, tough, longitudinally rugous, brownish-red. The stomach filled with
insects. The intestine is $6\frac{1}{2}$ inches long, from $1\frac{3}{4}$ twelfths to 1 twelfth in
width; the cœca $1\frac{1}{2}$ twelfths long, $\frac{1}{2}$ twelfth broad, 1 inch distant from the
extremity; the rectum gradually dilates into an ovate cloaca.

The trachea is 1 inch 7 twelfths long, from 1 twelfth to $\frac{3}{4}$ twelfth in breadth,
considerably flattened; the rings 78, with two additional dimidiate rings.
The bronchi are of moderate length, with 12 half rings. The lateral muscles
are very slender, as are the sterno-tracheales; the inferior laryngeal are very
small, and seem to form only a single pair.

Wood Pewee Flycatcher
Swamp Honeysuckle. Azalea Viscosa.

, Male

Drawn from Nature by J.J.Audubon, F.R.S.F.L.S.

Lith Printed & Col'd by J.T.Bowen Philad'

Pewit Flycatcher, *Muscicapa nunciola,* Wils. Amer. Orn., vol. ii. p. 78.
Muscicapa fusca, Bonap. Syn., p. 68.
Pewit Flycatcher or Phœbe, Nutt. Man., vol. i. p. 278.
Pewee Flycatcher, *Muscicapa fusca,* Aud. Orn. Biog., vol. ii. p. 122; vol. v. p. 424.

Wing much rounded, third quill longest, fourth scarcely shorter, but considerably longer than second, first intermediate between sixth and seventh; tail emarginate; upper parts dull olive, the head much darker; quills and tail dusky brown, secondaries and their coverts edged with pale brown; outer tail-feathers whitish on the outer edge, unless toward the tip; lower parts dull yellowish-white, the breast tinged with grey.

Male, 7, 9½.

Throughout the United States, and northward. Spends the winter in vast numbers in the southern parts.

THE COTTON PLANT.

Gossypium herbaceum, *Linn.,* Syst. Nat., vol. ii. p. 462.—Monadelphia Polyandria, *Linn.*—Malvaceæ, *Juss.*

This species, commonly known in America, is distinguished by its five-lobed leaves and herbaceous stem.

THE WOOD PEWEE.

Muscicapa virens, *Linn.*

PLATE LXIV.—Male.

It is in the darkest and most gloomy retreats of the forest that the Wood Pewee is generally to be found, during the season which it spends with us. You may find it, however, lurking for awhile in the shade of an overgrown orchard; or, as autumn advances, you may see it gleaning the benumbed insects over the slimy pools, or gliding on the outskirts of the woods, when, for the last time, the piping notes of the bullfrog are heard mingling with its own plaintive tones. In all these places, it exhibits the simplicity and freedom of its natural habits, dashing after the insects on which it principally feeds, with a remarkable degree of inattention to surrounding objects. Its sallies have also the appearance of being careless, although at times protracted,

when it seems to seize several insects in succession, the more so perhaps that it has no rival to contend with in such situations. Sometimes towards autumn, it sweeps so closely over the pools that it is enabled to seize the insects as they float on the water; while, at other times, and as if in surprise, it rises to the tops of the forest trees, and snaps the insect which is just launching forth on some extensive journey, with all the freedom of flight that the bird itself possesses.

The weary traveller, who at this season wanders from his path in search of water to quench his thirst, or to repose for awhile in the shade, is sure to be saluted with the melancholy song of this little creature, which, perched erect on a withered twig, its wings quivering as if it had been seized with a momentary chill, pours forth its rather low, mellow notes with such sweetness as is sure to engage the attention. Few other birds are near; and, should the more musical song of a Wood-thrush come on his ear, he may conceive himself in a retreat where no danger is likely to assail him during his repose.

This species, which is considerably more abundant than the *M. fusca*, is rather late in entering the Middle States, seldom reaching Pennsylvania until the 10th of May; yet it pushes its migrations quite beyond the limits of the United States. On the one hand, many of them spend the winter months in the most Southern States, such as Louisiana and the pine barrens of Florida, feeding on different berries, as well as insects; while, on the other, I have met with them in September, in the British province of New Brunswick, and observed their retrograde movements through Maine and Massachusetts. I have also seen them near Halifax, Nova Scotia, in Labrador, and in Newfoundland.

In autumn, when its notes are almost the only ones heard, it may often be seen approaching the roads and pathways, or even flitting among the tall and beautiful elms in the vicinity, or in the midst of our eastern cities. There you may observe the old birds teaching the young how to procure their food. The various groups, imperceptibly as it were, and in the most gradual manner, now remove southward by day; and, at this season, their notes are heard at a very late hour, as in early spring. They may be expressed by the syllables *pĕ-wĕe, pettowĕe, pĕ-wĕe*, prolonged like the last sighs of a despondent lover, or rather like what you might imagine such sighs to be, it being, I believe, rare actually to hear them.

This species, in common with the Great Crested Flycatcher, and the Least Wood Pewee, is possessed of a peculiarity of vision, which enables it to see and pursue its prey with certainty, when it is so dark that you cannot perceive the bird, and are rendered aware of its occupation only by means of the clicking of its bill.

The nest of the Wood Pewee is as delicate in its form and structure, as the bird is in the choice of the materials which it uses in its construction. In almost every case, I have found it well fastened to the upper part of a horizontal branch, without any apparent preference being given to particular trees. Were it not that the bird generally discloses its situation, it would be difficult to discover it, for it is shallow, well saddled to the branch, and connected with it by an extension of the lichens forming its outer coat, in such a manner as to induce a person seeing it to suppose it merely a swelling of the branch. These lichens are glued together apparently by the saliva of the bird, and are neatly lined with very fine grasses, the bark of vines, and now and then a few horse-hairs. The eggs are four or five, of a light yellowish hue, dotted and blotched with reddish at the larger end. It raises two broods in a season in Virginia and Pennsylvania, but rarely more than one in the Northern States. By the middle of August the young are abroad; and it is then that the birds seem more inclined to remove from the interior of the forest.

Although less pugnacious than the larger Flycatchers, it is yet very apt to take offence when any other bird approaches its stand, or appears near its nest.

In its ordinary flight the Wood Pewee passes through the gloom of the forest, at a small elevation, in a horizontal direction, moving the wings rapidly, and sweeping suddenly to the right or left, or darting upwards, after its prey, with the most perfect ease. During the love season, it often flies, with a vibratory motion of the wings, so very slowly that one might suppose it about to poise itself in the air. On such occasions its notes are guttural, and are continued for several seconds as a low twitter.

Although the Wood Pewee is found in Labrador and Newfoundland, as well as on the Rocky Mountains and along the Columbia river, it does not appear to have been seen in the Fur Countries. I have met with it abundantly in the Texas, where it breeds, as it does in all suitable localities in the United States.

The egg measures five-eighths of an inch in length, and nine-sixteenths in breadth. The vividness of the red markings varies considerably.

WOOD PEWEE, *Muscicapa rapax*, Wils. Amer. Orn., vol. ii. p. 81.
WOOD PEWEE, *Muscicapa virens*, Nutt. Man., vol. i. p. 285.
MUSCICAPA VIRENS, Bonap. Syn., p. 68.
WOOD PEWEE, *Muscicapa virens*, Aud. Orn. Biog., vol. ii. p. 93; vol. v. p. 425.

Slightly crested; second quill longest, first shorter than third and longer than sixth; tail deeply emarginate; upper parts dusky olive, upper part of

head much darker; a pale greyish ring round the eye; two bands of greyish-white on the wings, secondaries margined with the same; quills and tail-feathers blackish-brown; throat and breast ash-grey, tinged with green, the rest of the lower parts pale greenish-yellow.

Male, 6½, 11.

Throughout the United States. British Provinces. Labrador. New-foundland. Rocky Mountains. Columbia river. Migratory.

THE SWAMP HONEYSUCKLE.

AZALEA VISCOSA, *Willd.*, Sp. Pl., vol. i. p. 631. *Pursch*, Flor. Amer. Sept., vol. i. p. 153.
—PENTANDRIA MONOGYNIA, *Linn.*—RHODODENDRA, *Juss.*

The leaves of this species of Azalea are oblongo-obovate, acute, smooth on both sides; the flowers white, sweet-scented, with a very short calyx. It grows abundantly in almost every district of the United States, in such localities as are suited to it, namely, low damp meadows, swamps, and shady woods.

TRAILL'S FLYCATCHER.

MUSCICAPA TRAILLII.

PLATE LXV.—MALE.

This is a species which, in its external appearance, is so closely allied to the *Wood Pewee,* and the Small Green Crested Flycatcher, that the most careful inspection is necessary to establish the real differences existing between these three species. Its notes, however, are perfectly different, as are, in some measure, its habits, as well as the districts in which it resides.

The notes of Traill's Flycatcher consist of the sounds *wheet, wheet,* which it articulates clearly while on wing. It resides in the skirts of the woods along the prairie lands of the Arkansas river. When leaving the top branches of a low tree, this bird takes long flights, skimming in zigzag lines, passing close over the tops of the tall grasses, snapping at and seizing different species of winged insects, and returning to the same tree to alight. Its notes, I observed, were uttered when on the point of leaving the branch. The pair chased the insects as if acting in concert, and doubtless had a nest in the immediate neighbourhood, although I was unable to discover it. It

Traill's Flycatcher.
Sweet Gum. Liquidambar Styraciflua

Male.

Drawn from Nature by J.J. Audubon. F.R.S.F.L.S. Lith Printed & Col'd. by J. T. Bowen. Phil.

being in the month of April, I suspected the female had not begun to lay. Five of the eggs in the ovary were about the size of green peas. I could not perceive any difference in the colouring of the plumage between the sexes, and I have represented the male in that inclined and rather crouching attitude which I observed the bird always to assume when alighted.

I have named this species after my learned friend Dr. THOMAS STEWART TRAILL of Edinburgh, in evidence of the gratitude which I cherish towards that gentleman for all his kind attentions to me.

Many specimens of this Flycatcher were procured by Mr. TOWNSEND about the Columbia river, several of which are still in my possession, after giving one to the Prince of MUSIGNANO, who had not seen one before, and another to the Earl of DERBY.

TRAILL'S FLYCATCHER, *Muscicapa virens*, Aud. Orn. Biog., vol. i. p. 236; vol. v. p. 426.

Slightly crested; wing rounded, with the third quill longest, second and fourth almost equal, first a little longer than sixth; tail slightly rounded, and faintly emarginate; upper parts dusky olive, upper part of head much darker; a pale greyish ring round the eye; two bands of greyish-white on the wings, secondaries margined with the same; throat and breast ash-grey, the rest of the lower parts shaded into pale yellow.

Male, 5¾, 8½.

Arkansas. Columbia river. Migratory.

THE SWEET GUM.

LIQUIDAMBAR STYRACIFLUA, *Willd.*, Sp. Pl., vol. iv. p. 476. *Pursch*, Fl. Amer., vol. ii. p. 635. *Mich.*, Arbr. Forest. de l'Amer. Sept., vol. iii. p. 194, Pl. iv.—MONŒCIA POLYANDRIA, *Linn.*—AMENTACEÆ, *Juss.*

This species, which is the only one that grows in the United States, is distinguished by its palmate leaves, the lobes of which are toothed and acuminate, the axils of the nerves downy. In large individuals, the bark is deeply cracked. The wood is very hard and fine grained, but is now little used, although formerly furniture of various kinds was made of it. When the bark is removed, a resinous substance exudes, which has an agreeable smell, but is only obtained in very small quantity.

LEAST PEWEE FLYCATCHER.

Muscicapa pusilla, *Swains.*

PLATE LXVI.—Male.

This small and plainly-coloured species, first described by my friend WILLIAM SWAINSON, Esq. in the Fauna Boreali-Americana, under the name of "*Tyrannula pusilla,*" is a common inhabitant' of the northern and north-western parts of America, but has not, I believe, been known to pass along our Atlantic shores. Dr. RICHARDSON, who observed it in the Fur Countries, says that "it was first seen by us at Carlton House, on the 19th of May, flitting about for a few days among low bushes on the banks of the river, after which it retired to the moist shady woods lying farther north."

My friend THOMAS NUTTALL, Esq. procured this bird on Wapatoo Island, which is formed by the junction of the Multnomah with the Columbia, 20 miles long, and 10 broad. The land is high and extremely fertile, and in most parts supplied with a heavy growth of cotton-wood, ash, and sweet-willow. But the chief wealth of the island consists of the numerous ponds in the interior, abounding with the common arrow-head, *Sagittaria sagittifolia,* to the root of which is attached a bulb growing beneath it in the mud. This bulb, to which the Indians give the name of Wapatoo, is the great article of food, and almost the staple article of commerce, on the Columbia. It is never out of season, so that at all times of the year the valley is frequented by the neighbouring Indians, who come to gather it. It is collected chiefly by the women, who take a light canoe in a pond, where the water is as high as the breast, and by means of their toes, separate the root from the bulb, which on being freed from the mud rises immediately to the surface of the water, and is thrown into the canoe. This plant is found through the whole extent of the Columbia Valley, but does not grow farther eastward.

"I observed," he continues, "a male of this species very active and cheerful, making his chief residence in a spreading oak, on the open border of a piece of forest. As usual, he took his station at the extremity of a dead branch, from whence, at pretty quick intervals, he darted after passing insects. When at rest, he raised his erectile crest, and in great earnest called out *sishui, sishui,* and sometimes *tsishea, tsishea,* in a lisping tone, rather quickly, and sometimes in great haste, so as to run both calls together. This brief, rather loud, quaint and monotonous ditty, was continued for hours together, at which time, so great was our little actor's abstraction, that he al-

Pl.66

Least Pewee Flycatcher
White Oak. Quercus Prinus
Male

lowed a near approach without any material apprehension. As I could not discover any nest, I have little doubt it was concealed either in some knot or laid on some horizontal branch."

I found this species both in Newfoundland and on the coast of Labrador in considerable numbers. In the latter country, where the bushes are low and the fir-trees seldom attain a height of thirty feet, I observed that it preferred for its residence the narrow and confined valleys which at that season (July) are clothed with luxuriant herbage, and abound in insects, to which this little Flycatcher gives chase with great activity, returning, as is the well-known habit of all our small species, to the twig or top of the plant which it has selected for its look-out station. Two males I observed one morning, were constantly engaged in pursuing each other, when at times they would mount to some height in the air, there meet, snap their bills violently, separate, and return to their posts. Their continued cries induced me to believe that they had females and nests in the valley; and after searching a good while, I had the gratification of finding one of them placed between two small twigs of a bush not above four feet in height. This nest was composed of delicate dry grasses and fibrous roots, so thinly arranged as to enable me to see through it. It contained five eggs, so nearly resembling those of our Little Red-start Flycatcher, that, had I not started the female from the nest, I should have been induced to pronounce them the property of that bird. They measured five and a half eighths by four-eighths, and were rather sharp at the smaller end, pure white, thinly spotted, and marked with different tints of light red, with a few dots of umber, principally toward the apex. Many of the young were able to fly before our departure, which took place on the 12th of August; and I think that the pair which I found breeding must have been later than usual in arriving in that country, as a very few days afterwards I found a good number fully fledged, and travelling along the shore of St. George's Bay in Newfoundland. This species may perhaps breed in Nova Scotia, as I have seen a specimen obtained there in the collection of my young friend Thomas M'Culloch, Esq. of Halifax.

Tyrannula pusilla, Little Tyrant Flycatcher, Swains. and Rich. F. Bor. Amer., vol. ii. p. 144.
Little Tyrant Flycatcher, *Muscicapa pusilla*, Aud. Orn. Biog., vol. v. p. 288.

Third quill longest, fourth scarcely shorter, second nearly one-twelfth shorter, and exceeding the first by three and a quarter twelfths; tail slightly emarginate; upper parts light greenish-brown; loral band whitish, a narrow pale ring surrounding the eye; wings olive-brown, with two bands of dull white, secondaries margined with the same; tail olive-brown, the lateral

feathers lighter, the outer web pale brownish-grey; fore part of neck and a portion of the breast and sides ash-grey, the rest of the lower parts pale yellow.

Male, 5$\frac{4}{12}$, wing, 2$\frac{7}{12}$.

Columbia river. Fur Countries. Labrador. Newfoundland. Rare in the Atlantic States.

THE WHITE OAK.

QUERCUS PRINUS, *Willd.*, Sp. Pl., vol. iv. p. 439. *Pursch*, Fl. Amer., vol. ii. p. 633.—
QUERCUS PRINUS PALUSTRIS, *Mich.*, Arb. Forest. de l'Amér. Sept., vol. ii. p. 51. Pl. 7.—
MONŒCIA POLYANDRIA, *Linn.*—AMENTACEÆ, *Juss.*

Leaves oblongo-oval, acute, largely toothed, the teeth nearly equal, dilated, and callous at the tip; cupule craterate, attenuated at the base; acorn ovate. This species grows in low shady woods, and along the margins of rivers, from Pennsylvania to Florida. The wood is porous, and of inferior quality.

SMALL HEADED FLYCATCHER.

MUSCICAPA MINUTA, *Wilson.*

PLATE LXVII.—MALE.

The sight of the figure of this species brings to my recollection a curious incident of long-past days, when I drew it at Louisville in Kentucky. It was in the early part of the spring of 1808, thirty-two years ago, that I procured a specimen of it while searching the margins of a pond.

In those happy days, kind reader, I thought not of the minute differences by which one species may be distinguished from another in words, or of the necessity of comparing tarsi, toes, claws, and quills, although I have, as you are aware, troubled you with tedious details of this sort. When ALEXANDER WILSON visited me at Louisville, he found in my already large collection of drawings, a figure of the present species, which, being at that time unknown to him, he copied and afterwards published in his great work, but without acknowledging the privilege that had thus been granted to him. I have more than once regretted this, not by any means so much on my own

Small-headed Flycatcher.
Virginian Spider-wort. Tradescantia virginica!.
Male.

Drawn from Nature by J. J. Audubon F.R.S. F.L.S. Lith. Printed & Col.d by J.T. Bowen

account, as for the sake of one to whom we are so deeply indebted for his elucidation of our ornithology.

I consider this Flycatcher as among the scarcest of those that visit our middle districts; for, although it seems that WILSON procured one that "was shot on the 24th of April, in an orchard," and afterwards "several individuals of this species in various quarters of New Jersey, particularly in swamps," all my endeavours to trace it in that section of the country have failed, as have those of my friend EDWARD HARRIS, Esq., who is a native of that State, resides there, and is well acquainted with all the birds found in the district. I have never seen it out of Kentucky, and even there it is a very uncommon bird. In Philadelphia, Baltimore, New York, or farther eastward or southward, in our Atlantic districts, I never saw a single individual, not even in museums, private collections, or for sale in bird-stuffers' shops.

In its habits this species is closely allied to the Hooded and Green Blackcapt Flycatchers, being fond of low thick coverts, whether in the interior of swamps, or by the margins of sluggish pools, from which it only removes to higher situations after a continuation of wet weather, when I have found it on rolling grounds, and amid woods comparatively clear of under-growth.

Differing from the true Flycatchers, this species has several rather pleasing notes, which it enunciates at pretty regular intervals, and which may be heard at the distance of forty or fifty yards in calm weather. I have more than once seen it attracted by an imitation of these notes. While chasing insects on wing, although it clicks its bill on catching them, the sound thus emitted is comparatively weak, as is the case with the species above mentioned, it being stronger however in the Green Blackcapt than in this or the Hooded species. Like these birds, it follows its prey to some distance at times, whilst, at others, it searches keenly among the leaves for its prey, but, I believe, never alights on the ground, not even for the purpose of drinking, which act it performs by passing lightly over the water and sipping, as it were, the quantity it needs.

All my efforts to discover its nests in the lower parts of Kentucky, where I am confident that it breeds, have proved fruitless; and I have not heard that any other person has been more successful.

SMALL-HEADED FLYCATCHER, *Muscicapa minuta*, Wils. Amer. Orn., vol. vi. p. 62.
SYLVIA MINUTA, Bonap. Syn., p. 86.
SMALL-HEADED SYLVAN FLYCATCHER, Nutt. Man., vol. i. p. 296.
SMALL-HEADED FLYCATCHER, *Muscicapa minuta*, Aud. Orn. Biog., vol. v. p. 291.

Wings short, the second quill longest; tail of moderate length, even; general colour of upper parts light greenish-brown; wings and tail dark olive-brown, the outer feathers of the latter with a terminal white spot on

American Redstart.
Virginian Hornbeam or Iron wood Tree.
1. Male 2. Female

which may be expressed by the syllables *wizz, wizz, wizz.* While following insects on the wing, it keeps its bill constantly open, snapping as if it procured several of them on the same excursion. It is frequently observed balancing itself in the air, opposite the extremity of a bunch of leaves, and darting into the midst of them after the insects there concealed.

When one approaches the nest of this species, the male exhibits the greatest anxiety respecting its safety, passes and repasses, fluttering and snapping its bill within a few feet, as if determined to repel the intruder. They now and then alight on the ground, to secure an insect, but this only for a moment. They are more frequently seen climbing along the trunks and large branches of trees for an instant, and then shifting to a branch, being, as I have said, in perpetual motion. It is also fond of giving chase to various birds, snapping at them without any effect, as if solely for the purpose of keeping up the natural liveliness of its disposition.

The young males of this species do not possess the brilliancy and richness of plumage which the old birds display, until the second year, the first being spent in the garb worn by the females; but, towards the second autumn, appear mottled with pure black and vermilion on their sides. Notwithstanding their want of full plumage, they breed and sing the first spring like the old males.

I have looked for several minutes at a time on the ineffectual attacks which this bird makes on wasps while busily occupied about their own nests. The bird approaches and snaps at them, but in vain; for the wasp elevating its abdomen, protrudes its sting, which prevents its being seized. The male bird is represented in the plate in this posture.

Its nest is generally made on a low bush or sapling, and has the appearance of hanging to the twigs. It is slight, and is composed of lichens and dried fibres of rank weeds or grape vines, nicely lined with soft cottony materials. The female lays from four to six white eggs, sprinkled with ash-grey and blackish dots. It rears only a single brood in a season. The old birds, I am inclined to think, leave the United States a month or three weeks before the young, some of which linger in the deep swamps of the States of Mississippi and Louisiana until the beginning of November.

This birds differs in no essential respect from the Flycatchers above mentioned. Its mouth has the same structure, being only a little more concave in front. The tongue is of the same form, but proportionally narrower, its tip slit. The œsophagus is 1 inch 8 twelfths long, its average width 1 twelfth. The stomach 4½ twelfths by 3¾ twelfths. Intestine 3 inches 10 twelfths long, its greatest width barely 1 twelfth; cœca little more than ½ twelfth long, and 7½ twelfths distant from the extremity. Trachea 1¼ inches long, of 55 rings,

with 2 dimidiate; its muscles as in the other species, but the inferior laryngeal proportionally a little larger; bronchi of about 12 half rings.

American Redstart, *Muscicapa ruticilla*, Wils. Amer. Orn., vol. i. p. 103.
Muscicapa ruticilla, Bonap. Syn., p. 68.
American Redstart, *Muscicapa ruticilla*, Aud. Amer. Orn., vol. i. p. 202; vol. v. p. 428.
American Redstart, *Muscicapa ruticilla*, Nutt. Man., vol. i. p. 291.

Second and third quills equal and longest, fourth longer than first; tail rounded. Male with the head, neck all round, fore part of breast, and back, glossy bluish-black; sides of the breast, lower wing-coverts, a patch on the wings formed by the margins of the primaries and the basal half of most of the secondaries, together with three-fourths of both webs of the outer four tail-feathers on each side, and the outer web of the next, bright orange-red; abdomen and lower tail-coverts white. Female with the upper parts yellowish-brown; the head grey; the quills greyish-brown; the tail darker; the parts yellow which in the male are bright orange; the rest of the lower parts white, tinged with yellow. Young similar to the female, more grey above, and with less yellow beneath.

Male, 5, 6¼. Female.

Throughout the United States. Abundant. Migratory.

The Virginian Hornbeam, or Iron-wood Tree.

Ostrya virginica, *Willd.*, Sp. Pl., vol. iv. p. 469. *Pursch*, Flor. Amer., vol. ii. p. 623.—
Monœcia Polyandria, *Linn.*—Amentaceæ, *Juss.*

This species is distinguished by its ovato-oblong leaves, which are somewhat cordate at the base, unequally serrated and acuminate, and its twin, ovate, acute cones. It is a small tree, attaining a height of from twenty to thirty feet, and a diameter of about one foot. The wood is white, and close grained. The common name in America is *iron-wood*, which it receives on account of the great hardness of the wood.

Harvard Natural History
Society.

Pl 69.

Townsend's Ptilogonys.

Female

Genus III.—PTILOGONYS, *Swains.* PTILOGONYS.

Bill short, rather strong, somewhat triangular, depressed at the base, a little compressed at the end; upper mandible with the dorsal line convex at the end, the nasal groove wide, the sides convex toward the end, with a distinct notch, the tip short, rather obtuse; lower mandible with the angle rather long and wide, the dorsal line ascending and convex, the sides convex toward the end, the tip small, with a slight notch behind. Nostrils linear, oblong, partially concealed by the feathers. Head ovato-oblong; neck rather short; body slender. Feet short, and rather slender; tarsus shorter than the middle toe with its claw, compressed, covered anteriorly with a long plate and three inferior scutella; toes free, the outer only adherent at the base; hind toe rather large, stouter, outer a little longer than inner; claws moderate, arched, much compressed, laterally grooved, acute. Plumage soft and blended; slight bristles at the base of the upper mandible, and the feathers in the angle of the lower jaw bristle-tipped and curved forward. Wings long, rounded; first quill very small, fourth longest. Tail very long, straight, emarginate, and rounded, of twelve feathers.

This genus seems to connect the Thrushes with the Flycatchers.

TOWNSEND'S PTILOGONYS.

Ptilogonys Townsendi, *Aud.*

PLATE LXIX.—Female.

The only individual of this species that I have ever seen is a female, which was shot near the Columbia river, and kindly transmitted to me by my friend Mr. Townsend, after whom, not finding any description of it, I have named it. The genus, which was instituted by Mr. Swainson, is very remarkable, combining, as it appears to me, the characters of some of the Flycatchers and Thrushes.

Townsend's Ptilogonys, *Ptilogonys Townsendi,* Aud. Orn. Biog., vol. v. p. 206.

General colour dull brownish-grey; quills and coverts dusky brown; edge of wing dull white; basal part of primaries pale yellow, of secondaries ochre-

Blue-grey Flycatcher.

Black Walnut. Juglans nigra.

1. Male. 2. Female.

Drawn from Nature by J.J. Audubon FRSE. Lith. Printed & col.d by J.T. Bowen Philad.

Harvard Natural History
Society.

greater number proceed far eastward, and spread over the United States, although they are not common in any part.

The Blue-grey Flycatcher arrives in the neighbourhood of New Orleans about the middle of March, when it is observed along the water-courses, flitting about and searching diligently, amidst the branches of the golden willow, for the smaller kinds of winged insects, devouring amongst others great numbers of moschettoes. Its flight resembles that of the Long-tailed Titmouse of Europe. It moves to short distances, vibrating its tail while on wing, and, on alighting, is frequently seen hanging to the buds and bunches of leaves, at the extremities of the branches of trees. It seldom visits the interior of the forests, in any portion of our country, but prefers the skirts of woods along damp or swampy places, and the borders of creeks, pools, or rivers. It seizes insects on wing with great agility, snapping its bill like a true Flycatcher, now and then making little sallies after a group of those diminutive flies that seem as if dancing in the air, and cross each other in their lines of flight, in a thousand various ways.

When it has alighted, its tail is constantly erected, its wings droop, and it utters at intervals its low and uninteresting notes, which resemble the sounds *tsee, tsee.* It seldom if ever alights on the ground, and when thirsty prefers procuring water from the extremities of branches, or sips the rain or dew-drops from the ends of the leaves.

Its nest is composed of the frailest materials, and is light and small in proportion to the size of the bird. It is formed of portions of dried leaves, the husks of buds, the silky fibres of various plants and flowers, and light grey lichens, and is lined with fibres of Spanish moss or horsehair. I have found these nests always attached to two slender twigs of willow. The eggs are four or five, pure white, with a few reddish dots at the larger end. Two broods are reared in a season. The young and old hunt and migrate together, passing amongst the tops of the highest trees, from one to another. They leave the State of Louisiana in the beginning of October, the Middle States about the middle of September. I have seen some of these birds on the border line of Upper Canada, along the shores of Lake Erie. I have also observed them in Kentucky, Indiana, and along the Arkansas river.

In the plate is represented, along with a pair of these delicate birds, a twig of one of our most valuable trees, with its pendulous blossoms. This tree, the *black walnut,* grows in almost every part of the United States, in the richest soils, and attains a great height and diameter. The wood is used for furniture of all sorts, receives a fine polish, and is extremely durable. The stocks of muskets are generally made of it. The black walnut is plentiful in all the alluvial grounds in the vicinity of our rivers. The fruit is contained in a very hard shell, and is thought good by many people.

Blue-grey Flycatcher, *Muscicapa cœrulea*, Wils. Amer. Orn., vol. ii. p. 164.
Sylvia cœrulea, Bonap. Syn., p. 85.
Blue-grey Sylvan Flycatcher, *Muscicapa cœrulea*, Nutt. Man., vol. i. p. 297.
Blue-grey Flycatcher, *Muscicapa cœrulea*, Aud. Orn. Biog. vol. i. p. 431.

Upper parts bright blue, deeper on the head, paler on the tail-coverts; a narrow black band on the forehead, extending over the eyes; wings brownish-black, margined with blue, some of the secondaries with bluish-white; tail glossy black, the outer feather on each side nearly all white, the next with its terminal half, and the third with its tip of that colour; lower parts greyish-white. Female similar, but with the tints duller, and the black band on the head wanting.

Male, 4½, 6¼.

From Texas northward. Abundant. Migratory.

THE BLACK WALNUT.

Juglans nigra, *Willd.*, Sp. Pl., vol. iv. p. 456. *Pursch*, Flor. Amer., vol. ii. p. 636.
Mich., Arbr. Forest. de l'Amer. Sept., vol. i. p. 157, pl. 1.—Monœcia Polyandria,
Linn.—Terebinthaceæ, *Juss.*

This species belongs to the division with simple, polyandrous male catkins, and is distinguished by its numerous ovato-lanceolate, subcordate, serrated leaflets, narrowed towards the end, somewhat downy beneath, as are the petioles, its globular scabrous fruits, and wrinkled nuts. The leaves have seven or eight nearly opposite pairs of leaflets. The male catkins are pendent. The fruits are sometimes from six to eight inches in circumference, the kernel brown and corrugated, and, although eaten, inferior to the common walnut. The bark of the trunk is thick, blackish, and cracked; the wood of a very dark colour.

LIST OF SUBSCRIBERS.

Albany, N. Y.

Rufus King,
W. C. Little, (3 copies.)

Annapolis, Md.

R. W. Gill,
T. W. Franklin,
T. W. Wells,
Mrs. Bland,
Sommerville Pinckney,
Thomas H. Alexander,
Wm. S. Green,
A. Randall,
G. R. Barber,
Col. J. B. Walbach, U. S. A.
Capt. P. F. Voorhees, U. S. N.

Augusta, Ga.

John Millage,
Henry H. Cummings,
Rev. J. P. King.

Baltimore, Md.

Robert M'Kim,
John Gable,
J. Q. Hewlett,
Basil B. Gordon,
P. E. Thomas,
J. E. Atkinson,
C. W. Pairo,
R. M. R. Smith,
Thomas P. Williams,
Hough, Hupp & Co.
Evan T. Ellicott,
Elias Ellicot,
Samuel & Philip T. Ellicott,
Hugh M'Eldery,
Wm. M'Donald & Son,
Thomas M. Smith,
Thomas Whitridge,
Samuel Hurlbut,
G. S. Oldfield,
John Hurst,
Francis T. King,
Wm. H. Beatty,
James W. Jenkins,

W. H. De C. Wright,
John Ridgeley,
W. G. Harrison,
John Clark,
David Keener,
Charles Wyeth,
Enoch Pratt,
Martin Keith, jr.
James Harwood,
Samuel K. George,
M. N. Falls,
E. Jenner Smith,
Hon. Judge U. S. Heath,
Wm. J. Albert,
George Baughman,
William Reynolds,
Mrs. Sarah F. Law,
Gen. G. H. Stewart,
William N. Baker,
Richard Duvall,
George Brown,
John Hopkins,
Miss Emily Hoffman,
Ch. Simon,
A. B. Riely,
C. S. Fowler,
Charles F. Mayer,
Mrs. Samuel Feast,
H. Le Roy Edgar,
Charles W. Karthaus,
B. Deford,
R. Sturges,
Alexander Turnbull,
Philip T. George,
William Schley,
C. Kretzer,
D. S. Wilson,
James Armour,
Thomas W. Hall,
George C. Morton,
Wm. Stewart Appleton,
Alex. L. Boggs,
Hugh Birkhead,
Thomas Palmer,
A. B. Cleveland, M. D.
Hon. Judge John Purviance,
George W. Hall,

Lambert Gettings,
Z. C. Lee,
John M. Harman,
Thomas Butler,
Gideon B. Smith, M. D.
James Cheston,
James Gibson,
J. T. Ducatel,
Robert Gilmor,
William G. Pogue,
Isaac Munroe,
Samuel Hoffman,
J. Pennington,
Gustav W. Lurman,
Robert P. Brown,
H. D. Chapin,
Capt. Samuel Ringold, U. S. A.
Robert Mickle,
John V. L. M'Mahon,
John Glenn,
Wm. E. Mayhew,
John Buckler, M. D.
F. W. Brune,
John H. B. Latrobe,
J. Mason Campbell,
Com. Jacob Jones, U. S. N.
John L. Dunkel,
Wm. H. Hoffman,
Robert A. Taylor,
Joseph Todhunter,
P. Macauley, M. D.
Edward Patterson,
John Bradford,
George M. Gill,
Thomas Swann,
R. S. Stewart, M. D.
St. Mary's College,
I. N. Nicollet,
W. C. Shaw,
Comfort Tiffany,
George W. Cox,
John C. Brune,
Edward Pitman,
J. M'Henry Boyd,
George W. Dobbin,
T. Parkin Scott,
George T. Jenkins,
Hugh Jenkins,
James Howard,
Frederick Rodewald,
John M'Tavish,
Samuel Riggs,
Thomas Harrison,
Andrew Aldridge,
John H. Alexander,
Samuel Jones, jr.
Thomas R. Ware,
George H. Howard,
Charles Fisher & Co.
John R. Moore,

P. Baltzell,
Thomas Meredith,
Andrew D. Jones,
William Woodward,
J. S. Inloes,
S. T. Thompson,
John K. Randall,
William Kennedy,
Edward Jenkins,
Mark W. Jenkins,
Richard Plummer,
Robert M. Ludlow,
Charles Howard,
Robert S. Voss,
Charles A. Williamson,
Benjamin D. Higdon,
George Tiffany,
James H. Marston,
R. M'Dowell,
Plaskett & Cugle,
Benjamin C. Ward,
O. C. Tiffany,
Richard Sewell,
Riverdy Johnson,
Richard Linthicum,
H. G. D. Carroll,
Alonzo Lilly,
E. B. Loud,
George S. Norris,
Brantz Mayer,
Samuel M'Pherson,
Nathan Rogers,
David U. Brown.

Baton Rouge, La.

T. W. Chinn.

Beaufort, S. C.

Dr. H. M. Fuller,
Miss Richardson,
J. Milne,
Beaufort Library Society.

Bedford, Pa.

William Lyon.

Boston, Mass.

Simon E. Greene,
D. Eckley,
Ignatius Sargent,
F. C. Gray,
Amos Binney,
Thomas Douse,
J. P. Cushing,
N. G. Snelling,
James Savage,
Ozias Goodwin,
Thomas H. Perkins,
Jonathan Phillips,

John C. Warren, M. D.
John M. Bethune,
James Pierce,
Seth Bass, M. D.
Benjamin D. Greene,
Abbott Lawrence,
Miss Inches,
Rev. Francis Parkman, D. D.
John James Dixwell,
Nathaniel J. Bowditch,
George Hayward,
J. C. Gray,
Edmund Dwight,
Samuel Appleton,
Miss Nancy Hooper,
William Appleton,
N. Appleton,
P. C. Brooks,
Charles Jackson,
James S. Amory,
Pascal P. Pope,
John S. Tyler,
An Unknown Friend,
Mrs. Wigglesworth,
Increase S. Smith,
J. J. Bowditch,
Miss Gibbs,
Jonathan French,
James Brown,
Thomas Wetmore,
Miss C. Nichols,
Miss C. Crowninshield,
J. Hall, jr.
Dr. James Jackson,
Miss Charles Taylor,
William Pratt,
George Parkman, M. D.
G. C. Shattuck, M. D.
E. Stewart,
E. Sturgis.

Brooklyn, N. Y.
James Hall,
Robert Havell,
W. Talcott,
Alfred Greenleaf,
Joseph A. Perry,
J. Farley Clark,
E. D. Hurlbut.

Cambridge, Mass.
Book Club.

Carlisle, Pa.
Spencer F. Baird.

Cedar Hill, Pa.
N. Dodge.

Cleaveland, Ohio.
Rufus K. Winslow.

Charleston, S. C.
Mrs. Mary A. Faber,
Samuel Wilson, M. D.
Rev. John Bachman, D. D.
Dr. Baron,
James Bancroft,
Allard H. Belin,
Thomas H. Deas,
Miss Wareham,
Charles Parker,
Isaac W. Walter,
Edward Watson,
Dr. Teideiman,
Mrs. Benjamin R. Smith,
J. W. Warley,
Dr. Edward North,
Dr. Edward W. North,
C. Wienges,
S. W. Barker,
O. L. Dobson,
Joseph F. Bee,
Dr. Thomas Y. Simons,
Hugh Wilson, jr.
James M. Wilson,
Miss H. S. Baker,
Dr. F. Wurdemann,
M. G. Gibbes,
Chancellor B. F. Dunkin,
Edwin P. Starr,
Mrs. La Bruce,
A. C. Smith,
Thomas Warring,
Miss Annelly,
W. A. Carson,
E. L. Strohecker,
C. C. Strohecker,
Frederick Porcher,
Samuel Stevens,
Mrs. Wm. Heyward,
James L. Pettigrue,
Dr. H. Ravenel,
J. D. Legare,
C. R. Brewster,
Mrs. James Ferguson,
William Blanding,
William Seabrook,
R. Bentham,
S. G. Deveaux,
P. Gourdin,
Thomas W. Porcher,
R. Barnwell Rhett, M. C.
John Ramsey,
J. C. Tunno,
W. B. Deas,
J. L. Manning,
John Kirkpatrick,
George Oates, (7 copies.)

Chippewa, U. C.
F. Huddleston,

Cold Springs, N. Y.

Gov. Kemble.

Columbia, S. C.

B. T. Elmore,
John M'Cully,
Mrs. Hampton,
R. W. Gibbes,
Hon. W. C. Preston,
Maxcy Gregg.

Dover, N. H.

E. T. Lane.

Detroit, Mich.

Major S. H. Webb.

England.

H. Thomas Weld.

Fort Crawford, Wis. Ter.

W. D. M. Rissack, 5th Reg. Inf. Library.

Gallatin county, Missouri.

A. G. Brower.

Georgetown, D. C.

George C. Bomford,
Georgetown College,
Charles Cruickshank.

Georgetown, S. C.

B. B. Smith, Esq., M. D.
J. Motte Alson.

Greenbriar county, Va.

Matthew Arbuckle.

Greensborough, Ala.

Rev. D. P. Bestor,
Joseph A. Moore, M. D.

Hagerstown, Md.

Joseph J. Merrick.

Halifax, N. S.

Thomas M'Culloch.

Hartford, Conn.

C. H. Olmstead.

Holmesburgh, Pa.

Humphrey J. Waterman.

Hopetown, Ga.

James H. Couper.

Jersey City, N. J.

C. Van Vorst.

Lancaster, Pa.

Arthur W. Mallon, (4 copies.)

Lexington, Ky.

Daniel Vertner,
M. C. Johnson,
Henry Johnson,
Hon. Henry Clay.

London Eng.

Sir Thomas Phillips,
William Yarrell, F. L. S., &c.
Lemuel Goddard,
B. Phillips, F. R. S., &c.
Binney Colvin,
W. Phillips.

Long Island, N. Y.

W. O. Ayers, Suffolk co.

Macon, Ga.

P. C. Pendleton, M. D.

Margaretta Furnace, Pa.

Henry Slaymaker.

Mobile, Ala.

Paul S. H. Lee,
J. Martin Lee,
Alg. S. Vigus, (2 copies.)
F. A. Lee,
Wm. Bower,
S. V. Allen,
Wm. M. Patterson,
Jos. H. Young,
James W. Goodman,
J. L. Lockwood,
John K. Randall,
George Haig.

Montreal, U. C.

Hon. G. H. Ryland,
Frederick Griffin.

Moorestown, N. J.

J. J. Spencer, M. D.
Edward Harris.

Nantucket, Mass.

Charles G. Coffin,
Nantucket Athenæum.

New Bedford, Mass.

Wm. W. Swain,

S. W. Rodman,
Benjamin Rodman,
R. R. Crocker,
Samuel Rodman,
Robert Gibbs,
E. Sawin,
George O. Crocker,
T. G. Coffin,
Nathaniel S. Spooner,
George Howland,
David R. Greene,
Hilliard Nye,
William R. Rodman,
George T. Baker,
Gideon Allen,
J. B. Congdon,
Reuben Nye,
Atkins Adams,
S. Merrihew,
Stephen S. Lee,
John Henry Clifford,
Francis S. Hathaway,
E. E. Swain,
Charles W. Morgan,
Thomas R. Robeson,
William Eddy,
Thomas Mandell,
Abram Shearman, jr.
A. D. Stoddard,
Wm. L. B. Gibbs,
Alfred Gibbs,
F. L. Brigham,
George Howland, jr.
William P. Jenney,
William P. S. Cadwell,
Andrew Robeson,
George B. Worth,
Miss Sylvia Ann Howland,·
Andrew Robeson, jr.
Lemuel C. Tripp,
James A. Roberts,
Lawrence Grinnell,
New Bedford Lyceum,
Miss Mary Rotch,
J. C. Delano.

New Bloomfield, Pa.

B. M'Intire.

New Garden, Pa.

Ezra Michener.

New Orleans, La.

Alexander Gordon,
W. F. Brand.

New York City.

W. D. Cuthbertson,
Mercantile Library Association,

John G. Bell,
Paul R. Hodge,
J. E. Dekay, M. D.
J. Cozzins,
J. Prescott Hall,
J. C. Jay,
Samuel Ward,
H. J. Hall Ward,
Walter C. Green,
W. L. Stone,
C. A. Clinton,
W. C. Maitland,
David B. Ogden,
Isaac A. Johnson,
W. A. F. Pentz,
Frederick Pentz,
C. N. S. Rowland,
Jehiel J. Post,
John H. Riker,
O. J. Camman,
J. J. Palmer,
J. Delafield,
Daniel Lord, jr.
Henry Coit,
T. Tileston,
J. Trenor, M. D.
Wm. Edgar,
Jonathan Sturgis,
Ambrose Burrows,
Benjamin L. Waite,
Benjamin Moore,
John H. Abeel,
John Frazee,
John H. Costar,
Wm. Burger,
George Washington Costar,
Dr. Bartlett,
N. T. Hubbard,
Thomas E. Walker,
N. G. Ogden,
Robert F. Fraser,
E. F. Sanderson,
Lyceum of Natural History in the City of
 New York,
John A. King, jr.
O. Bushnell,
J. J. Boyd,
Henry Robinson,
Delmonico Bro,
Robert E. Launitz,
Henry Edey,
W. J. Graham,
H. H. Jackson,
H. C. De Rham, jr.
Richard H. Ogden,
Edwin Lord,
Wm. H. Drake,
Alfred Ogden,
R. L. Maitland,
T. W. Ogden,

G. H. Costar,
Capt. J. Chadwick,
R. L. Kennedy,
J. F. Sheafe,
James Lennox,
W. O. Clason,
Henry Meyer,
Mrs. James Sheafe,
James Donaldson,
E. G. Hyde,
Edward Hardy,
Wm. F. M'Clenahan,
John M. S. M'Knight,
John M. Birdsall,
Jacob P. Giraud, jr.
L. H. Meyer,
Edmund Penfold,
John Durand,
James Simoson,
Hermon Morris,
Archibald Russell,
Thomas Williams, jr.
A. Barclay,
George B. Smith,
T. A. Napier,
F. Pell,
Daniel Trimble,
John Ewen,
Patrick Dickie,
H. M. Sheaff,
V. Pellevoisin,
Thomas B. Rich,
Bradish Johnson,
W. W. Valk,
Joseph E. Sheffield,
J. L. O'Sullivan,
G. Matfield,
Joshua Brookes,
S. L. Southard, jr.
Wm. P. Powers,
W. H. Bradford,
Ramsey Crooks,
John Hall,
G. C. Dekay.

Norfolk, Va.

W. E. Taylor.

Northborough, Mass.

Dr. J. J. Johnson.

Ogdensburgh, N. Y.

H. Vanrensselaer.

Orangeburgh Court House, S. C.

Gen. J. Whitemore.

Osnabruck, U. C.

Ira Hawley.

Owensborough, Ky.

Philip Triplett.

Perrymansville, Md.

George H. Perryman.

Philadelphia.

Mrs. Stott, (2 copies,)
Thomas P. Cope,
Wm. Hembel,
P. B. Goddard, M. D.
Samuel C. Sheppard,
Judah Dobson,
William Gamble,
Henry Haydock,
William Norris,
John F. Frazer,
John P. Wetherill,
Alfred Elwyn,
Philadelphia Lyceum,
J. H. Mullen,
William M'Guigan,
Philip B. Chase,
Benjamin G. Mitchell,
J. S. Lippincott,
Sidney V. Smith,
James Kinsey,
M. J. Hopkins,
William Stockton,
C. R. Moore,
Joseph Price,
John Siter,
Charles D. Meigs, jr.
Lambert Wilmer,
Charles Manley,
Thomas A. Myers,
W. B. Chase,
T. M. Smith,
R. J. Iddings,
S. W. Mifflin,
Wm. T. M. Cannon,
Edward Browning,
John Farnum,
Dominic Eagle,
Mrs. Sarah Ann Price,
Wm. Ashbridge,
Thomas Dunlap,
Jos. C. Oliver,
John R. Bowers,
Daniel L. Miller,
John J. Walker,
Jacob P. Jones,
Caleb Parker,
A. M'Intire,
H. Walton,
C. W. Hallowell,
William Young, M. D.
Owen Jones,
John Bacon,

W. H. Howell,
Joseph T. Baldwin,
Sigmond Pancoast,
James T. Caldcleugh,
Carey & Hart,
George C. Leib, M. D.

Pittsburgh, Pa.

Hon. Wm. Wilkins,
John H. Brown,
E. Simpson,
A. Kirk Lewis,
R. M'Master,
Frederick B. Smith,
W. E. Rogers,
Robert Dalzell.

Pittsfield, Mass.

Rev. H. N. Brinsmade,
J. C. Chesbrough,
D. Campbell,
B. Mills.

Pomaria, S. C.

Wm. Summer.

Portsmouth, N. H.

Portsmouth Athenæum.

Providence, R. I.

William Jenkins,
Alexander Duncan,
Moses B. Ives,
Jacob Donnell,
George M. Richmond,
Amory Chapin.

Quebec, L. C.

James Turnbull.

Queensborough, Ga.

W. C. Dawson. M. C.

Reading, Pa.

H. H. Muhlenberg, M. D.
Edward Brooks,
Joseph L. Stichter,
Henry Conard,
Samuel Ritter,
Benjamin Keim,
Joseph H. Spayde,
Miss Catharine Hiester.

Richmond, Va.

J. H. Strobia,
Library of the State of Virginia,
G. A. Myers,
Robert Stannard,
William H. Richardson,
Frederick Marx, M. D.
William Shapard,
R. J. Daniel,
Isaac Davenport,
Henry Myers, M. D.
Wynsham Robinson,
William H. M'Farlan,
E. H. Carmichael, M. D.
Philip Duval, jr.
William Carter,
James Beale, M. D.
G. Persico,
Thomas Ritchie,
William Copland,
Mrs. Mary M. Elfreth,
A. W. Nolting,
Henry L. Brooke,
William R. Myers,
B. W. Leigh,
P. W. Lemosy,
James Lyons,
William Mitchell, jr.
Joseph Mayo,
Wm. J. Barksdale,
University of Virginia,
John B. Southall,
John Cullin, M. D.

Roxbury, Mass.

W. J. Reynolds.

Salem, Mass.

S. C. Phillips,
John H. Silsbee,
Miss E. Hodges,
William A. Lander,
Francis Peabody,
Benjamin Merrill,
William Pickman,
Charles Hoffman,
William H. Chase.

Savannah, Ga.

J. H. Turner,
William King.

Simcoe, U. C.

Duncan Campbell.

Sing Sing, N. Y.

T. J. Carmichael.

Steubenville, Ohio.

Benjamin Tappan, U. S. S.

St. Augustine, Fa.

Gen. Joseph M. Hernandez,
J. G. Landon.

St. Louis, Missouri.

Western Academy of Natural Sciences.

Taunton, Mass.

William A. P. Sproat,
Taunton Social Library.

Throgg's Neck, N. Y.

Ogden Hammond.

Trenton, N. J.

H. W. Green,
G. Whitman.

Uniontown, Pa.

L. W. Stockton.

Vermilionville, La.

A. Mouton.

Washington, D. C.

M. Williams, M. D.
A. A. Humphreys,
Col. W. W. Seaton,
Joseph Gales, jr.
Joseph H. Bradley,
Thomas Allen,
Col. Croghan, U. S. A.
Treasury Department, by Hon. Levi Woodbury,
Topographical Bureau, by Col. J. J. Albert,
Lt. Col. J. H. Hook,
Richard Gott,
Maj. Gen. Macomb, U. S. A.
Wm. B. Lewis, Auditor.
Capt. W. W. S. Bliss, U. S. A.
Dr. Lawson, Surgeon Gen. U. S. A.
Major S. Cooper,
T. H. Crawford, Commis. Indian Affairs.

Adj. Gen. Jones, U. S. A.
Com. A. S. Wadsworth, U. S. N.
Major Turnbull, U. S. A.
Major Gen. Jessup, U. S. A.
War Department, by Hon. J. R. Poinsett,
Library of Congress,
Capt. W. D. Fraser, Cor. Eng.
A. Vail, War Dep.
James Kearney, Lt. Col. Topog. Eng.
R. S. Coxe,
G. Talcott, Ordnance Dep.
J. E. Johnson, 1st Lieut. Cor. Topog. Eng.
Capt. W. G. Williams, Topog. Bureau,
Capt. W. Hood, Topog. Eng.
Hon. John Forsyth, Sec. of State,
Benj. F. Sands, U. S. N.
Charles Seruggs,
J. M. Wise,
Navy Department, by Hon. J. K. Paulding.
Hon. J. K. Paulding, Sec. of Navy,
Dr. T. B. J. Frye,
Edward H. Fuller,
Major L. Whiting,
Com. Morris, U. S. N.
Hon. W. D. Merrick, U. S. S.
Major L. Thomas, Asst. Adj. Gen.

Wilmington, Del.

Frederick C. Hill,
J. R. Latimer.

Waterborough, S. C.

D. S. Henderson.

Waterloo, N. Y.

J. S. Clark.

West Point, N. Y.

Z. J. D. Kinsley.

Lightning Source UK Ltd.
Milton Keynes UK
UKHW021837061222
413480UK00006B/170